THE AR

Entrance to La Tourelle, Fox Chapel, Pa.,
1924-25.

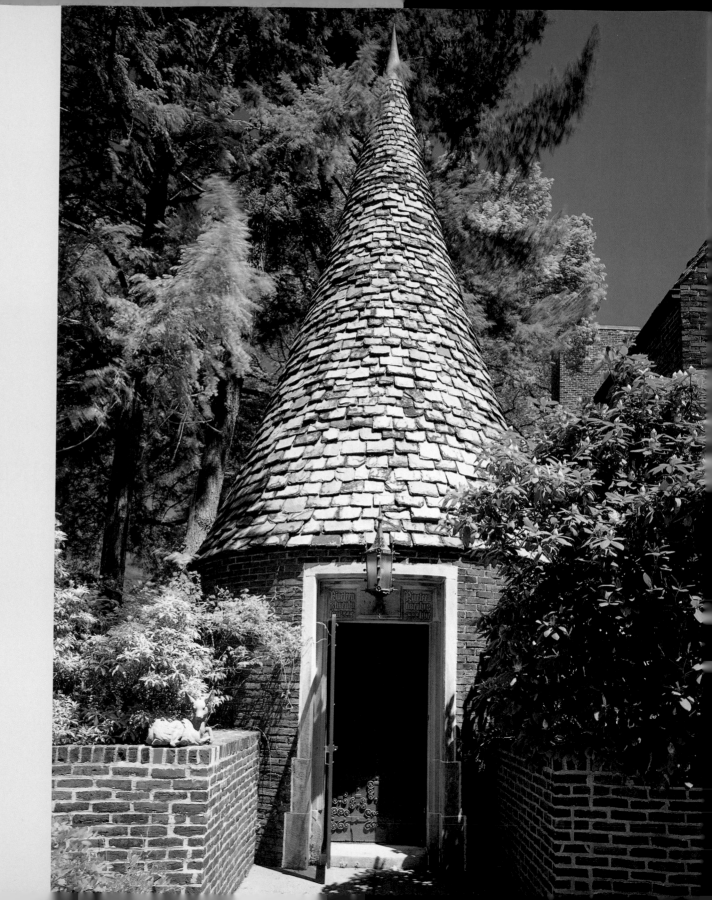

The ARCHITECTURE OF BENNO JANSSEN

DONALD MILLER

New Photography by Edward Massery

CARNEGIE MELLON UNIVERSITY
Pittsburgh, Pennsylvania

FRONT JACKET COVER: **Facade of La Tourelle.**

BACK JACKET COVER: **Facade gate, Elm Court.**

This book's shell and seahorse motif is derived from panel inlays in the lecture hall of Mellon Institute, Pittsburgh, Pa. (see page 151).

First Edition

Library of Congress Catalog Card Number: 97-94375

ISBN 0-9660955-0-2 (casebound)
ISBN 0-9660955-1-0 (paperback)

This book is printed on acid-free paper.

Designed by Douglas W. Price, Maidens, Virginia

New photography by Edward Massery, Pittsburgh, Pennsylvania

Printed by Carter Printing Company, Richmond, Virginia

❀ For Pat, Jane, and Bette. ❀

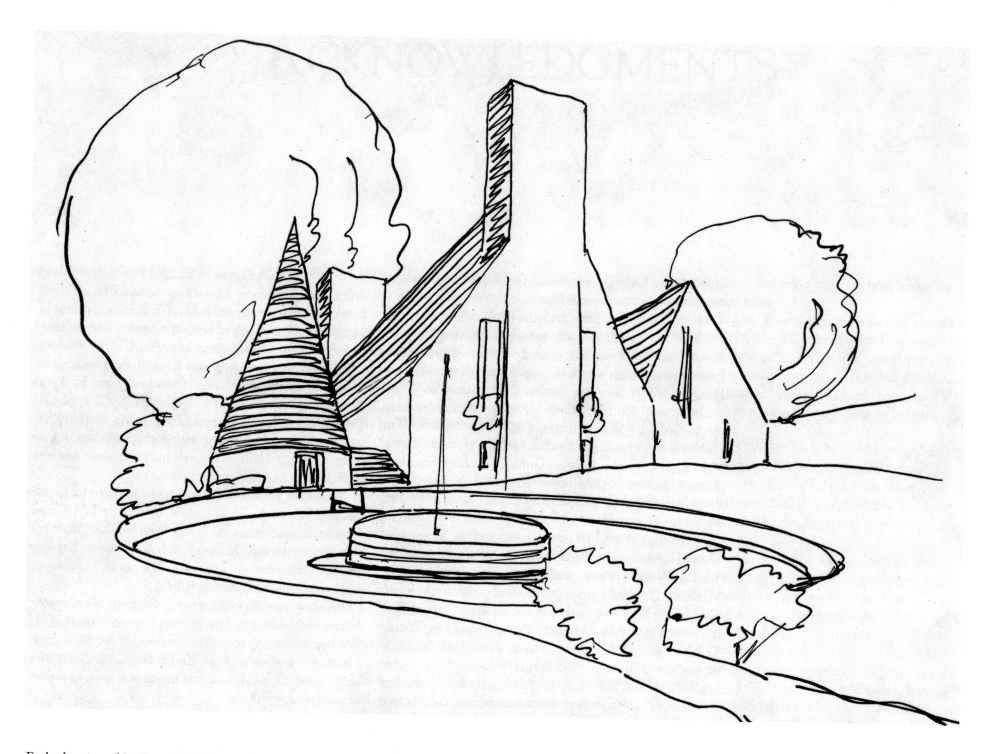

Early drawing of La Tourelle by Benno Janssen, C.1923.

THE ARCHITECTURE OF BENNO JANSSEN

...Architecture has always meant
to me the effort to express something
beautiful.

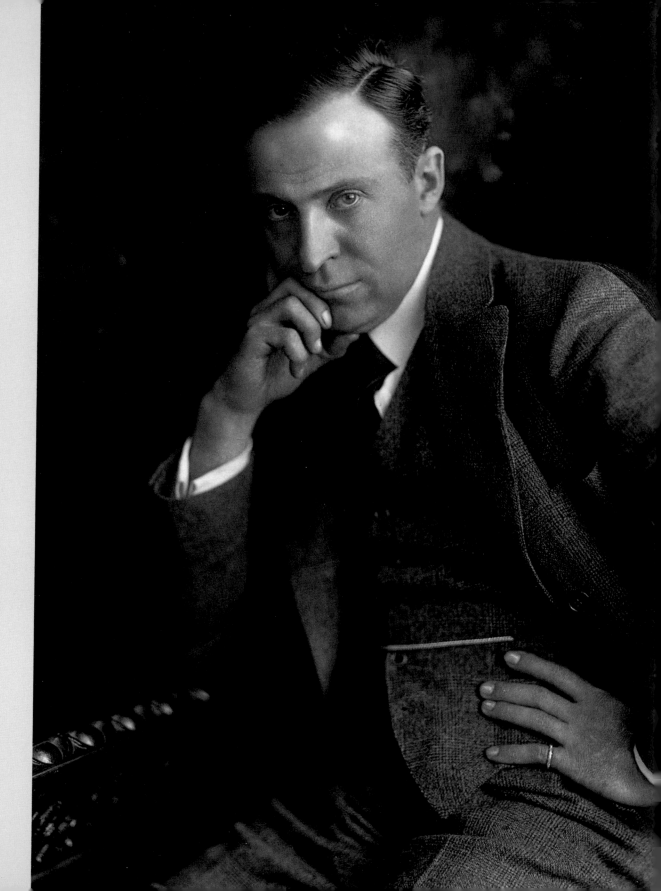

CHAPTER ONE

THE ARCHITECT

Not a great deal is known of Benno Janssen's early life, of which he rarely spoke. He was born in St. Louis, Mo., on March 12, 1874, the youngest of seven children, five boys and two girls, of Oscar and Thekla Susenbeth Janssen. Benno's father, Johann Karl Oskar Janssen, or Oscar, was born in Frankfurt-am-Main, Germany, on February 27, 1830. He immigrated to the United States in 1851, and for seven years operated a fancy goods store in Chillicothe, Ohio.

Oscar Janssen married Phillippine Johanna Paula Susenbeth, called Thekla, in Buffalo, N.Y., on March 9, 1854. During the Civil War, Oscar was a member of the Ohio National Guard. In 1865, the Janssens moved to St. Louis, where Oscar worked fourteen years for Charles F. Hermann & Company, a well-known hop and brewery supplier.

In 1879, in Atchison, Kansas, Oscar became senior partner in Florence, Janssen & Freyschlag, purveyors of wholesale notions. It became Janssen & Freyschlag after 1882. The firm directed four wagons with seven salesmen throughout Kansas and Nebraska. Oscar Janssen died on February 4, 1918 in Erie, Kansas.

Like her husband, Thekla S. Janssen was born in Frankfurt-am-Main. According to family lore, she named their last child Benno after a character in a book she was reading when he was born because she liked the sound of the name. In history, St. Benno was made bishop of Meissen, Saxony, in 1066.

He took the emperor's part in his conflicts with Pope Gregory VII, and was deposed. Later, imperialist Pope Clement III restored St. Benno to the bishopric, which he held until his death in about 1106. The name remains well-known in Germany. As recently as 1996, Gunter Behnisch, architect of Munich's Olympic roof and Bonn's plenary assembly, designed the colorful and contemporary Sankt Benno Gymnasium in Munich.

The other Janssen children were:

Ernest C. Janssen, born in 1855 in Chillicothe, studied architecture in Karlsruhe, Germany, in 1877-79, which polarized his style for twenty years. Ernest Janssen became a

Benno Janssen, about age 45, circa 1919.

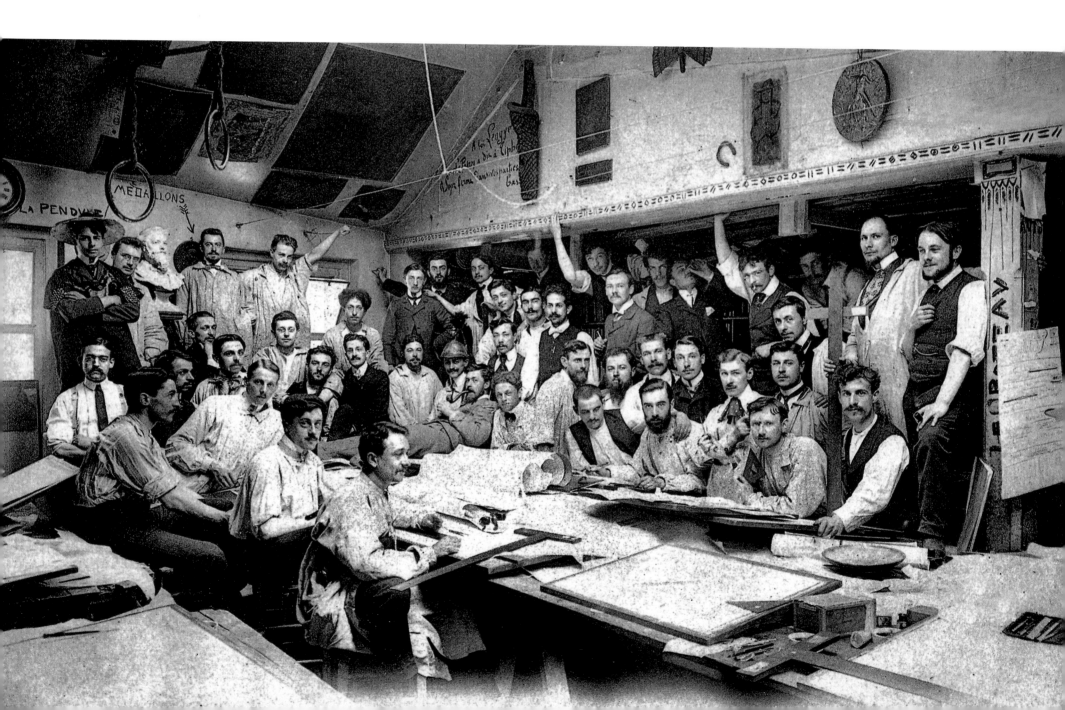

prominent architect of breweries and houses in St. Louis and did work in several American cities and Mexico. He did not marry and died September 25, 1946 in St. Louis.

Emma Janssen, born about 1857 in Chillicothe, married Paul Coste in 1881 (he died in 1906). Their children were Miriam, Elizabeth, and Paul Jr. Emma died December 2, 1936 in St. Louis.

Alexander Janssen, born November 20, 1858 in Chillicothe, married Maude Elton Stout (1872-1943) on October 1, 1890 in Atchison, Kansas, and died in 1937 in Kansas City, Mo. Their children were Mildred Elenor (born 1891) and Marie Thekla (born 1893).

Charles Janssen, born about 1861 in Chillicothe, married Jolivet Paquette; their children were Oscar and Dorothy.

Leopold, or Leo, Janssen, born March 30, 1865 in Chillicothe, married Nellie Helen Smith on September 17, 1889. Their children were Ernest, Thekla, Johanna, Leroy, and Hester.

Cornelia Marie Janssen, born on November 30, 1869 in St. Louis, Mo., married George F. Burt. Their children were Eloise and Ruth.

Of the second generation Janssens in the United States, Benno was the last surviving sibling.

After his early education in St. Louis, Janssen attended the University of Kansas in 1893-1894, and received his early architectural training in St. Louis.

He worked in his brother Ernest's architectural office and made working drawings for the red brick courthouse in Fort Worth, Texas. Ernest's firm was located over a saloon. For lunch the brothers would each buy a roast beef sandwich on rye with a draft of beer for ten cents.

Later in life, Janssen rarely saw his relatives and did not attend his mother's funeral. But his family kept in touch with one of his Midwestern nieces, the late Thekla Susenbeth Beard, and much later a cousin, Merritt Janssen.

With an extremely busy office in Pittsburgh, Janssen's life with its important business connections must have seemed totally removed from his Midwestern youth. Yet even in Pittsburgh, Janssen did not socialize with his partners, first Franklin Abbott and then William Y. Cocken. He was more attracted to the titans of industry, particularly Arthur Vining Davis, chairman of the Aluminum Company of America, the Mellon brothers, and Edgar J. Kaufmann.

After moving to Boston, Mass., Janssen, then twenty-four, served in the Spanish-American War in 1898, and was stationed at a United States Army camp in Chickamauga, Ga. His squadron commander was Captain Alfred E. Hunt, of Pittsburgh, elder brother of Roy A. Hunt Sr., who later became president of Alcoa and a Janssen client. Captain Hunt, who died of influenza in 1899, may have suggested Pittsburgh's possibilities to young Janssen, who is believed to have seen service in Cuba.

After the war in 1899, Janssen returned to Boston as a draftsman for Shepley, Rutan & Coolidge, successor firm to Henry Hobson Richardson, which had many Pittsburgh commissions; and then, from 1902-05, for Parker & Thomas in Boston. At these offices, Janssen received a thorough grounding in architectural practice. His ambitions began to soar when, in 1902, he won second place in the Rotch Traveling Scholarship, a national drafting competition still sponsored by the Boston Society of Architects. Applicants must have worked a year in a Massachusetts firm to be eligible.

Comic postcard photograph of instructors, Department of Architecture, Carnegie Institute of Technology, postmarked April 17, 1908. Janssen, top row left, clowns with fellow instructors inside canvas stretcher. Henry Hornbostel, fourth from right, straddles sawhorse. Edward Weber stands at center.

Parker & Thomas lent Janssen $2,000 to finish his artistic and theoretical education at the Ecole des Beaux-Arts, Paris. There he attended the atelier of architect Jean-Louis Pascal, a popular studio for Americans. Janssen was well aware that many of America's most renowned architects had studied at the Ecole. They included Richard Morris Hunt, Richardson, Louis Sullivan, Bernard Maybeck, Addison Mizner, Julia Morgan, John Mervin Carrère, his partner Thomas Hastings, and John Russell Pope.

Later, a national architectural magazine would compare Janssen and Abbott's work on the interior of the Fort Pitt Hotel with that of Carrère & Hastings and McKim, Meade and White in New York. And Janssen would become a friend of Pope, architect of the West Building of the National Gallery of Art, built by their mutual client Andrew W. Mellon.

One friend Janssen may have known in Boston before going to Paris and the Pascal studio would become a future colleague. Edward Joseph Weber (1877-1968), of Cincinnati, was also the son of a German-born father and a Rotch scholarship runner-up. After his 1903-05 studies with Pascal, Weber worked in Boston for Peabody and Stearns, which had a Pittsburgh office led by Colbert A. MacClure.

While abroad, Janssen immersed himself in the architectural styles of France and adjacent countries he visited. A 1904 drawing he later reproduced to give to friends shows the exterior of Chartres Cathedral. One of the walled southern French town of Carcassonne may have stimulated his love of conical towers. At the atelier, Janssen found that high-spirited students had fun by throwing sausage balls in the drafting rooms, often ruining many fine drawings.

Returning to Parker & Thomas in 1904, Janssen worked to repay the stipend while helping to draw plans for the Johns Hopkins Medical Center, Baltimore. The architecture he saw on his visit abroad would be remembered vividly and permanently influenced his stylistic choices.

Also in 1904, Janssen joined the busy Pittsburgh firm of MacClure & Spahr, Architects. Colbert A. MacClure, besides having worked in Boston and Pittsburgh for Peabody and Stearns, also attended the Ecole and probably invited Janssen and Weber to join his firm. Later, Weber would work for Janssen as an artistic designer on the Masonic Temple, the University of Pittsburgh's Alumni Hall, and the former Downtown YMCA. In 1925 or 1926, Weber became a partner in Link, Weber and Bowers, designing many period schools, churches, and houses in the Pittsburgh region. Weber's masterpiece is St. Joseph Cathedral, Wheeling, W.Va., done around this time.

MacClure and Spahr designed in Downtown Pittsburgh the Union National Bank, now National City Bank of Pennsylvania (1906); the Diamond Building, now 100 Fifth Avenue Building (1905); the Grand Opera House, later Warner Theater, now Warner Centre (1906); the Jones & Laughlin Building, now John Robin Civic Building (1907); and Meyer & Jonasson's, a women's department store, now 606 Liberty Avenue Building (1909-10).

Janssen joined the Duquesne Club, the city's most important gathering place for businessmen, in 1904.

Membership would prove valuable but not only for business contacts. In 1929, Janssen and Cocken would design a twelve-story addition to the club.

In 1907, Janssen, then living on North Neville Street, Bellefield, joined with another young architect, Franklin Abbott, of 808 Morewood Avenue, Shadyside, to form their first office, Janssen and Abbott. It was located in the new (1905) Machesney Building, now Benedum-Trees Building, Fourth Avenue, Downtown. Soon busily engaged, the firm moved to larger quarters on the ninth floor of the Renshaw Building, 901 Liberty Avenue. In 1914, the firm settled into the eighth floor of the Century Building, Seventh Street. Janssen worked there until the day he retired.

Franklin Abbott was the son of William Latham Abbott, a prominent Pittsburgh steel manufacturer. Born in Columbus, Ohio, in 1852, William Abbott rose to be president and chairman of Carnegie, Phipps & Company. Representing management, Abbott negotiated the 1889 Homestead strike with the successful Amalgamated workers. Henry Clay Frick judged this a debacle for the company. He took over in the strike of 1892, calling in the Pinkerton private police. This act precipitated historic and tragic consequences that broke steel unionism for forty years and caused Frick to be called the "most hated man in America."

As a partner of Andrew Carnegie, Abbott voluntarily resigned in 1892, under Carnegie's Iron-Clad Agreement pressures, with a fortune. As a highly influential officer and director of Pittsburgh banks and other businesses, Abbott was important to the early rise of the young architectural firm.

Franklin Abbott had worked since 1894 for Alden &

Harlow in the Conestoga Building on Wood Street. This Pittsburgh firm had its roots in Richardsonian Boston when the firm was Longfellow, Alden & Harlow. With the Carnegie Institute and many other structures to its credit Alden & Harlow was Pittsburgh's most distinguished architectural firm from 1886 to the 1920s. After 1922, Janssen would not only adapt or add to several Alden & Harlow projects, such as the Duquesne Club, as subsequent designer but would also carry forward the earlier firm's eclectic legacy through the 1930s.

William L. Abbott, a member of the Duquesne Club, thought so much of Janssen's ability, according to Janssen's son, A. Patton Janssen, that Abbott offered Janssen $4,000 a year for three years to practice with Franklin. Janssen considered his partner's social connections his greatest value to the firm. Abbott stayed for thirteen years.

In 1910, Janssen and Abbott designed a Tudor Revival house for Franklin Abbott at 5365 Darlington Road, Squirrel Hill, Pittsburgh. Although it had some Arts and Crafts details, a style Abbott must have enjoyed while working for Alden & Harlow, the brick house also had three arched windows as part of its facade.

It is evident that arches appealed to Janssen from the number he employed in his early works. Their grandeur is a dominant part of both the Palm Court lobby and Terrace Room of the William Penn Hotel, now Westin William Penn. Use of arches culminated in the concrete piers of the Washington Crossing Bridge at Fortieth Street, Pittsburgh. The span's soaring vaults when seen from the side recall Giovanni Battista Piranesi's etchings. They may have been

an influence, since Janssen owned books of Piranesi prints.

The Abbott house's windows joined with rectangular ones recall somewhat those of High Hollow, a 1913 Arts and Crafts house with a similar combination, along with tall slate roofs, that Mellor Meigs and Howe, of Philadelphia, did for partner George Howe. Its grand residential work is comparable to Janssen's. Although Mellor Meigs and Howe was one of the best designers of its kind, it was only one of many eclectic firms in American cities.

Abbott's house stood a few doors from Ben Elm, the picturesque 1903 Arts and Crafts mansion Alden & Harlow created for William Larimer Mellon, nephew of Andrew and Richard B. Mellon, at 5360 Forbes Avenue and the corner of Darlington Road. The younger Mellon was president of Gulf Oil Refining Company and a grandson of Judge Thomas Mellon, founder of Mellon Bank. Both houses, now demolished, overlooked the Schenley Park public golf course.

What sort of man was Benno Janssen? Obviously artistically gifted and respected, he oversaw the work of his office like a pleasant and personally elegant director. He was particularly attentive to romantic details that gave character to his buildings. Ambitious, courtly, almost reserved but approachable, he had qualities that would quickly advance him as an architect and businessman.

Janssen was both chief designer and inspirer of the many architects and others employed in the office. He stood five feet, nine inches tall and was always a well-dressed gentleman. Calm and quiet, he had a kind word for anyone he met.

Among men, he demonstrated a ribald humor.

The Brickbuilder, a national trade magazine, described him in 1915:

Janssen was always admired by his associates in his student days for his remarkable ability of architectural expression, no less than for his personal charm.

He nevertheless was misunderstood by many, due to the fact that he unconsciously was an exponent of the "new school," which teaches that the final result of an architectural attempt is the "building itself" and not the effect produced on paper, the latter being the vogue at that time. His rapidly made drawings were especially interesting to those who understood and left an indelible impression upon them.

His seeking for truth of expression, the reasonable use of architectural forms, and for the understanding of the fundamental principles that govern architectural designs, portrayed only the dominating characteristics of the man as he is.

Janssen's work shows not only individuality, but a comprehension of his problem, a forceful composition and yet an understanding of the value of detail and the selection of material. Add to this executive ability, tireless energy, and one has little reason not to understand his success.

One has only to look at the Pittsburgh Athletic Club to appreciate the influence of this personality. For this firm to have the force to impress upon a

committee the necessity and importance of producing a building of this character is no less an achievement than the design itself. The residences his firm has executed show not only individuality but an indigenous quality which is so essential for a good architectural result.

Although Mr. Janssen has devoted the larger part of his life to competitions, he nevertheless has shown the rare capacity to devote himself as energetically to the production of a beautifully finished building as to the production of the drawings which have won the commissions...

In 1918, three and a half blocks east of Abbott's house, Benno and his first wife, Edna Margaret McKay Janssen, acquired a large red brick Colonial Revival house at 5625 Darlington Road. Built in 1905 by a county delinquent tax collector, it suggested the period taste of New York architect William Delano, whom Janssen admired. After Edna's death the next year, Janssen kept the house, and then brought his second wife Edith to it in 1921. They would live there for most of their time in Pittsburgh. Their children, Dr. Benno Janssen Jr., A. Patton Janssen, and Mary Patton Janssen, were born between 1922 and 1924.

But in 1923-1924, the Janssens temporarily vacated this house, renting it furnished to the Edgar J. Kaufmanns. Although the reason for this is not known, the timing coincides with the planning and construction of La Tourelle, the Norman-style manor Janssen designed for the Pittsburgh department store owner who was a longtime client and friend. The Kaufmanns had been renting a Janssen and Abbott house near Abbott's home. In the interim, the Janssens rented a house on West Woodland Road, Squirrel Hill, from Mrs. W. B. Rodgers. This was near Andrew Mellon's house, now Mellon Hall, Chatham College.

In these years Janssen met many influential people and potential clients. Besides the Duquesne Club, he was a member of the Allegheny Country Club, Sewickley Heights, Pa.; Fox Chapel Country Club, Fox Chapel, Pa.; Longue Vue Club, Penn Hills, Pa., which he designed; Oakmont Golf Club, Oakmont, Pa.; and the Rolling Rock Club, Ligonier, Pa.

For Rolling Rock he created the grand stables and the charmingly styled kennels that once housed the Mellons' prized English hunting hounds. The interior of the kennels has been redesigned by MacLachlan Cornelius and Filoni, Pittsburgh architects, as a private museum of the Mellon family's hunting and riding history.

Richard B. Mellon, builder of the Rolling Rock Club, also asked Janssen, according to his son Pat but not generally known, to design several public rooms in the clubhouse as well as second floor guest rooms in the English country style with a restrained arts and crafts mood. But like Frank Lloyd Wright's work on the Arizona Biltmore Hotel, Phoenix, Janssen's clubhouse contributions, other than a dining room, go unrecorded.

His club memberships and strong interest in golf brought Janssen into contact with the financier brothers. The wealth of Andrew William Mellon (1855-1937) and Richard Beatty Mellon (1858-1933) has been estimated at more than $350 million each. The architect would have

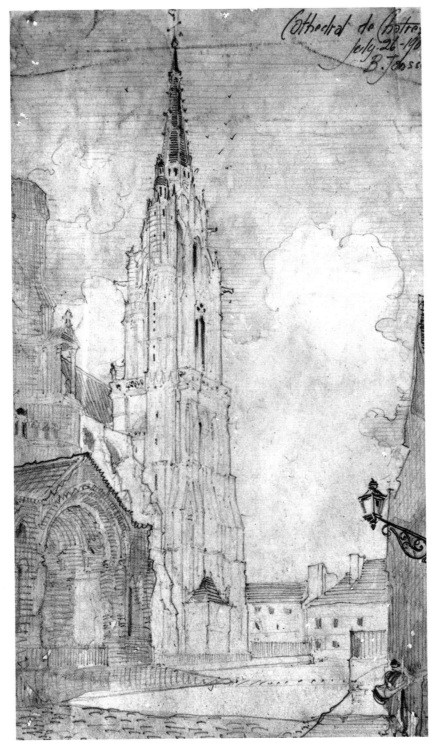

Janssen freehand drawing, signed, titled, Chartres Cathedral, Chartres, France, July 26, 1904.

Sketch, signed and titled "Memories of Carcassonne, France, after a Poster"; undated, probably 1904.

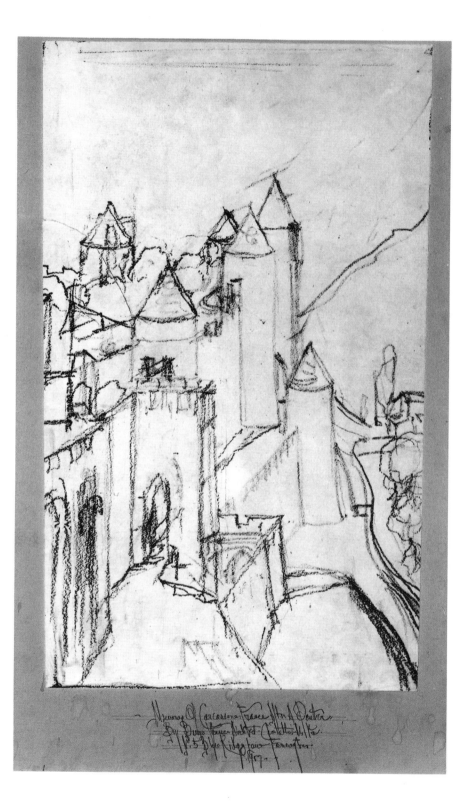

another important client, Henry Clay Frick (1849-1919, estimated wealth $225 million), who commissioned the William Penn Hotel, which was built in two stages almost a decade apart.

Janssen's friendships with Arthur Vining Davis and Roy A. Hunt Sr., respectively chairman and president of the Aluminum Company of America, were also productive. The Davises played bridge, often twice a week, with the Janssens at their Darlington Road home. The Mellons and Edgar J. Kaufmann, ordering several large commissions, were the architect's most important clients.

Janssen and Abbott was quite capable of producing large and small commissions, often simultaneously. There is no question that the palatial beauty of the Pittsbugh Athletic Association in the city's new Oakland Civic Center dazzled one and all and set the stage early for the firm's continuing success.

Preceded by an addition to the Fort Pitt Hotel, the P.A.A. would be followed by the mystic Masonic Temple next door and the first phase of the William Penn Hotel as well as the smaller Penn-McKee and Penn-Lincoln Hotels, respectively in McKeesport and Wilkinsburg, in Allegheny County.

Also on the drawing boards in 1912 were the enlargement of Kaufmann's Department Store and, for the ambitious developer Franklin Nicola, designs of the Nicola Building, now Buhl Building, covered in vivid blue and white tile. Other structures included the Young Women's Christian Association in East Liberty and the Young Men's Christian Association, Downtown.

At the same time, in addition to elementary schools and the Tuberculosis Hospital, Hill District, the firm drew handsome houses and designs for Oakland's Schenley Farms district as well as Squirrel Hill, Shadyside, and Point Breeze. All are credits to their neighborhoods.

With the firm doing well on the eighth floor of the Century Building in 1918, Janssen, according to his son Pat, became tired of his socialite partner's presence. Abbott's value was in whom he and his father knew. Janssen offered Abbott a 25 percent interest in the firm, with Janssen taking the rest, and Abbott could continue on that basis without working. Abbott declined Janssen's offer and left the firm.

Abbott's father owned a summer residence, Sidbrook, in Cobourg, Ontario, Canada. In the 1920s, Abbott designed a sumptuous residence for Pittsburgh businessman George A. Howe on Cobourg's King Street East. It was featured in the December 1931 *Canadian Homes and Gardens*. Franklin Abbott moved to New York City in 1924, where he worked in Room 403, 52 Vanderbilt Avenue, in 1924-25, and at 230 Park Avenue in 1929-34. He is not listed in the American Institute of Architects archives after this, and his last years are not known.

Janssen ran the firm alone until asking his chief draftsman, William York Cocken Jr. (pronounced "Coken"), to become his partner in 1921, forming Janssen and Cocken. The junior partner had started with Rutan and Russell in 1902, then joined Janssen and Abbott in 1907. He attended night school at Carnegie Institute of Technology, sang with the Glee Club, played on hockey and football teams, and graduated in 1912. With Cocken, Janssen was able to

achieve many of his dreams while overcoming many of the technical problems of design and construction. Janssen was always most interested in the firm's creative aspects.

The firm was extremely active in the 1920s and beauty poured forth: the Washington Crossing Bridge over the Allegheny River; Longue Vue Club; a large 1922 addition to the Joseph Horne Company department store, Downtown; and many more works. These included Edgar J. and Liliane Kaufmann's house that Janssen named La Tourelle for its distinctive entrance in a part of Aspinwall soon to become Fox Chapel. This fine suburban borough lies northeast of the Washington Crossing Bridge.

As early as 1913, as stated, the Kaufmanns had rented a Janssen and Abbott red brick Tudor Revival house on a terrace at 5423 Darlington Road, around the corner from Abbott. This house was designed in 1909 for Thomas McK. and Clara Walton Cook, of the North Side, for their son J. Walton Cook, partner in a Downtown real estate company, and his family.

A drawing of the house appeared in *The Builder*. The land had been formerly owned by William Larimer Mellon and Frederick G. Kay, nearby residents. They had planned speculatively to secure the neighborhood with up-scale houses and building restrictions stipulated in deeds.

Franklin Toker, architectural historian, University of Pittsburgh, theorizes Kaufmann hired Janssen because he was the Mellons' architect, for whatever help this might bring the ambitious magnate. Kaufmann, born in Connellsville, Fayette County, was impressed with the rise of Henry Clay Frick through his Fayette coke ovens. Toker believes Kaufmann knew that while he lived at 5423 Darlington Road a Mellon would be his neighbor.

But Kaufmann would make his impact on Pittsburgh as a unique individualist. He probably inspired novelist Ayn Rand's portrait in "The Fountainhead" of Gail Wynand, a newspaper publisher who commissions a modern house from Howard Roark. Kaufmann, who died in 1955, is also recalled in the forty-seven May Department Store Company branches that bear his name.

Kaufmann gave Janssen at least four commissions, prin-

cipally two expansions of Kaufmann's Department Store and the Young Men & Women's Hebrew Association of Pittsburgh, built at the same time as La Tourelle. This work was followed by the Grant Street addition to the William Penn Hotel, 1926-29. Other projects of the period were the T.W. Phillips Gas and Oil Company headquarters, an Italianate palazzo in Butler, Pa., and nearby Elm Court, baronial home of its chairman. Impressive Janssen and Cocken houses would also rise at the same time in Sewickley Heights during the last years of that suburb's golden age that ended in 1940.

In the late 1920s and early '30s, the firm also designed the Duquesne Club addition; the Gothic highrise Keystone Athletic Club; a Louis XIV-style addition to the Westinghouse Air Brake Company; the crenellated Union Switch & Signal Company office building in Swissvale and Annunciation School, North Side. A relatively stripped form of design was quite adaptable. It would become a powerhouse in Quebec Province and the basis for several other structures.

For Janssen the era ended with the firm's most unusual and difficult structure, Mellon Institute of Industrial Research. Although the temple form appears relatively simple, the building's design was extremely complex. Janssen, a contemporary architect with a period sensibility, would rise to his directorial best in adapting a universally admired ancient ideal to a new purpose.

Shortly after Mellon Institute's completion, several important projects were curtailed by Depression doubt and pre-World War II caution. Pushing back from his desk, the architect, sixty-four years old and proudly accepting that he had done his best, decided to bring his career in Pittsburgh to a close.

Although the greater part of Janssen's buildings remain in existence, there has been a sizable amount of demolition and change. It is also perhaps surprising, given his prominence, that so much work was never realized. Several of these plans would have added even more to Janssen's legacy and Pittsburgh's history. One such concept of 1916 was Janssen and Abbott's grand Oakland apartment complex,

recalling Paris' Place des Vosges, proposed for Henry Clay Frick's property, Frick Farms. The four acres in question now contain the University of Pittsburgh's Cathedral of Learning, Heinz Memorial Chapel, and Stephen Foster Memorial, all by Philadelphia architect Charles Z. Klauder.

The apartments would have been placed between the Pittsburgh Athletic Association building, Masonic Temple, and Longfellow, Alden & Harlow's Carnegie Institute. Why were these apartments not built? The Frick Archives has not a word about it, but the costly idea may have been another of Nicola's speculations. He had wooed both the University of Pittsburgh and the Pittsburgh Pirates from the North Side to Oakland, built old Forbes Field in four months, and was a friend of the coke king.

Frick, who had changed Grant Street with three major buildings and would die at seventy in December 1919, had other interests on his mind in his last years, particularly corporate board business, philanthropy, and waning health.

Many architects were severely curbed by the Great Depression. Among unrealized Janssen and Cocken projects of the 1930s was a proposed international headquarters for the Pittsburgh Plate Glass Company, now PPG Industries. It was planned for Fifth and Bellefield Avenues, former studio of WQED-TV and currently the Pitt music department building.

Unlike Mellon Institute diagonally across Fifth Avenue, the block-long limestone-clad PPG structure, as delineated by J. Floyd Yewell, was contemporary and businesslike. Dark glass panels accented the proposed lobby's art moderne elegance. But pre-war corporate doubt followed by post-war growth doomed the design. The firm's headquarters remained Downtown.

Also unfruitful was Janssen and Cocken's 1930s concept for a massive Pittsburgh Country Club apartment clubhouse. It and the Schenley Towers, a highrise proposed for Fifth Avenue at University Place, are documented in the Carnegie Mellon Architecture Archives but otherwise forgotten. The twenty-story Towers, echoing somewhat in outline the nearby Cathedral of Learning, died in the Depression, but handsome renderings, including a delineation by Hugh Ferriss,

outstanding American artist of urban architecture, and floor plans survive. The potential site remains a parking lot across from the Soldiers and Sailors Memorial by Henry Hornbostel (1867-1961).

The Schenley Towers would have looked across Fifth Avenue to the Schenley Apartments of 1922 (now Schenley Quadrangle, the University of Pittsburgh's dormitories) and would have risen one door away from the University Club, also by Hornbostel. Among this architect's many accomplishments was being first dean of the College of Fine Arts at Carnegie Institute of Technology (now Carnegie Mellon University) and head of its Department of Architecture.

Janssen and Cocken designed units in the Schenley Apartments for well-to-do clients. Ground-level decorative details with a suave Italian and French character suggest Janssen's influence. But such bravura is more prominent in Janssen and Cocken's 1930 plan for the Twentieth Century Club at Bigelow Boulevard and Parkman Avenue two blocks away.

A more restrained neoclassicism is seen in Janssen's 1920-21 design of Pitt's Alumni Hall, owing at least in part to a limited alumni budget, but still a remarkable gift. Halfway up a steep hillside, Janssen would insert this hall of sciences, a long cream brick and limestone building. It offers many classrooms, professors' offices, and a limestone eagle at its roof's low apex, but its outstanding feature is a splendidly simple central interior staircase of steel and slate.

With this hall Janssen helped, in a massive but less elaborate fashion, to extend the impact of the beaux-arts academic acropolis Hornbostel had planned for the university in 1908. There was a like-minded friendship between the two architects; and Janssen was teaching at Tech in 1908. But in the competition that year for Pitt's upper campus, Janssen and Abbott came in second to Palmer and Hornbostel. The situation recurred when Hornbostel and his New York partners won the 1915-17 design for the City-County Building, Grant Street, Downtown. With good reason.

Both of Janssen's firms participated in and won competitions, but records of these are incomplete. Drawings of Janssen and Abbott's courthouse and city hall — the City-

County Building — in the Carnegie Mellon University Architecture Archives are ungainly. The Georgian Revival design recalls the silhouette of Philadelphia's Second Empire City Hall with many floors, an inner courtyard, and a large tower topped by a figural sculpture. That may seem unlike Janssen, but he had a deep love of American colonial design, to which he returned throughout his career. It is no accident that he resettled in Thomas Jefferson's Charlottesville.

After joining the American Institute of Architects in 1907, Janssen taught architecture part-time under Hornbostel at Carnegie Institute of Technology until 1916. It was formerly thought Janssen taught from 1914, but a faculty photograph shows him with Hornbostel and others in 1908. As dean, Hornbostel oversaw the school's several departments, including architecture. As architect, he had laid out the campus and designed its first buildings in 1904.

Janssen always respected Hornbostel and visited him late in their lives. With the Pittsburgh Athletic Association and Masonic Temple behind him, and with Hornbostel's likely endorsement, Janssen was elected a Fellow of the American Institute of Architects on December 8, 1916. He was a precocious forty-two.

Janssen, Abbott, and Cocken were members of the Pittsburgh Architectural Club for many years. The club sponsored annual exhibitions in the library galleries of Carnegie Institute from 1900 to 1916. Here Pittsburgh architects and artists joined their plans, drawings, photographs, and sketches with those of peers in other cities. It was an education for them and the public.

Janssen was active in the club's selection and hanging committee. In 1907, the year he joined, he exhibited seven drawings done in England and France, including Oxford University's Trinity College and France's Chartres Cathedral. Many of Janssen and Abbott's renderings, plans, and photographs of projects were shown at these exhibitions, indicating the firm's early pride of accomplishment.

Other plans and photographs were printed in such gentlemanly omnibus periodicals as *The Builder*, published by T.M. Walker of the Heeren Building, Downtown Pittsburgh.

Janssen and Abbott's first rendering appeared there in May 1908 under the title "A Schenley Farms Home."

This was a substantial three-story Edwardian house with a steep roof, four gables, half-timbering and a large porch extending the length of the four-bedroom dwelling. There was also a variation of this design for what Franklin Nicola's declamatory advertisements of the day called "The city's social, educational, club, and best residence center, a place par excellence for fine homes."

By 1910, half of Schenley Farms' lots were sold, mostly to the University of Pittsburgh for its acropolis. That December, *The Builder* illustrated the firm's Italianate gymnasium for the Western Pennsylvania School for Blind Children, North Bellefield Avenue, as well as drawings of three more three-story houses for Schenley Farms. In March 1911, William York Cocken won third prize in the Pittsburgh Architectural Club's exhibition for a house designed to be built of terra cotta hollow tile blocks.

Among early designs exhibited at Carnegie Institute were Kaufmann's Department Store as expanded in 1913 and the William Penn Hotel, represented by five drawings, including the ballroom as realized.

Janssen's Architectural Club committee co-members in 1910-11 were distinguished. Under church architect John T. Comes, chairman, were: Hornbostel; Colbert A. MacClure (Janssen's former employer who would die in 1912); architect Frederick A. Russell; and J. Horace Rudy, who, with his brothers, was a well-known designer of stained-glass windows.

In his early Pittsburgh years, Janssen was struck by a car while he was walking home along Bigelow Boulevard. He fell twenty feet down a hillside and hit a galvanized bucket. He broke his left leg and was hospitalized for six weeks. When the cast was removed, Janssen sat down and broke his leg again in the same place.

As a result, his left leg was half an inch shorter than the right. He did not limp but this was the reason he gave for going to New York to have his shoes made. He loved clothes of quality. Wetzel of New York, later

joined with Saks Fifth Avenue, made his suits.

Janssen married Pittsburgher Edna Margaret McKay Janssen about 1914. Edna Janssen's father owned a machine shop that did much work for steel mills in and around Pittsburgh. During World War I, the McKay Company was busy with government work and developed automobile and truck chains. After the war the firm became the McKay Chain Company, a large chain manufacturer. Edna died of influenza in 1919 and Janssen bought their Squirrel Hill house from her estate in March 1920.

Edna's niece Betty McKay was the wife of attorney George W. Wyckoff, a friend of Paul Mellon, Andrew's son, and a trustee of the A.W. Mellon Educational & Charitable Trust that Andrew formed in 1930. One of its first duties was to disburse funds to buy Old Master paintings from the Soviet Union. Andrew Mellon then donated them, with his own collection, to the National Gallery of Art.

The gallery's 1937-39 construction funds, a total of more than $71 million, the largest gift ever given to the United States government, also came through the trust. But Andrew Mellon only lived to see the gallery's excavation. In 1937, Benno Janssen was a pallbearer at his funeral in Pittsburgh's East Liberty Presbyterian Church.

Carnegie Institute of Technology and the Mellon Institute of Industrial Research merged in 1967 to become Carnegie Mellon University, with the Mellon Institute building becoming part of the university. Paul Mellon, chairman of the institute's board of trustees at the time, and other family members largely made the merger decision.

Mellon was not finished. Over its fifty years, the A.W. Mellon Educational & Charitable Trust gave away $199.8 million, mostly to non-profit health and arts organizations, many located in Pittsburgh. Noting their advancing ages, Paul Mellon with the other trustees ended the trust in 1980. Liquidating assets of $21.1 million, the trust made The Pittsburgh Foundation its residuary donee. Final grants went to: the National Gallery; Carnegie Mellon University for additional endowment of the College of Fine Arts; Carnegie Institute, where the trust's endowment helps to fund the Carnegie Internationals and acquisitions; the University of Pittsburgh; and The Pittsburgh Symphony Society.

Meanwhile, Janssen was able to deal with his grief over losing his wife. On April 4, 1921, a widower for a year and a half, he married Edith Dill Patton, daughter of State Senator Alexander Ennis Patton and Mary Boynton Dill, of Curwensville, Clearfield County, Pa. The wedding, at Philadelphia's Bellevue-Stratford Hotel, was followed by a six-month honeymoon in Europe. The bride called it "an architectural tour" during which Janssen rekindled his old memories.

The Pattons had deep roots in Pennsylvania. Edith's grandfather, John Patton, was in the lumber business. He became a bank president, a congressman, a friend of Abraham Lincoln, and philanthropist. His grandfather, General John Patton, a Scots-Irish immigrant, was a member of George Washington's body guard, a colonel in the 16th Additional Continental Regiment, and in the American Revolution commanded Philadelphia's defense.

The Janssens were a golfing family. Edith Janssen, who enjoyed the game, ran the house, oversaw servants, took care of family accounts, and was a talented bridge player. She joked that sending the Janssen boys to the Oakmont Golf Club every day in summer meant they had caddies for baby-sitters. She laughed and said she played golf with young women at the club in the mornings and bridge with their parents in the afternoon.

But her life was not all fun. In World War I, Edith drove an ambulance in Europe, as did Helen Clay Frick and other American women wanting to serve the cause. During the Great Depression Edith volunteered in Pittsburgh soup kitchens.

At Oakmont, the Janssen boys hit golf balls back and forth on the old grass tennis courts with caddy Frank Bonaratti, who spent many hours teaching them. Pat and Benno Jr. reached the finals of the Men's Western Pennsylvania golf championship in 1938. Their sister Mary Patton Janssen recalls, "They played almost faultlessly, shooting sixty-seven and sixty-eight, with Pat winning two and one. A Pittsburgh newspaper headline read, 'A Janssen Will Win.'"

Although usually in good health, Janssen contracted pneumonia in 1935. He was treated with mustard plasters and recuperated during a six-week vacation with Edith in Barbados. During Pittsburgh winters, he wore heavy Ulster overcoats.

Nevertheless, at sixty-four, Janssen won the Oakmont seniors championship in 1938, the same day that Benno Jr. won the club championship.

The Janssens continued playing golf after moving to Virginia. Edith Janssen was runner-up in the Farmington Country Club women's championship in 1940. She continued playing duplicate bridge as a master. Pat Janssen won Farmington's Kenridge Tournament at age seventeen. Benno Jr. won the Fair Acre Tournament on the Cascades Course in Hot Springs, Va., in 1954 and qualified for the National Amateur Golf Championship many times.

After several years of horseback-riding and fox-hunting at the Allegheny Country Club, Sewickley Heights, and in Virginia, Mary Patton Janssen joined the links in 1948. Over twelve years she won twenty-one tourneys, including the Virginia Women's Amateur Championship six years and the Eastern Amateur Championship, played at Allegheny Country Club. Mary Patton Janssen reached her pinnacle, the finals of the Ladies British Open Championship at Sunningdale, in 1956. It was the first time there had ever been an all-American final — she and Wiffie Smith — since the contest began in 1885.

The Mellons and Kaufmanns did not become more than acquaintances. But, curiously, the rear of Andrew and R.B. Mellon's joint Pittsburgh memorial, Mellon Institute, was just across the pavement from the Young Men & Women's Hebrew Association (now Pitt's Bellefield Hall, 315 South Bellefield Avenue). And Mellon Bank, then and now, stood across Fifth Avenue from Kaufmann's store.

Besides Kaufmann's role with the YM&WHA, he would also choose a Janssen and Cocken associate, New York architect and designer Joseph Urban, to create swimming pool tiles for Pittsburgh's Irene Kaufmann Settlement, a recre-

ation and education center in Pittsburgh's Hill District, early home of many Jewish immigrants, backed by the Kaufmanns. Urban was to redesign Kaufmann's store's first floor and did drawings. But Janssen and Cocken, strongly influenced by Urban's ideas, did a simpler and undoubtedly far less expensive installation.

Unknown to anyone at the time, Edgar Kaufmann's discussions on architecture over the years with Janssen would prepare the magnate for a project of considerable significance: commissioning Frank Lloyd Wright to design Fallingwater in 1935. The project rekindled Wright's reputation and ambitions and also brought Kaufmann international renown. It was the same sort of fame, akin to immortality, that the Mellons sought with their great public gifts.

After selling La Tourelle in 1940, the Kaufmanns moved into the Janssen and Cocken-designed William Penn Hotel, where they had a large and comfortable suite. Liliane's body was laid out there on a chaise-longue after she died from an overdose of barbiturates taken at Fallingwater in 1952. The coroner ruled her death in Mercy Hospital, to which the Kaufmann's had given donations, an accident.

Did Kaufmann ever consider Janssen for a house in the woods along Bear Run in Fayette County? Probably not since Janssen was not known for weekend retreats and Kaufmann was thoroughly aware of what Janssen's interests were. Besides by 1935, the architect was busy with Mellon Institute. But the idea of a house at Bear Run was probably long in Kaufmann's thoughts. The family had had cabins in the woods there for years — as well as a dairy herd, with the milk going to the store. Friends and many employees were often invited to enjoy the rustic facilities.

The modern retreat came into focus after Edgar Jr., then twenty-four, told his father of his experiences, in the fall of 1934, at Wright's Taliesin Fellowship in Spring Green, Wis., and urged a visit there. The Kaufmanns were delighted with Taliesin, the colorful master architect, and his young followers. Edgar Tafel, Wright's first apprentice, recalled to the author that Kaufmann Sr. on that visit offered Wright $1,000 in two payments to construct the model of his visionary plan, Broadacre City. With the check, "Wright went out

immediately and bought a truck."

The success of Fallingwater, 1935-37, led Kaufmann to suggest many more projects to Wright. As with Janssen, Kaufmann would become Wright's most active client as well as one of the country's most prolific amateur planners, as Toker notes. Still, Pittsburgh architect Dahlen K. Ritchey, who also worked for and with Kaufmann, most notably on Pittsburgh's Civic Arena with its retractable steel roof, remembered Kaufmann was not as adept at reading blueprints as was his brother Oliver.

The house on the waterfall, the recently restored Broadacre City model, and Kaufmann's office in the store, now permanently installed at the Victoria and Albert Museum, London, were the sole fruit of the Kaufmann-Wright union. Their other plans, including a twelve-story highrise apartment for Pittsburgh's Mount Washington, a circular department store garage, and redesign of Pittsburgh's Point, remained drawings.

If Janssen, seven years younger than Wright, had thoughts about Kaufmann, his new architect and the spectacular house on Bear Run, he did not express them. His attention was elsewhere.

Janssen in 1938 left the firm to Cocken, who continued with a crew of associates until he also retired in 1958. In 1950-51, Cocken was associated with Harrison & Abramovitz in design and construction of the former United States Steel Mellon Bank Building, now Two Mellon Bank Center, 525 William Penn Place, Pittsburgh. Another Cocken project was the Carbide and Carbon Chemical Corporation office building in Charleston, W.Va.

Cocken was also president and later board member of Pittsburgh Hotels Inc., which owned the William Penn Hotel before it was bought by Sheraton Hotels and became in the 1950s-60s the Penn-Sheraton. Alcoa bought the hotel in 1971, and in 1984 began a $30 million renovation with Westin Hotels and Resorts. The Westin William Penn is run in agreement with the owner, Servico Hotels.

Other Cocken designs included the $2.5 million Rockwell Hall of Law & Finance and Assumption Hall, both at Duquesne University, Pittsburgh; an addition to the Federal Reserve Bank, Pittsburgh; and the Benjamin Fairless Library at the Fairless Works of United States Steel Corporation, now USX Corporation, Morrisville, Pa.

The architect was married to Helen Stewart Cocken, who died in 1957. They lived at the Royal York Apartments in Oakland. Their children are Mrs. Franklin Knight Jr., of Coral Gables, Fla., and Mrs. J. A. Dillon, of Santa Fe, N.M. Cocken also had a sister, Mrs. Irene Passmore, of Pittsburgh, and six grandchildren. In ill health for a year, Cocken died at age seventy-three on November 10, 1958 in Mercy Hospital, Pittsburgh.

Janssen's spirit of combining simple forms with telling details was carried on, with his quiet blessing, by former associates Roy F. Hoffman (1888-1985) and Kenneth R. Crumpton (1891-1956). In 1939, they formed Hoffman and Crumpton in Pittsburgh and did buildings for some of Janssen and Cocken's important clients. Hoffman was a fine detailist. Crumpton, like Janssen, was an excellent freehand draftsman. Their firm designed many Mellon Bank branches as well as renovations to the main floor of Mellon's principal office in the early 1950s. One of their projects was the Pleasant Hills Community Presbyterian Church and School.

Benjamin D. Phillips, long after Janssen and Cocken had designed his house and office building, commissioned Hoffman and Crumpton to create the Disciples Research Library for the Christian Church, Nashville, in Tudor Gothic style. It would be their finest structure. The library is a memorial to Thomas W. Phillips, B.D.'s older brother who had headed the company before him and died in 1922.

Among other architects who worked for Janssen and Cocken were Leroy Lawrence, Fred Loeffler, and George M. Wolf. Hoffman and Crumpton's successor firm was Loeffler/Johnson and Associates, now Johnson/Schmidt and Associates, of Pittsburgh.

James Johnson recalled that Christopher Gaus worked for both Janssen and Cocken and Hoffman and Crumpton, specializing in drawings for stone reliefs. He did the shaded pencil drawings for Elm Court's carvings, probably the Byzantine/Romanesque bas-reliefs for the Duquesne Club's garden patio, and the moderne owls on the Rolling Rock

stables' entrance gate. Kress Stone Company's workmen produced the carvings after first making plaster models, then transferring dimensions to the stone with calipers.

Architect E.J. Hergenroeder joined Janssen and Abbott in 1910 and was with Janssen and Cocken from 1921 to 1934 and again in 1937. He worked with Cocken from 1942 to 1958, then continued the firm as Hergenroeder & Bott, Architects, until 1965.

LIFE IN FARMINGTON

Tying up his career neatly, and taking little from the firm except his books and some drawings done over thirty-four years in Pittsburgh, Janssen left Pittsburgh on December 31, 1938. The Janssens moved to Farmington, an elegant Charlottesville, Virginia, suburb, where, since 1934, Benno and Edith had often visited. Janssen was a member of the Farmington Country Club, which has as a primary structure a plantation house with a large oval parlor that Thomas Jefferson designed.

Pat Janssen, then fifteen, drove his father to their new life in Virginia. Janssen's reasons for retiring at sixty-four were the severe post-Depression construction slump, his comfortable savings, and a feeling he had made his contributions to architecture. He had too affable a nature to be sad or sorry. Janssen's love of Charlottesville can be traced to its Jeffersonian architecture, which Janssen adored, as well as its pleasant lifestyle and clement weather.

After moving to Charlottesville, the Janssens sold their Darlington Road house to Leon M. and Chrysteen Ayers in 1939. The Ayerses in turn sold to Cyrus C. and Alice M. Hungerford in 1944. Cy Hungerford was the longtime *Pittsburgh Post-Gazette* editorial cartoonist and sold the house to the James L. Winokurs in 1952. James Winokur, a Carnegie Institute trustee and collector, believes Janssen, although he did not design the house, probably added the English-style squared oak paneling to the living room.

A similar pattern is in the Westin William Penn's Panel Room as well as a library added to a childhood home of Mrs. Elsie Hilliard Hillman on Aylesboro Avenue, Squirrel Hill, and the Grill Room of the Pittsburgh Athletic Association. Mrs. Hillman also lived as a child in Janssen and Abbott's George H. Calvert house in Hampton Township, Allegheny County.

Janssen maintained his interest in architecture. He and Edmund S. Campbell, dean of the School of Architecture, University of Virginia, won an honorable mention in a 1938 competition to design an art gallery in Washington, D.C. for the Smithsonian Institution. Its purpose was to encourage the visual arts "in collaboration with the Mellon bequest," that is, the National Gallery of Art, that neither the donor nor his architect, John Russell Pope (1874-1937), would live to see.

Pope, one of the most important architects to come from the Ecole des Beaux-Arts, created three fascinating variations on a theme: the National Gallery, Henry E. and Arabella Huntington's mausoleum at the Huntington Library and Gallery, San Marino, Calif., and the Jefferson Memorial all are derivations of the ancient circular temple

Benno, Edith, and A. Patton Janssen, circa 1945.

(*tempietto*) by way of designer Richard Mique's Temple of Love at Versailles. According to *The Dictionary of Autobiography*, Pope was "perhaps the individual most responsible for that last flowering of the classic ideal which has placed its stamp so firmly" on the capital.

Besides several important buildings in Washington, Pope designed the Duveen Galleries at the Tate Gallery and extensions to the British Museum, London. In New York, he adapted the Frick Collection for public use. And in Pittsburgh in 1919, Pope designed Frick Park's stone pavilions, gates, and markers. Some of the works suggest turret forms. And the rustic rubble style resembles The Waves, Pope's own 1927 summer house, a large Cotswoldian pile, now condominiums, on Newport, R.I.'s southern tip, Land's End. One can easily imagine Pope and Janssen inspecting the Frick Park project together.

The prize of $7,500 for design of the proposed Washington gallery went to Eliel Saarinen, his son Eero, and J. Robert Swanson for a radically modern design. But the project was never built. At the time of the awards, Janssen telephoned to congratulate Dahlen K. Ritchey, a modernist whose firm had also won an honorable mention in the competition that drew 408 entries. Ritchey told the author he always admired Janssen's work.

Janssen's response to the younger architect was quite different from Wright's comment, Ritchey recalled, in 1959 when Edgar Kaufmann Jr. introduced them at the opening of the Solomon R. Guggenheim Museum, New York. Wright, in his last days, stung Ritchey with, "What did *you* ever do?" and turned away.

Besides the Civic Arena, to which Kaufmann gave $1 million, Ritchey and his firms Mitchell and Ritchey and later Deeter Ritchey Sippel (now DRS Hundley Kling Gmitter) designed Mellon Square Park, a gift of the Mellons to the city. DRS, local architect of Allegheny Center, a North Side office complex and shopping mall, also designed Three Rivers Stadium. In 1948, Ritchey, who had earlier done store display work for Kaufmann, designed a small house in Squirrel Hill. Kaufmann out of patronly friendship lent a local high school teacher, Anna Tisherman, $13,000 to buy it. She paid

him back, and for his scholarship loans to her as well.

Once at Fallingwater, Kaufmann invited Ritchey to shower with him under the waterfall one summer day. Ritchey nearly fainted from the shock of the cold cascade.

In 1940, at 5 Blue Ridge Road in Farmington, Benno Janssen built Boxwood, his rectangular two-story, four-bedroom house of white-painted stone on 1.8 acres. From the rear it looked out on the country club's fifteenth fairway.

Janssen loved the location, and every day for three months he studied the prevailing winds before deciding the house's site. He placed it to benefit from the winds. The house has since been air-conditioned, but the present owners rarely use it because of adequate natural ventilation.

Janssen called his first floor study the Pittsburgh Room. Its walls were lined with framed drawings and photographs of projects and memorabilia. Janssen received many friends here, often marveling to them about what his firms had done.

The retired architect traveled throughout Virginia buying evergreen boxwood shrubs that he and Edith Janssen planted around the house. In time the shrubs virtually concealed the house from the street.

Janssen also designed a house for son Pat and his wife Jane. The younger Janssens built a red brick Tudor house in 1951-52 in nearby Bellair, where they still live.

Visiting Pat when he was in military service during World War II, Janssen stayed four months at the Argonaut Hotel in Denver and often sketched the Rocky Mountains. Pat recalled, "He was always drawing and did a lot of sketching in charcoal and watercolor after retiring," retaining his linear fluidity.

The Janssens visited Pittsburgh several times in the 1940s and 1950s, staying variously in a suite atop the United States Steel Building (USX Tower), the William Penn and the Rolling Rock Club.

Janssen was proud of his work, and especially Mellon Institute, which he considered his masterpiece. But his favorite building seemed to be, wrote J. Alex Zehner, of the *Pittsburgh Sun-Telegraph*, in 1955, a one-story cook house that Thomas Jefferson designed with handmade brick and

hand-split shakes that Janssen took Zehner to see. Janssen loved Jefferson's use of clean lines and pleasant proportions, and he put them into his own Colonial Revival designs.

Zehner found the architect "fun-loving, spry, and brilliant as a conversationalist, telling dramatic stories about each of 'his' buildings, regardless of whether or not they were ever built." Janssen still seemed "a bit awed at himself for having the courage to decree" the sixty-two monolithic columns, sixty tons each, that flank Mellon Institute on four sides.

Finally feeling his years, Janssen would occasionally drive his gray 1949 Buick convertible around the Farmington golf course. He never asked permission and no one at the club objected. "It was just his way of doing things," Pat Janssen said. "He never asked anybody; he just did it. He was the only one who did."

Janssen suffered a cardiac infarction at age seventy-nine but was still playing golf at eighty-eight. While sitting on a bench watching Pat practice on the greens at Farmington one day he said, "You know, Pat, that shot sounded pretty good but I can't see it." His age was affecting his sight.

At eighty-nine, the architect had a mild stroke while asleep in a barber's chair. As a result, he dragged his left leg slightly. "During his last six months Father stayed in his bedroom a lot," Pat said. "We also have pictures of him sitting in the 1963 Pontiac Grand Prix I had. I drove him around if he wanted to go anywhere. He always wanted to be clean-shaven and I shaved him."

One of Benno Janssen's passions over the years was collecting books and drawings on architecture. In 1958 he donated his library of 959 volumes and related items to the University of Virginia, where they were valued at nearly $17,000.

Among Janssen's favorite volumes were:

Houses and Gardens by E. L. Lutyens by Lawrence Weaver. Janssen left a copy of this book in the office when he retired and it came to successor firms.

Domestic Architecture of Harrie T. Lindeberg, 1941, his favorite residential architect, inscribed: "To Benno Janssen — whose work I much admire — with affectionate greetings from his old friend, Harrie T. Lindeberg, Oct. 12, 1942."

Mellor Meigs & Howe by Paul Wenzel and Maurice Krakow, 1923.

And *The Architecture of John Russell Pope* in three bound volumes.

Benno Janssen died at Boxwood on October 14, 1964. Edith Janssen followed her husband on June 27, 1968. They are buried in St. Paul's Episcopal Church Cemetery, Ivy, Va., not far from the home they loved.

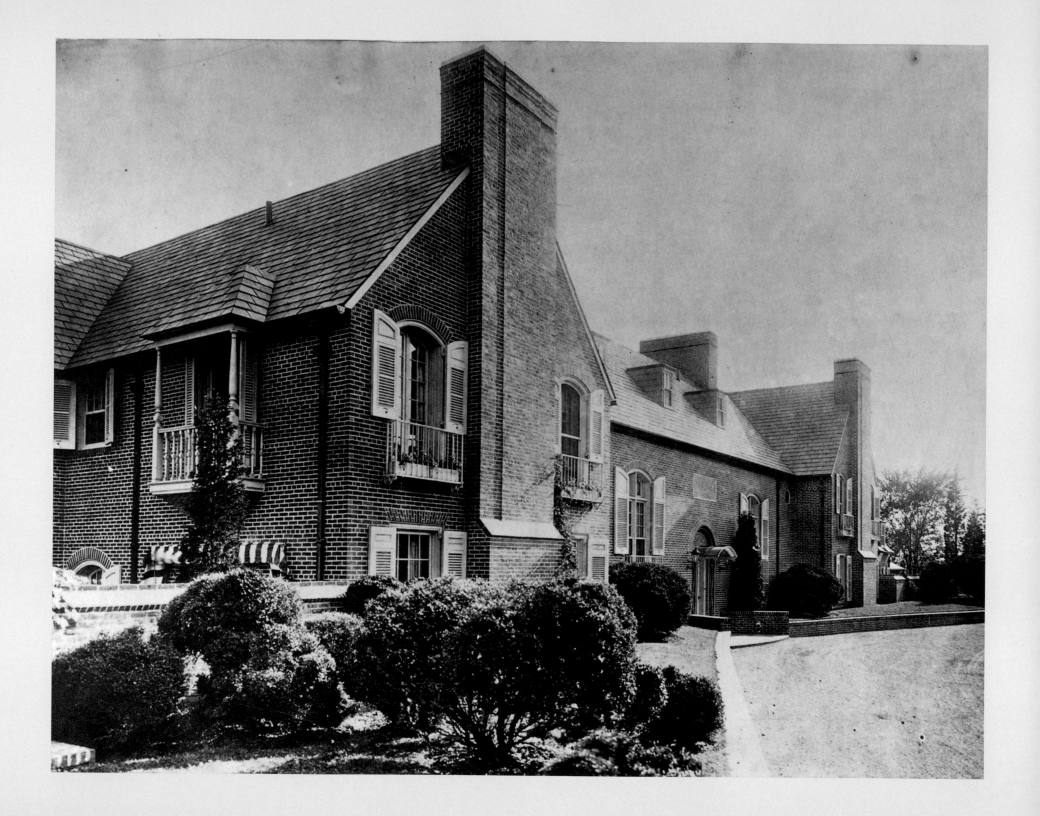

REMINISCENCES

Harry B. Croft house, Greenwich, Conn., 1922-23, Janssen and Cocken.

A. Patton "Pat" Janssen:

In 1943, my father came up to see me in Middletown, Conn., where I was in Navy pre-flight school. We went to see the Harry B. Croft house that my father designed at 100 Clapboard Ridge Road, in Greenwich, Conn.

Croft came from Grampion, near Curwensville, and was a friend of the Pattons. My father introduced himself as the architect of the house to the butler who went inside to inform the Crofts. He came back to say, "Mr. and Mrs. Croft don't know a Benno Janssen."

"You go back in," my father said, "and tell Mr. and Mrs. Croft I was the architect of this house." We followed him in. It was before lunch. The Crofts — they were old then — were having old-fashioneds. We talked with them and were later walking down a 40-foot-long hallway, looking out on a 300-foot lawn.

Mrs. Croft had my father by the arm and said, "I certainly wish my old friend Ben Janssen were here to tell me what to do with this house."

Once when Benno [Jr.] and I were students, my father drove by Shady Side Academy [when located in the Pittsburgh's Shadyside district] to pick us up after school. A fellow student,

Roger Loughney, whose father had a Chrysler-Plymouth dealership in Pittsburgh, walked up to the car to ask if he could help.

My father said, "I'm the Janssens' chauffeur and I'm waiting for the boys." Loughney said, "Are you sure you're the Janssens' chauffeur?"

Father said, "Certainly, I am. The boys are supposed to come out in a few minutes."

"That's strange," the youth said. "Your shoes are just like my father's. He has them made by Moore in New York."

Father would kid people like this and have a great time.

Jane Janssen:

Dad Benno always had a twinkle in his eye. I don't remember him ever getting upset about anything. If he did he wouldn't say. He would just get up and leave the room.

Pat Janssen:

With architecture, if Father didn't like something, he wouldn't have anything to say about it. I think that's just the way he was brought up. And I never heard him swear.

We would take long walks together. Once in New York we

were staying at the Biltmore Hotel and Father said, "Let's go over to the Alcoa office" on 42nd Street. We went to see Arthur Vining Davis. In Pittsburgh the Davises would come to our house twice a week to play bridge. Father had a wonderful clientele.

One day at T. Mellon and Sons, the Mellon brothers, along with Edward R. Weidlein, Mellon Institute director, and Father were deciding what the Institute's exterior should be. They were pushing samples of limestone and granite around. A granite facing was a possibility.

Finally Andrew Mellon said, "What are we doing considering this? Benno Janssen hasn't made any mistakes. Let's leave the decision up to him." There was a $2 million difference between the two types of stone. Father chose Indiana limestone, a favorite medium, because he liked its texture. This was the most significant decision on stone he ever made. He never wanted to put wood on residential exteriors because it needed to be painted. He preferred brick or stone.

Father would never have thought of calling Sarah Mellon Scaife by her first name. One day, he and his partner, York Cocken, were watching the columns being delivered to Mellon Institute with R.B. Mellon and his daughter.

Cocken said, "Well, Sarah, how are you?" That was something terrible in those days! You just didn't address people of that station like that. But Cocken was excellent at overseeing the project's electrical and mechanical details, about which Father had less interest.

Mary Patton Janssen:

Daddy took me to see the life-size model he had made of a corner of Mellon Institute just to make sure the proportions were correct. Later, before the columns were lowered into place, Benno Jr., Pat, and I put a penny under different columns. [Other youngsters like Torrence Hunt were also invited to perform this historic act.] I was sure I would always remember where my penny was. Guess what? I don't.

Pat Janssen:

When Elm Court was being built, Roy L. Hoffman oversaw construction every day and Albert Tappe was a beautiful delineator.

One day B.D. Phillips came by and said to Hoffman, "You know, this house is costing me an awful lot of money." (In excess of $1 million.) To which Hoffman replied, "Yes, Mr. Phillips, that's true. But you're getting a whole lot of house."

Andrew Mellon kept a large framed drawing of Mellon Institute by J. Floyd Yewell in his office while he was Secretary of the Treasury. Mellon showed John Russell Pope, his architect for the National Gallery, Yewell's drawing.

Jack Pope had worked with Father when they were judges for ten years on the White Pine Series of Architectural Monographs [an excellent eclectic publication sponsored by Weyerhaeuser Forest Products, St. Paul, Minn., and given free to users of white pine]. Pope said to Mr. Mellon, "This is a beautiful building and you should go with Mr. Janssen's plans." Harrie T. Lindeberg was also a juror with Father on the White Pine Series.

I remember walking through the hayfields when they were building the Rolling Rock stables. R. B. Mellon's nephew, the architect Edward Purcell Mellon, designed the clubhouse and rustic stone water tower that is also an observation point. When

E.P. started on the clubhouse interior, Mr. Mellon became disenchanted and brought in my father. He and others at the firm did the elegant things in the interior.

There was a fireplace in the living room where Mr. Mellon could press a button in a secret panel and a log would roll into the fireplace. It was lifted on a mechanism from a supply on the floor below. [The secret panel is still there but the room below has long since been converted into a meeting room.]

R.B. Mellon told Father one night at dinner his daughter Sarah was going to marry Pittsburgh industrialist Alan M. Scaife. R.B. said he wanted to build a reception pavilion for the event but didn't know where it should go.

Father said, "There's one perfect place but you've got a formal garden there." "Excellent," Mellon said, and he had the garden torn out and the pavilion constructed.

The Mellons had the wedding rehearsal and reception there [in November 1927], plus a ball for the Rolling Rock Hunt. The pavilion which Father said cost $100,000 was then pulled down. But R.B. was very pleased.

Richard B. Mellon had an aesthetic side. He collected Gothic and Elizabethan wood carvings. His Alden & Harlow Tudor mansion of red Michigan sandstone at 6500 Fifth Avenue was razed in 1940. It was recycled into Saint Peter of the Mount Roman Catholic Church, New Kensington, a remarkable example of redesign.

The Mellon house had wrought-iron fixtures and gates by Samuel Yellin (1885-1940), a business friend of Janssen for twenty-five years. On at least one occasion Yellin told Mellon about early wood carvings available in New York that Mellon then purchased. Some of these are now in the Carnegie Museum of Art. Yellin also produced iron work for the Allegheny County Courthouse, La Tourelle, the former YM&WHA of Pittsburgh, Elm Court, Pittsburgh's Twentieth Century Club, and the University of Pittsburgh. Janssen had a business relationship and friendship with Yellin that lasted until the Philadelphian's death.

Some time later, Father was sitting in the Duquesne Club when R.B. came up, put his hand on his shoulder, and said, "Janssen, if I can ever do anything for you, call me." R.B. did something! He got his brother Andrew to go along with him on selecting Janssen and Cocken to design Mellon Institute. J. Floyd Yewell, of New York, did the delineations.

Yewell, who won the prestigious Birch Burdette Long Prize in 1942, wrote describing his work as a renderer of proposed buildings that could be understood in advance through their context with reality:

"Truth may be conveyed in a pleasant way by a picture which is well composed with correct values or tone in proper relation to each other, with the form and color properly balanced, and an underlying scheme of pattern just as would be found in a good painting of nature." Janssen shared that belief to his core.

Mario Celli:

The co-founder of Celli-Flynn Associates, Architects and Planners, Pittsburgh, worked on the addition to the William Penn in 1928-29, staying with Janssen and Cocken six months.

Ken Crumpton was in charge of design and I worked in that department under him. Roy Hoffman was doing the working drawings for the Renaissance-style Phillips Gas & Oil Company Building in Butler. Roy was absolutely fantastic; he could split lines! I know for the Keystone Athletic Club, and it was probably true for other projects, one architect would be in charge of a crew for all the drawings.

Benno was really precise. Always well-dressed and well-groomed, he would come around the office every morning. He had a great library and allowed us to borrow books. There were thirty-five to forty people in the office.

One day, Benno gave me $60 to go and look at the Federal Reserve Building on Wall Street in New York. I stayed two days and did thumbnail sketches. Then he asked me about it, what I liked and didn't like. I said it was not original enough. I guess he appreciated that.

There was a plan then to move the Pennsylvania Railroad headquarters from Philadelphia to Pittsburgh. The project was cancelled but complete drawings were done for it. It would have stood about where the USX Tower is now. There is a great watercolor rendering of this project. It was done by Birch Burdette Long in three weeks, working at the Roosevelt Hotel [now Roosevelt Arms, Pittsburgh].

In the late 1920s, the Pennsylvania Railroad was aware of crowded conditions at the Union Terminal and rail yards in Pittsburgh. The company also wanted to consolidate its other railroads in the surrounding region. The Pennsylvania expanded its capacity for handling food and freight in the Strip District, Pittsburgh, making room for 447 locomotives. That the Pennsylvania ever wanted to move from Philadelphia to Pittsburgh sounds extreme. Historians of the Pennsy consulted know nothing of this plan; they assume instead the railroad wanted a new building in Pittsburgh to promote its interests. The Long drawing is proof of the venture. The City of Pittsburgh was also involved and rebuilt part of Grant Street. But instead of erecting a building, the railroad probably sold the site to the federal government for Pittsburgh's central post office.

Pat Janssen:
Father asked the Pennsylvania's regional manager, Thomas Rodd, what to do about the drawings for the cancelled project. Rodd said to prepare as many drawings as he wanted and submit them for payment. Father returned to the office and said to his secretary Ottelia Zohner he was ordering the draftsmen to do more drawings; a great many were submitted. Father said the firm was paid $150,000. At the time Janssen and Cocken was designing a house for Mr. Rodd [on Beechwood Boulevard at Dallas Avenue, Squirrel Hill].

At Oakmont, Benno Janssen played golf with the Mellon brothers, Edward Weidlein, director of Mellon Institute, and Chester Garfield Fisher, founder of Fisher Scientific Company. His son James A. Fisher said that whenever there was a supply order from Mellon Institute, Fisher Scientific was always quick to fill it and no effort was too difficult.

Edward R. Weidlein Jr.:

Benno Janssen and my father were very close friends. From April to November the two of them with Chester Fisher and another man from United States Steel would play a foursome at Oakmont every Saturday. Benno was a very warm and friendly sort of man of my father's age. I can remember Father talking about the columns for Mellon Institute. It was Benno's concept. R.B. Mellon was sold on the design and was closer to it than Andrew, who was then ambassador to Great Britain.

The Mellons had a plan to give the land east of Mellon Institute [including a former parking lot now the site of Carnegie Mellon's Software Engineering Institute] for a park across the street from St. Paul Cathedral. But [much later] Pittsburgh National Bank built a branch office at Fifth Avenue and Craig Street and Mellon Bank decided it needed a branch there too.

My wife and I visited the Janssens in Charlottesville and saw the Pittsburgh Room. They could not have been nicer to us.

Pat Janssen:

Father and I would drive around Virginia looking for box-wood shrubs for his place. In 1943 we bought two shrubs that were twenty feet high. He liked the looks of boxwoods and they stayed green all year.

Mary Patton Janssen:

I have a lovely little sketch of a country house which Daddy drew for me, and for me alone, inscribed "For little Sister from Daddy, Oct. 26, 1924, at St. Margaret's Hospital — B.J." That was the day of my birth. I shall always cherish the memory that he loved having "little Sister" and drew for her one of his beautiful houses. I remember him sketching. He sharpened his pencil with a penknife. He did lovely drawings.

Janssen's legacy continues within the family. A grandson, Roger Patton Janssen, son of Benno Jr., is a registered architect in West Palm Beach, Fla.

THE WORKS OF BENNO JANSSEN

Richard Morris Hunt, the first American admitted to the Ecole des Beaux-Arts in 1846, set a high standard of accomplishment with his many palatial houses. More than 500 American architects would follow him to Paris over the years. The school's influence on architecture in the United States could be seen across this country from Hunt's return in 1855 through the 1930s.

Among those deeply impressed by what they learned in Paris were John Russell Pope, designer of the National Gallery of Art's West Building and Jefferson Memorial, and Benno Janssen, who would oversee creation of the National Gallery's Pittsburgh equivalent, the Mellon Institute of Industrial Research. Both buildings had the same donors and the same general contractor, the former Mellon Stuart Company, of Pittsburgh.

Since its founding under Louis XIV, attendance at the Ecole des Beaux-Arts was free and open to anyone who passed an entrance examination. Students were expected to register with one of several Parisian ateliers, virtually schools of architecture, run by renowned professors who were grand prix-winning architects as well as products of the Ecole. By 1900, there were just a few large studios, each with thirty to thirty-eight students, where foreigners grouped themselves by nationality.

Their designs were judged in a series of competitions for both sketches and rendered projects; competitions in construction were the most important challenges and probably the most difficult. Historically, the ateliers' emphasis was on symmetry, the classical orders, building circulation, plan, concept of axial organization and expression of function.

Originally created to produce architects for state buildings, the Ecole had a powerful hold on French architecture, even after failing to keep up with newer times and practices. This regimen was smashed by the student rebellion of May 1968, and French architecture was allowed to become more accessible to its aspirants.

Already a registered architect, Janssen attended the Ecole for two years but received no degree or certificate. He studied in the popular atelier of Jean-Louis Pascal. Architectural historian Richard Chafee, of Providence, R.I., an authority on Americans at the Ecole, believes Janssen

while in Boston received special tutoring from Constant-Désiré Despradelle, a student of Pascal.

Despradelle taught at the Massachusetts Institute of Technology from 1893 until his death in 1912. He undoubtedly directed Janssen to Pascal. Janssen was in France from 1902 to 1904; a signed drawing of Chartres Cathedral is dated 1904.

The Ecole's practices gave Janssen's judgments direction and assurance. A study of his designs reveals how faithful Janssen was to the Ecole's ideas in a wide variety of commissions and despite changing times. A true eclectic, Janssen adored the proven grace of period architecture: particularly Norman, Tudor Gothic, Renaissance Italian and French, and Colonial American.

Although Janssen reveled in these traditions and his library was full of references to the best designs of the past, he was always an architect of his own age, however much he studied other masters for inspiration. Some of his projects, while similar in spirit to a traditional style, carried motifs of the art moderne period in which he lived.

Not only did past styles' decorative suavity appeal to Janssen's own sense of gracefulness, but they also helped him and his staff to enliven traditions that by the 1920s and '30s were formulaic and open to refreshing adaptation. Modernists had found these older concepts prosaic and outworn — but not Janssen's clients who desired them as signs of their own affluence and power.

Budget concerns during and after the Great Depression also stimulated changes, particularly the practice of reducing older styles to simplified yet attractive forms. At this, Janssen was a master. His reductive details and ornamentation are found in both his period houses as well as his later large buildings.

In 1947, retired nine years, Janssen summarized his beliefs in "What Architecture Has Meant to Me," a two-page essay he wrote for *The Charette*, a now defunct magazine then published by the Pittsburgh Architectural Club. Janssen began by reflecting on the characteristics of his most important dwellings.

The study of the profession of architecture has always meant to me the effort to express something beautiful. In the domestic field there always seemed to be great opportunity to make beautiful proportions and silhouettes, where the work was of such size as to lend itself to extended outlines and contrasts of low and high parts.

The use of materials also plays such a large part in producing beauty. This is especially true of the beautiful stone work of the buildings of England, France, Italy and our own country, which have always fascinated me.

In monumental work, the materials are just as important as in the beauty of classical columns, expecially monoliths, where the flow of the graceful lines is not interrupted by joints, which often distort the grace of the columns by the variety of colors of the different pieces...

An allusion here to Mellon Institute of Industrial Research is unmistakable, although nowhere in the essay does the architect mention any of his projects, which was

characteristic of him. Yet anyone seeing them would surely want to know who their designer was.

Janssen always saw himself as a team player; the leader of the team but not a heroic figure. He, of course, knew his firm could never accomplish as much as it did without a large and well-running staff.

Janssen continues in his essay:

I am writing now of the old, more or less conventional architecture, in which it was my opportunity to work. No doubt the same opportunity exists in modern work, and I believe that if the economic conditions allow the same freedom that existed in the ancient days [that is, of Janssen's career], we will have just as fine work in the future; perhaps these dates are too restricted, but so much beautiful work was done in the domestic field during this time by men like William Delano and Harrie Lindeberg, just to mention two of the best. These two men built some of the most beautiful houses in our country, and I always was inspired by them.

In monumental work, I think the Lincoln Memorial in Washington expresses the greatest beauty possible in classical architecture. Without such wonderful detail, this building could not approach the present result by mere mass and proportions. Its architect, Henry Bacon, in my opinion, was a master of detail as well as mass and proportion. These men I have mentioned had a great love of beauty and kept striving endlessly to produce it...

Since Janssen was most comfortable with period architecture, particularly in his houses, he was not interested in creating new styles but in adding to existing ones, in the best eclectic sense. At the same time many of his firms' corporate commissions were contemporary to their time, prior to the rise of the International Style. As a true son of the beaux-arts, however, Janssen was extremely flexible within his chosen areas of design.

In fact, as Pittsburgh architectural historians Walter C. Kidney, Franklin Toker, and the late James D. Van Trump have agreed, Janssen was not only the most talented architect working in Pittsburgh in his time but also that his firms' designs were equal to and sometimes better than the work of similar firms of the period, including Carrère & Hastings, which designed Henry Clay Frick's Louis XVI mansion in New York; Mellor Meigs and Howe; and New York's Lindeberg and Delano.

At the same time, it is evident Janssen was deeply influenced by the backward-looking architecture of Sir Edwin Landseer Lutyens (1869-1922), particularly in designs of picturesque country houses redolent of what the English called "the vigorous style," stressing form over decoration and comfort over modernity. In Janssen's case and for his generation of eclectics, these designs descended from the English Arts and Crafts master designer William Morris through British architects Philip Webb and C.F.A. Voysey.

Janssen was adept at fashioning elegant traditional designs to modern sensibilities. The architect's scope and excellence were wide, ranging from houses derived in simplified fashion from Norman, English Cotswold, and Colonial patterns — Janssen's favorites, judging by the many he created — and monumental edifices.

Regardless of the rise of modernism in architecture, the aesthetic persuasion of Janssen's clients, with one important exception, was traditional. Janssen's longtime impact on

his frequent client and friend Kaufmann sensitized him to architecture's possibilities, priming him for an exceptional future.

The collaboration between Kaufmann and Wright on Fallingwater, called the most important and influential house of the 20th century by American Institute of Architects members, resulted in a score of projects, of which only a few were done. However, Wright's abortive plans for a parking garage with exterior ramp for Kaufmann's Department Store, another for Carnegie Institute and a huge megaplex for Pittsburgh's Point would finally be transmuted into the Solomon R. Guggenheim Museum.

In his *Charette* essay, Janssen, out of his beaux-arts past, writes,

> I have seen reproductions of beautiful modern homes in California, and the future seems endless along these lines. However, there are also those terrible concoctions which are called modern architecture, a mixture of glass and steel in domestic work, and these buildings I think are simply ugly and have no connection whatsoever with good architecture. [At least not to anything that ever interested him.]
>
> There is the practical side of planning buildings, which has always meant a great deal to me. Building plans contain the same beauty which is expressed in the exteriors, in my opinion, and the conception of the plan and the exterior should all be clearly visible to the architect's imagination.

> One of the most important matters to me was always to try and give the clients what they would like, whether in domestic, monumental or commercial work, and, by all means, something that was practical.
>
> It is a great satisfaction to try and build well, so that the buildings can be kept up without tearing them to pieces when equipment wears out; if this is kept uppermost in mind, I think it can be approached in nearly all cases...

Janssen was much thought of throughout his career. As early as 1915, a glowing tribute in *The Brickbuilder*, a national trade magazine, concludes:

> His seeking for truth of expression, the reasonable use of architectural forms, and for the understanding of the fundamental principles which govern architectural designs, portrayed only the dominating characteristics of the man as he is. Mr. Janssen's work shows not only individuality but a comprehension of his problem, a forceful composition and yet an understanding of the value of detail and the selection of material.
>
> One might assume from the foregoing that Mr. Janssen is some sort of a super-genius. He is not, however, but merely a talented young man whose human quality can be vouched for by those who know him.

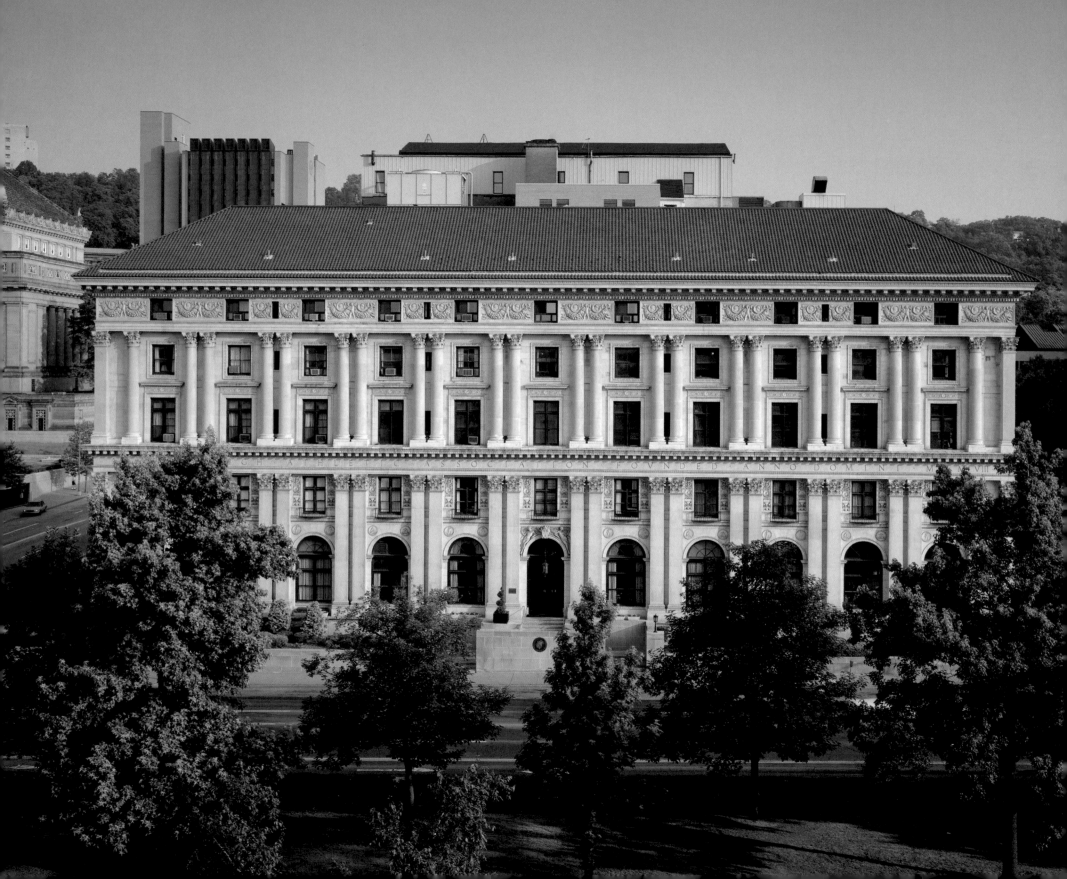

THE EARLY YEARS 1905-1920

FORT PITT HOTEL ADDITION

Pittsburgh Athletic Association's Venetian Renaissance style established Janssen and Abbott as the city's most important architectural firm.

One of Janssen and Abbott's most delightful commissions was the colorful Norse Room. This windowless basement space was designed for Alden & Harlow's red brick Italianate Fort Pitt Hotel at Penn Avenue and Tenth Street (circa 1905-68), today the site of The DoubleTree Hotel, formerly Vista International.

This unusual room, originally a buffet, was one of several on nationality themes in the hotel catering to patrons of the nearby Pennsylvania Station. A low groined and vaulted ceiling in rathskeller style was entirely clad in tile. Twenty-two-foot-wide mural panels were designed on a Viking theme by ceramic artist John Dee Wareham and fabricated by the esteemed Rookwood Pottery, Cincinnati.

Architectural Record in an unsigned editorial described the sixty-foot square room below street level as being divided by four stout pillars into nine compartments. The murals, based on Henry Wadsworth Longfellow's "The Skeleton in Armor," were full of embossed ocean scenes of dramatic figures, ships, fjords, and curling waves. A corner entrance led to a fireplace and projecting hood set with tiles. Viking galleys attached to chandeliers sailed above the patrons.

The color scheme was vivid: "bluish green or greenish blue" walls, yellow-gold ceiling, rich brown mosaic trim on vault ribs, and a dull red tile floor. A bandstand was equipped for an orchestra and dancing. Even bare the room had a look, the writer marveled, of being fully furnished "and leaves nothing to desire." The space was compared to the tiled taproom of the Hotel Belevedere, Baltimore,

Impact was increased by oak furniture carved with Norse motifs. The floor was covered by the 1960s. As for acoustics in this tile room, a guest at a New Year's party in the early 1960s recalls no harshness.

Janssen did other, more magnificent, designs in this hotel. The firm was responsible for the elaborate 1908 Jacobean-style strapwork ceiling and walnut paneling that lined the large banquet room. A massive carved limestone fireplace held the large crest of William Pitt, Earl of Chatham, from which Pittsburgh takes its seal. *The Brickbuilder*, published by Rogers and Manson Company, of New York and Boston (1896-1916), compared this room in 1914 with the best design work of Carrère and Hastings

and McKim, Mead and White. The firm never received higher praise.

The demolished banquet room's paneling, decorated with distinctive arches, pilasters, capitals, and square studs, was salvaged and, with a lustrous black finish, has since the 1960s enriched the lobby and bar of the Concordia Club, Oakland.

Growing in stature, Janssen and Abbott designed an eleven-story addition to the Fort Pitt Hotel (1909-11), following the spirit of Alden & Harlow's original Renaissance Revival structure with its dark brickwork. Janssen would reprise this Italianism with the James Rogers Elementary School of 1915 and then even more grandly with the 1924 Young Men & Women's Hebrew Association building, Oakland.

The firm in its early years was full of vigor. Its projects included the 1913 enlargement of Kaufmann's 1885 store at Fifth Avenue and Smithfield Street. The store's large windows were surrounded by white terra cotta tiles embossed with classic Renaissance reliefs. However, Charles Bickel's 1898 store addition at Forbes Avenue and Smithfield blended various revival motifs, including American Indian heads in high relief, with early modern building styles.

JOHN M. ROBERTS COMPANY

In 1907, Janssen and Abbott began another Downtown landmark, the four-story John M. Roberts Company jewelry store, 429 Wood Street, as an early modern storefront influenced by Louis Sullivan. On the second and third floors, window bays surrounded by metal panels dominated the facade beneath a projecting tile roof-front with twin dormers. From spikes at end walls on each side, globular electric lanterns hung high above the street.

The Great Atlantic & Pacific Tea Company building next door was later swept away when Forbes Avenue, then Diamond Alley, was opened to the Diamond Market, now Market Square, a block west. In its 1925 renovation for Roberts, Janssen and Cocken kept the store's two front doors, three ground floor show windows and large metal marquee. But it covered the upper floors with four fluted Doric pilasters of white terra cotta, more in line with the district's neighboring banks.

The store's false roof-front was changed to a horizontal cornice, and neoclassic ornaments were added, in harmony with four lionheads securing the marquee's spiraled rod supports. The present building is a tribute to a slowly evolving family business. The sixty-foot-long by forty-five-foot-wide showroom is paved with its original Alabama pink marble. A mezzanine at the showroom's rear still functions as a working space, and third floor offices retain their original mahogany paneling.

The architects converted the jewelry store's exterior into a commercial temple. Street changes allowed another businessman to erect a shallow building on Roberts' brick flank along Forbes. This structure is similar to but less notable than Alden & Harlow's slightly deeper onetime Regal Shoe Store building three blocks away at Fifth Avenue and Market Street. It has held many other businesses over the decades.

Janssen and Abbott would also come to public attention in 1913 with the Nicola Building (Buhl Building), done for Franklin F. Nicola (1860-1938), head of The Nicola Building Company, with offices in the Farmers Bank Building (razed), Fifth and Wood Streets. How improbable this large-windowed but narrow six-story Renaissance Revival office tower must have seemed, covered in blue and white tile like an Italianate wedding cake in a then dark and sooty city.

The beautiful tiles still glow in sunlight. And one can appreciate the building despite the removal of its tall first floor show windows for much later uncoordinated treatments. It is hoped and expected that the tower will be restored, as was MacClure & Spahr's Meyer & Jonassen's (600 Liberty Avenue Building), with the inevitable upgrading of Fifth Avenue Downtown.

PITTSBURGH ATHLETIC ASSOCIATION

Although *The Builder* had its first mention of Janssen and Abbott in May 1908, with a house design for Schenley Farms, the firm's first great success, in the palatial tradition of Richard Morris Hunt, was the block-long Pittsburgh Athletic Association of 1909-11. This six-story clubhouse, its exterior designed to suggest three stories, resembles a Venetian Renaissance palace and was influenced by Michele Sanmicheli's sixteenth century Palazzo Grimani and Jacopo Sansovino's Library of St. Mark.

The building rises from a smooth limestone base in two double-floored treatments. The lower floors present flat twinned pilasters and capitals alternating with, at first, grand arched windows, then rectangular windows half their size and a wide dentiled entablature. On top of this rise three-quarter-round twinned pilasters with robust Corinthian capitals.

They divide two floors of decreasingly sized windows under a second, narrower entablature. Small square windows separated by twinned garland embossments follow under a dentiled cornice. A tiled hip roof crowns this measured symphony of superb details and character. The costs of land, building, and furnishings came close to $1 million.

The Pittsburgh Athletic Association building, despite changing fashion, has always been admired. It gave a new level of sophistication and elegance to Pittsburgh's then burgeoning cultural center less than four miles from Downtown. The gray marble lobby was designed as a Renaissance drawing room with three arched windows, a gorgeously coffered ceiling, two elevators, and service desks.

A large oil painting, "The Bathers," depicting nude athletes around a classical pool by New York muralist Albert Herter (1871-1950), glows above the magnificently carved marble fireplace. Beyond the lobby originally were large lounging rooms, dining and grill rooms, billiards room, and ladies' parlor. Most of these still function and are well maintained.

The barrel-vaulted Grill Room with its square quartersawn oak paneling and elaborate Grinling Gibbons-style carvings is one of the handsomest serving rooms in the city, advancing the fireplace motto, "When friends meet hearts warm." The overmantel contains two medallions in relief:

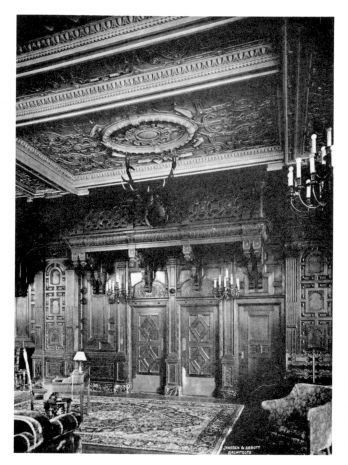

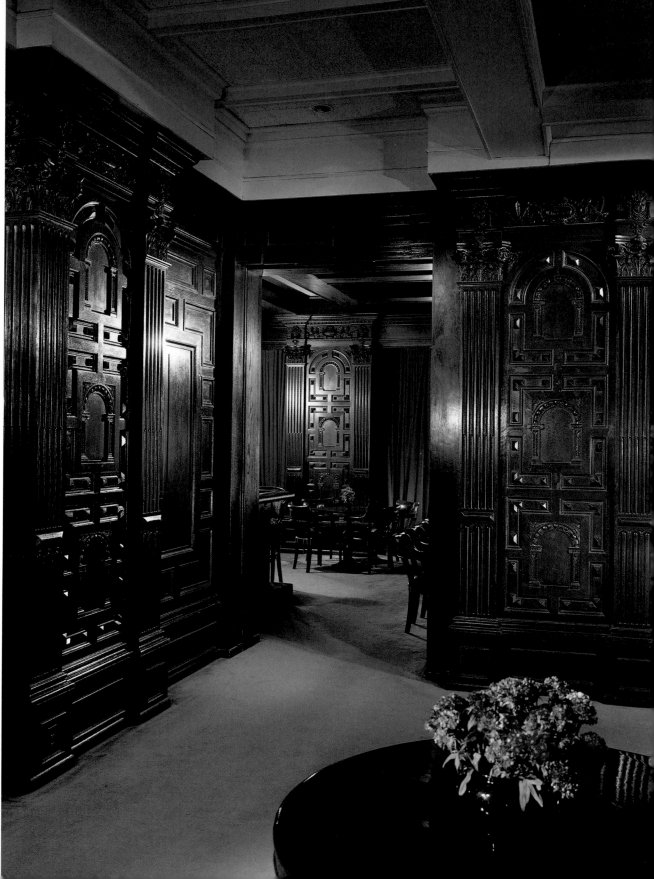

Facing page, left:
Walnut paneling, Elizabethan Room, Fort Pitt Hotel addition, Janssen and Abbott, 1909-1911.
Hotel razed 1968.

Facing page, right:
Paneling today in lobby and bar of the Concordia Club, Pittsburgh.

Right:
The Norse Room, basement, Fort Pitt Hotel, 1909, with Rookwood tiles. Viking ship models hang from chandeliers. Lost.

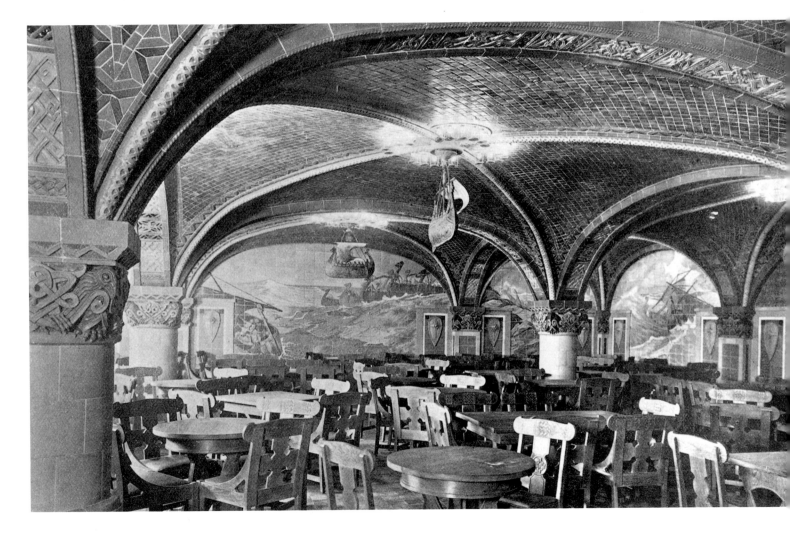

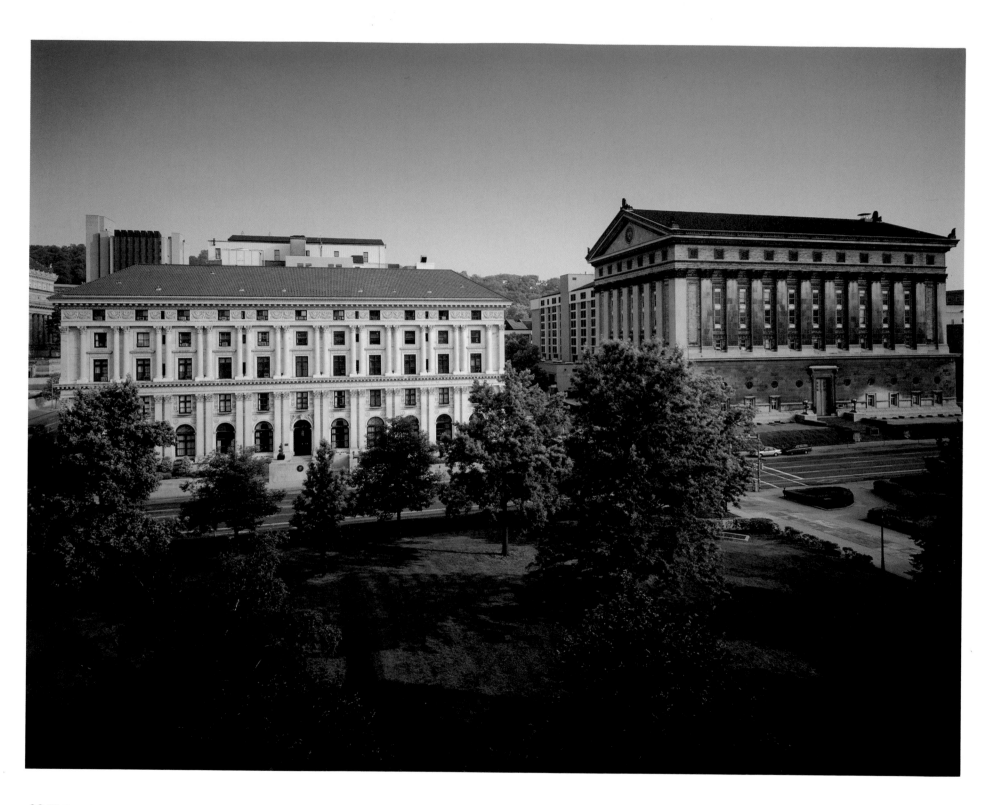

Facing page:
Dawn greets two buildings that helped transform Oakland: Pittsburgh Athletic Association, left, and Masonic Temple. View is from fifth floor parapet, Cathedral of Learning, University of Pittsburgh.

Right:
Pittsburgh Athletic Association exterior with elaborate limestone detailing.

one of the club's symbolic winged head of Mercury; the other, the seal of Pittsburgh, adapted from the Earl of Chatham's arms, both enriched by visored helmets and the founding date, MCMVIII. The ceiling's handsome plasterwork depicts large stylized English roses.

The second floor held an excellent library, followed by floors of guest rooms and apartments. The third floor contained the Edwardian swimming pool, seventy-five feet long by twenty-five feet wide, with a spectators gallery for races, the same as in the New York Athletic Club, of which Franklin Nicola was a member. The pool's floor could be adapted into a theater seating several hundred people.

The fourth floor held a large gymnasium and other features, while the basement contained eight bowling alleys, two more than in comparable clubs (there are now sixteen). A rifle range had five targets.

The building, erected by twenty members who were zealous young businessmen, was nevertheless Nicola's brainchild. The contractor was Henry Shenck Company, Century Building.

Beginning his real estate business Downtown in 1897, Nicola purchased the Schenley Farms district, north of Bigelow Boulevard and east to Center Avenue, in 1905 from the estate of city benefactress Mary Schenley (d. 1903). Her family had owned the open land for more than 100 years. Nicola envisaged the area not only as residential lots but as a choice neighborhood of mostly two-and-one-half-story houses: "The Most Beautiful Building Spot in America — Schenley Farms," he boasted in advertisements.

Janssen and Abbott, with other local and New York architects, filled the district's sycamore-lined streets with beautiful period houses in many styles. Janssen designs here are mostly English and Colonial styles characterized by integration of forms and details.

The new clubhouse, clad in limestone, brick, and terra cotta, gave Oakland its first taste of visual magnificence and was a sensation. It brought Janssen and Abbott regional attention that would quickly flower into more work. In 1976, the P.A.A. was included in the National Register of Historic Places.

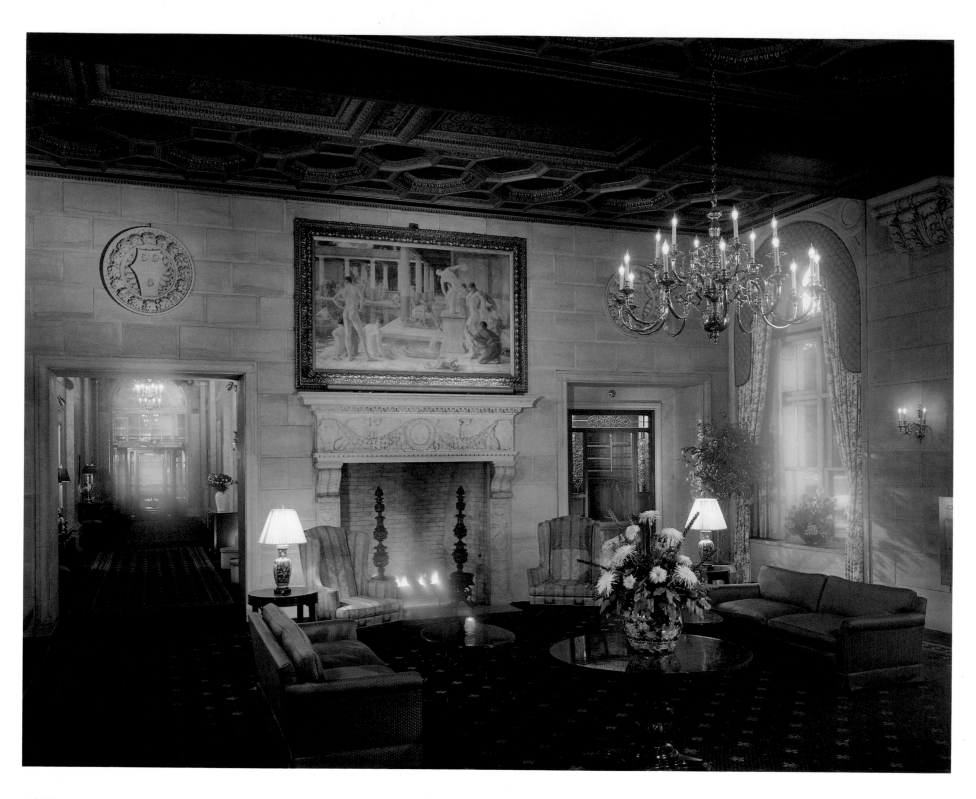

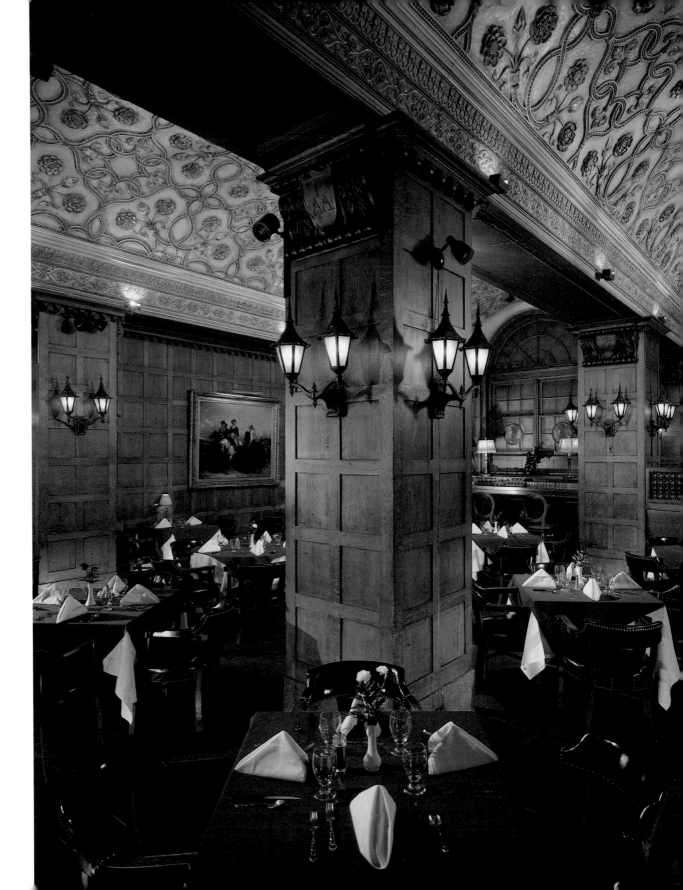

Facing page:
Lobby, P.A.A., with carved gray marble fireplace, crests, marble walls. Main corridor at left; coatroom, right. "Bathers" by New York muralist Albert Herter early set club's sophisticated tone.

Above:
Detail, P.A.A. lobby, coffered ceiling with gilded and polychromed shields, symbols, rosettes.

Right:
Grill Room, P.A.A. Plaster English roses cover multi-barrel vaulted ceiling. Oak paneling carries note of masculine elegance.

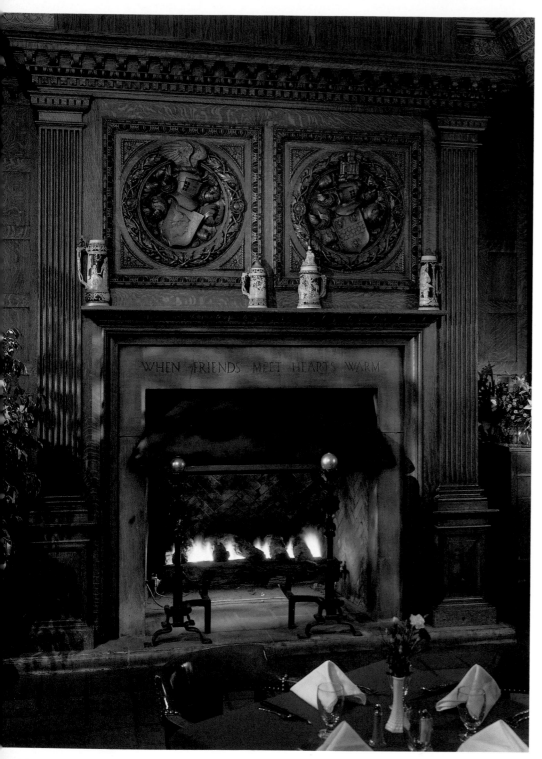

Left:
Medallions over Grill Room fireplace have unusual crests. P.A.A.'s winged head is at left; City of Pittsburgh's, right.

Below:
P.A.A. swimming pool with tiled spectator galleries.

Facing page:
Main dining room, P.A.A., scene of countless parties, dinner-dances, luncheons.

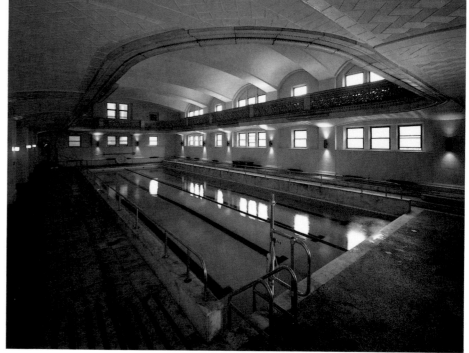

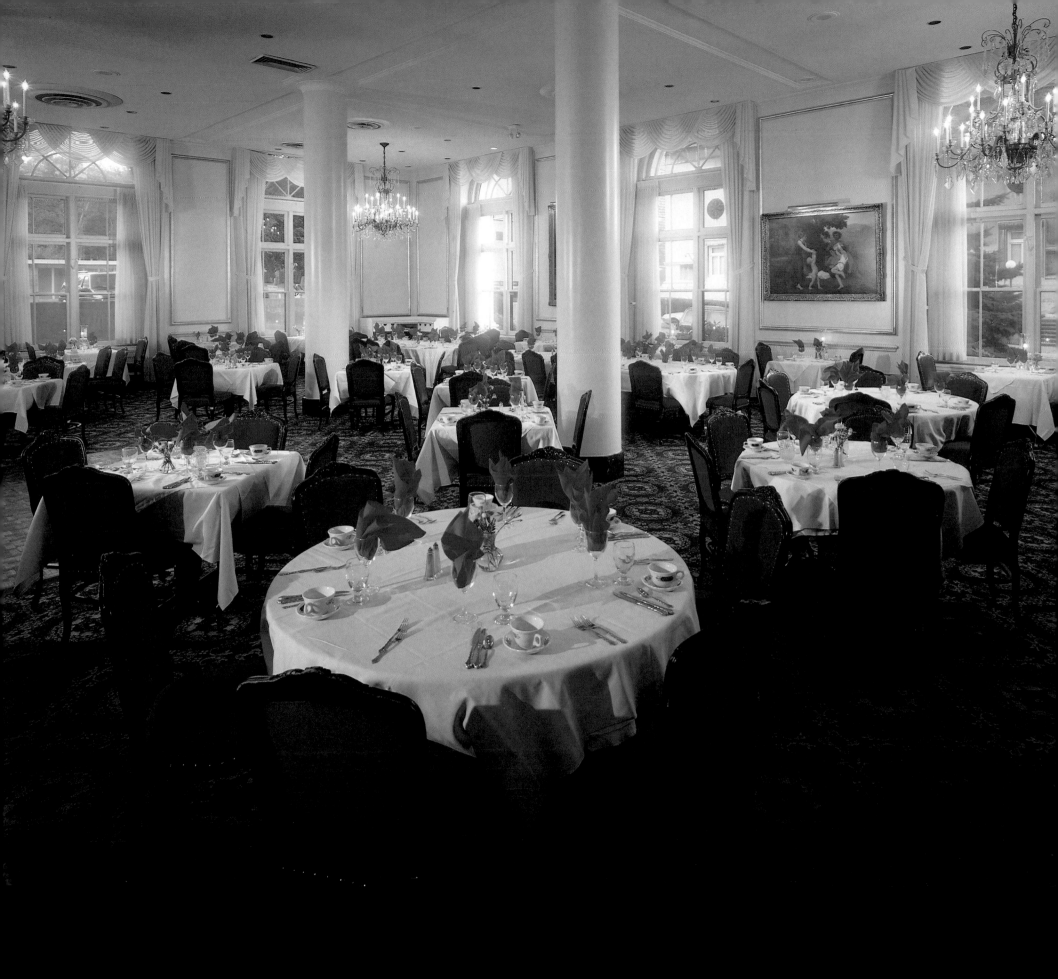

Masonic Temple's Grecian-style oak front doors were designed to enhance mystic atmosphere. Janssen and Abbott. Now owned by University of Pittsburgh.

MASONIC TEMPLE

The Masons, impressed with the athletic club, commissioned Janssen and Abbott in 1913 to proceed with a design for their temple just across Lytton Avenue at Fifth Avenue. For their new clients the firm, with Pittsburgher Edward Stotz as consulting architect, would create, after six months of drawings, a block-long edifice resembling a giant Grecian jewelbox. In 1914, The Schenley Farms Company constructed it for $1.5 million.

This magnificent building's solid, eternal-appearing mood is attributable to its bold design and reduced exterior distractions that heighten the structure's private nature. In an unusual design concept, the utility lines were placed inside double walls of the north and south facades for convenience.

So simple is the structure's exterior massing that few would guess it contains ten floors, most with high ceilings, and 162,970 square feet of space. Compared with today's buildings, the scale is extraordinary.

Rising from a simple Indiana limestone base, the exterior is marked by twenty-four-foot-tall double wooden doors and trapezoidal stone frames carved in the manner of ancient Greek temples. The main part of the building offers a cadence of repeating pilasters with Corinthian capitals between stacked windows. They soar to a frieze surmounted by smaller single windows, then the cornice, pedimented gables at each end, and a slate roof decorated with large anthemion cheneaux. The walls above the first floor windows are set with large filigree terra cotta rosettes. Consisting of four anthemions in a cruciform pattern, they screen the lower windows to aid the structure's simplified massing. The building has its practical side, however: the north face, not often seen, is finished in brick.

The ceiling of the white marble lobby is twenty-eight feet high. Beyond this is a long corridor, followed by the central grand ballroom, 119 feet long by seventy-five feet wide, that can seat more than 1,000. Above this is a gallery mezzanine 600 feet long and fifteen feet wide.

Until after the Masons sold the building to the University of Pittsburgh for $8.5 million in 1993, the fourth floor held four lodge halls, large open rooms, for Masonic ceremonies. Named Egyptian, Doric, Ionic, and Tudor, the rooms held tiers of seats against long side walls, as in the British House of Commons. Raised platforms for officers were at the eastern end of each room with carpeted altars and candelabra at room centers. Each dais contained officers' chairs and thrones. Except for furniture, the halls were plainly finished with light-painted walls.

There were in addition four "Blue Lodge" floors for first- to third-degree Masons, the beginning steps of Freemasonry. The Masons trace their beginnings, metaphoric or otherwise, to Solomon's temple. As a fraternal organization, they promote good social attitudes, are open to members of any religion, and hold a belief in some kind of supreme being.

Their memorial library held records and memorabilia behind beveled-glass doors, and showcases contained symbolic Masonry trowels and richly embroidered aprons. Several floors offered changing rooms and lockers for ceremonial costumes. The large basement contained many stainless steel surfaces that could hold 500 meals in steam boxes while cooks prepared 500 more. There were once a bowling alley and billiards room on this level.

Two floors contain a modern 1,000-seat auditorium, mezzanine, and organ that the Masons renovated after a 1965 fire. This was the temple's only altered, and air-conditioned, area. The University of Pittsburgh is expected to use the building for library and classroom space. Novelist Salman Rushdie spoke here in 1997. Most Pittsburghers recognize this majestic structure but relatively few have visited it.

Typical lodge room, Masonic
Temple, 1996.

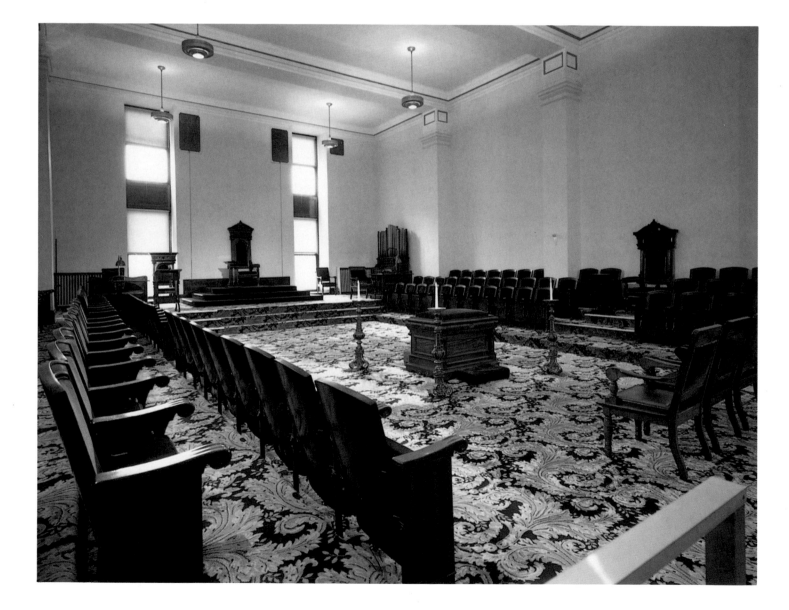

Hidden utility corridor between temple's inner and outer walls.

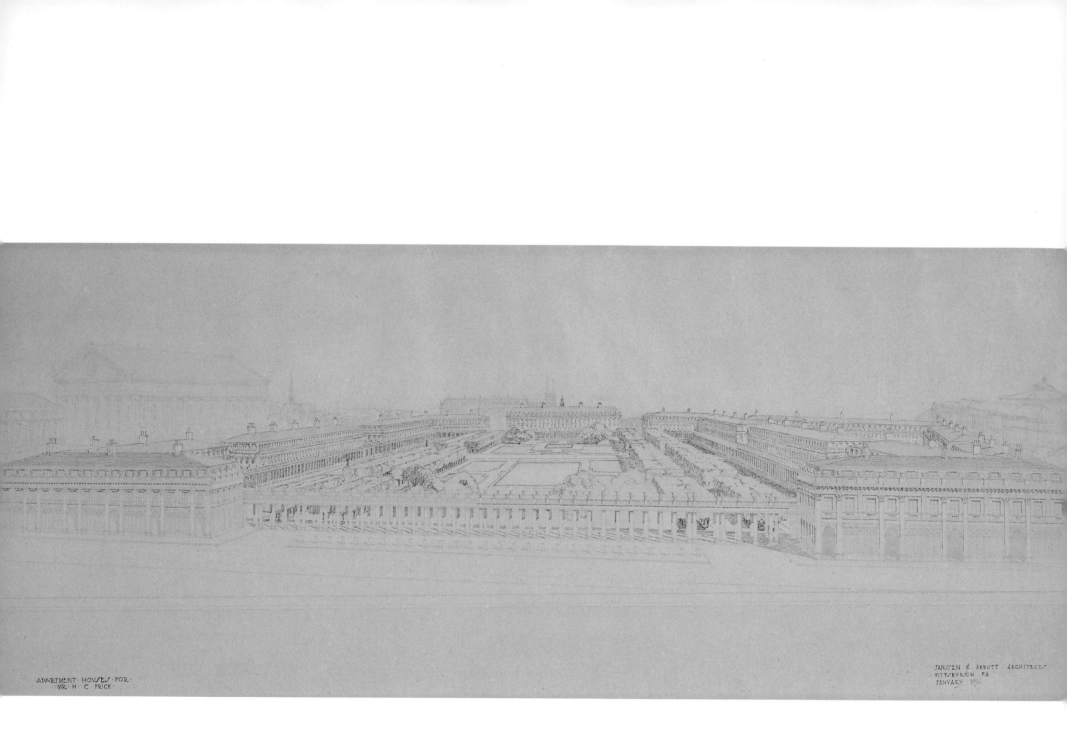

APARTMENT · HOVSES · FOR ·
· MR · H · C · FRICK ·

JANSSEN & ABBOTT · ARCHITECTS
PITTSBVRGH · PA
JANVARY 1916

Speculative drawing, grand apartment complex, Frick Acres, now site of Cathedral of Learning, University of Pittsburgh. Masonic Temple, left; Carnegie Institute, right. Janssen and Abbott, 1916.

WILLIAM PENN HOTEL

Janssen and Abbott's work on the Fort Pitt Hotel would be a prelude to its largest early commission, the $6 million William Penn Hotel (1914-16; addition 1928-29), now the Westin William Penn. Exuberant managing director Charles A. Blanchard, in an advertisement in *The National Architect* magazine, called his new domain "The most beautiful hotel in the world."

Built by Henry Clay Frick, the construction was troubled by strikes, no strangers to him. In a 1914 letter on the hotel in the Frick Archives, Pittsburgh, Frick typically cautioned subalterns, "Do very little talking and keep your eye on the ball." Tight-lipped concentration was the key to his success. Frick records show Janssen and Abbott was paid $118,980 for the design. In April 1915, 652 men worked on steel riveting at the same time; the figure rose to 700. Exterior brick cost a heavy $7 apiece.

This Renaissance Revival building, with a 28,000 square foot plot and a 216-foot frontage on William Penn Place, rises in the shape of the letter "E," with three wings facing north. The same south-facing conformation was added twelve years later when land on Grant Street was acquired. Although resembling other hotels done in the same style, the William Penn was designed with special care as owner Henry Clay Frick's third structure on Grant Street and his last building venture.

Opening on March 9, 1916 with 800 staff, the hotel, as Frick hoped, quickly became the city's social hub as well as a convention facility. Eugene Eppley, owner of twenty-two other hotels, gained control of the William Penn in 1928 and built the Grant Street annex, giving the tower a total of 1,600 guest rooms.

The first three stories on a granite base are faced in Indiana limestone with rich exterior decoration over windows. Then come fifteen stories of red brick with terra cotta ornamentation, which also completes the last two stories with frieze and cornice.

The hotel's first floor is dominated by the Palm Court Lobby, a grand space twenty-five feet high flanked by seven arches on each long side. The north arches align with seven similarly shaped windows in the facade facing Mellon Square Park. An elaborate ceiling is set with sixty-five octagonal coffers, said to have been adapted from the Palace of Fontainebleau, and embossed with alternating "WP" monograms on shields and rosettes. The room, despite its rich interior, was originally meant to suggest an outdoor space. Dark Westfield green marble, used liberally on floors, wainscoting, and lower walls, adds restrained verdancy.

East of the Palm Court lies the warmly paneled Terrace Room, originally called the Italian Room, reached by crossing an indoor parterre, the terrace, where tables and chairs were placed in patio style. The effect was repeated on the Palm Court's west side. The Terrace Room is flanked by five arches on each long wall under a ceiling of elaborate plaster work. Eight tall window casements are enriched with arched grilles of Renaissance pattern. Additional grilles front arched mirrors at each end of the room.

Originally, walls above the paneling were filled with beautiful beaux-arts murals called "The Seasons," depicting

harvest festivals with goddesses and centaur, done by New York decorating artist Louis Schistle. Victims of style changes, these were later painted out. The current mural on an end wall, of George Washington being welcomed to Fort Pitt, is by Akaroly L. Szanto. On the Palm Court's west side is a similar terrace, leading to the former Georgian Room restaurant, later the Tuscany Cafe.

Over the years the Terrace Room has not only offered ballroom dancing but once ice-skating shows. KDKA, the world's first radio station, began broadcasting from here in 1922. Many theater, film, and show business stars — as well as presidents and other political luminaries — have stayed here. Show folk include Mary Pickford, Pola Negri, Mae West, Elsa Maxwell, Florenz Ziegfeld, Bette Davis and Julie Harris, to name a few.

Jerome Kern wrote "Why Do I Love You" for his musical "Showboat" in his suite. Here engineer Ludwig Dernoshek invented the bubble machine, a clock motor rotating children's bubble-makers through a soap mixture in a pie pan, that produced "accompaniment" for band leader Lawrence Welk's "champagne music." A Pittsburgh woman won dinner and dancing in the Terrace Room for naming his theme song "Bubbles in the Wine."

The second glory of the twenty-story hotel is the grand ballroom on the seventeenth floor. Twelve lobby elevators serve the thousands of people who have enjoyed this mezzanine-ringed space high above the city and any breezes that were available before air-conditioning. Janssen wanted the ballroom at or close to ground level but was outvoted in favor of an arcade of shops.

The ballroom's magnificent gilt Renaissance-style reliefs still enliven walls and ceiling. Frick's daughter Helen Clay Frick toured it with pleasure in 1916. A thousand people could be seated for a banquet and in summer the space became an open-air restaurant. This and other dining spaces on the floor had their own kitchen. The hotel's huge kitchen in the basement resembles the Masonic Temple's.

As a change of pace, a smaller art moderne banqueting space called the Urban Room was installed off the ballroom. Joseph Urban designed this space as part of the hotel's 1929 addition that added 600 sleeping rooms. Although Urban did several such rooms elsewhere, this is one of the few that survive.

The room was meant to become part of the ballroom, but because of the cost of removing walls the space was given its separate character, although it is often used for ballroom events. Urban paneled the walls in black Carrara glass offset by hand-painted decorative panels and red velvet draperies. The ellipse of Urban's golden ceiling mural is ringed by female figures in tall flowered hats playing musical instruments. The subjects were styled after Ziegfeld Follies girls Urban knew from designing sets for Florenz Ziegfeld. Urban, a Vienna-born architect and designer, also created sets and costumes for Marion Davies when she starred in her lover William Randolph Hearst's Cosmopolitan Pictures.

Urban also designed The Chatterbox Supper Club, a moderne nightclub that opened in the hotel's annex basement shortly after the repeal of Prohibition in 1933 "for debutantes and the younger dancing men." It was a chic and popular place where many groups performed, including Don

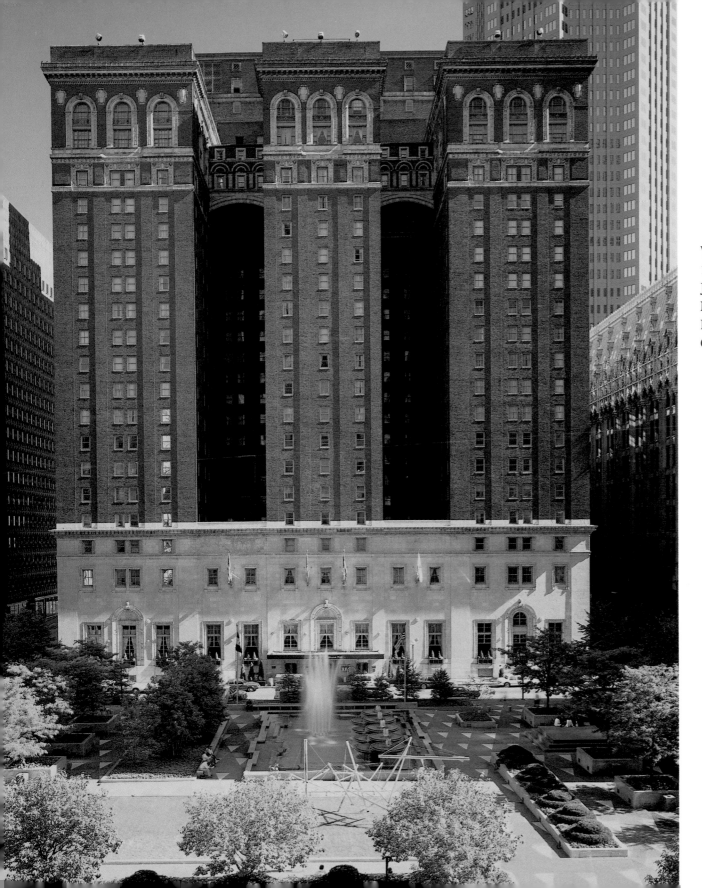

William Penn Hotel, now Westin William Penn, 1914-16 facade, 523 William Penn Place, Janssen and Abbott. It faces Mellon Square Park, Mitchell and Ritchey, 1955, honoring A.W. and R.B. Mellon. Hotel's construction office was in Oliver Building, site of photograph.

Bestor and Ramona, Orrin Tucker with Wee Bonnie Baker, Max Adkins, Earl ("Music, Maestro, Please") Truxell, Jimmy Joy, Kay Kaiser and his College of Musical Knowledge, and many others.

Urban installed a stage at one end; the other end contained backlit carved glass panels depicting figures of art and industry, two of which are still in place. The room's dado of tan marble is also extant, along with art moderne details in painted concrete pillars.

Newly invented fluorescent tubes, placed in rows on the ceiling, were of-the-moment inclusions. Being uncovered accentuated their novelty. Although the tubes are long gone, the connection covers are still visible. The Chatterbox was much later renamed the Pittsburgh Room and featured large photomurals of local scenes.

As early as 1916, a hotel addition had been planned, possibly with an indoor garage, but the latter was never built. And in matching up old and new floors on the hotel's sloping site, the new building did not match the older one by half a floor. This was corrected by adding the Club Floor to the new wing, reached by elevator or stairs from the south lobby. The aberration is visible on the exterior in an interrupted stone course line. Several professional clubs had meeting and dining rooms here for many years. The current Panel Room, with Janssen's English paneling, was one of these.

Of the hotel's original 900 guest rooms, all with outside light and air, seventy had private sitting rooms; the rest were simply bedrooms. Every sleeping room had a private bath. Rooms originally rented for $2.50 to $3.50 a day.

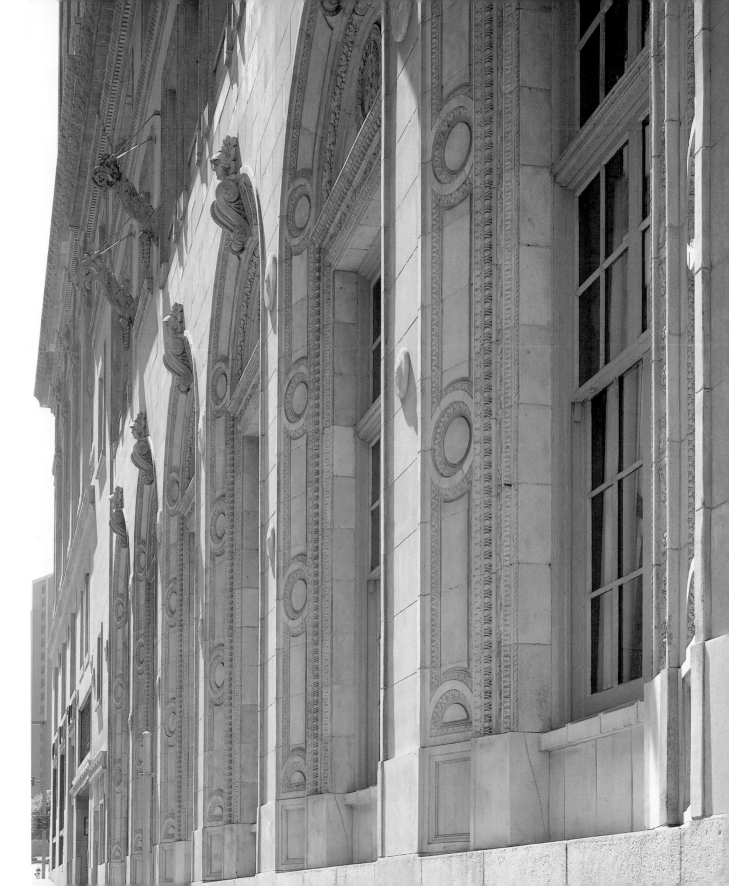

Details of William Penn Hotel's Renaissance
Revival limestone exterior, Sixth Avenue.

Left:
Italian Dining Room, William Penn, with
original mural, now Terrace Room.

Right:
Elizabethan Dining Room, where pillars held oscillating fans.

Facing page:
Terrace Room, Westin William Penn, today.

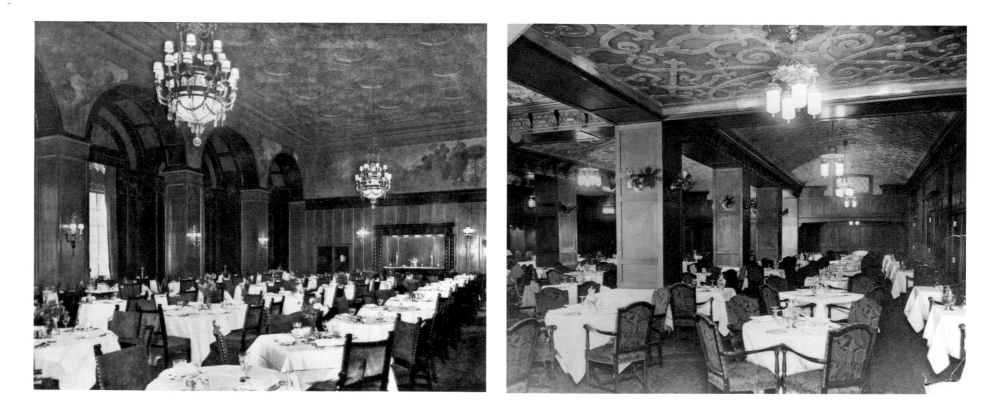

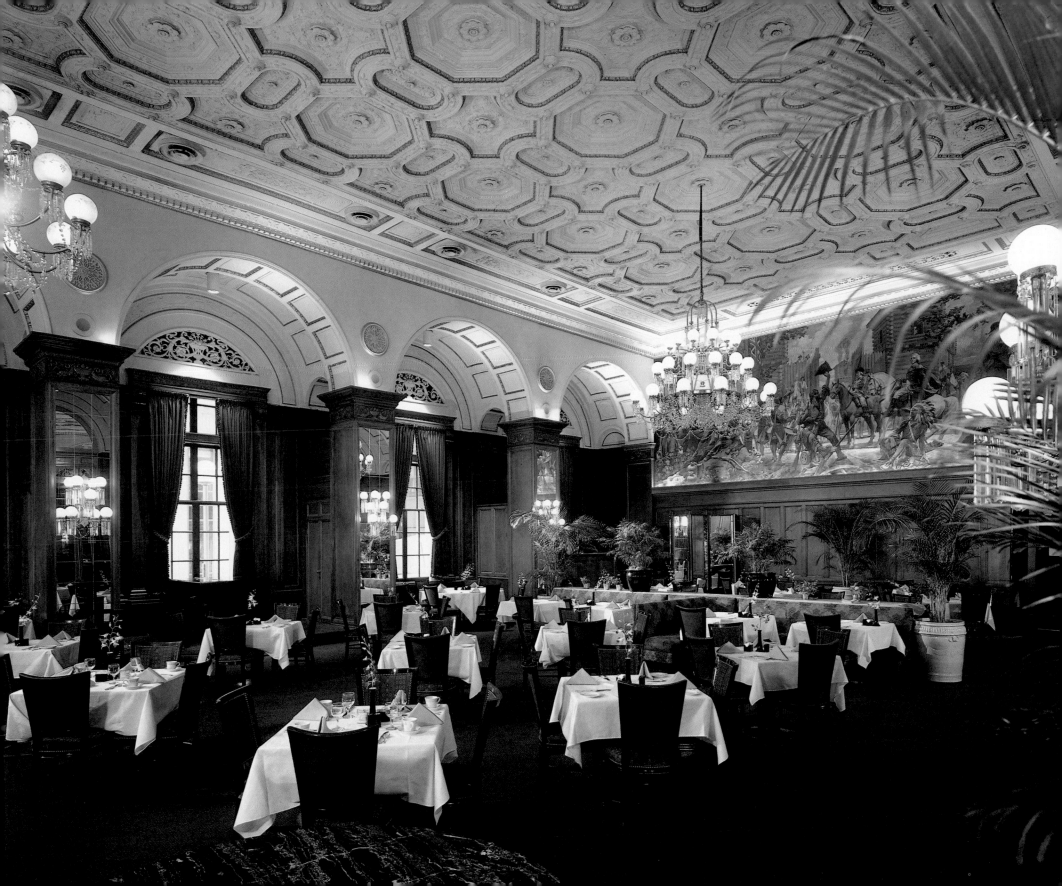

William Penn ballroom, seventeenth floor, 1916.

Facing page:
Westin William Penn ballroom today remains
much as it has been since 1916.

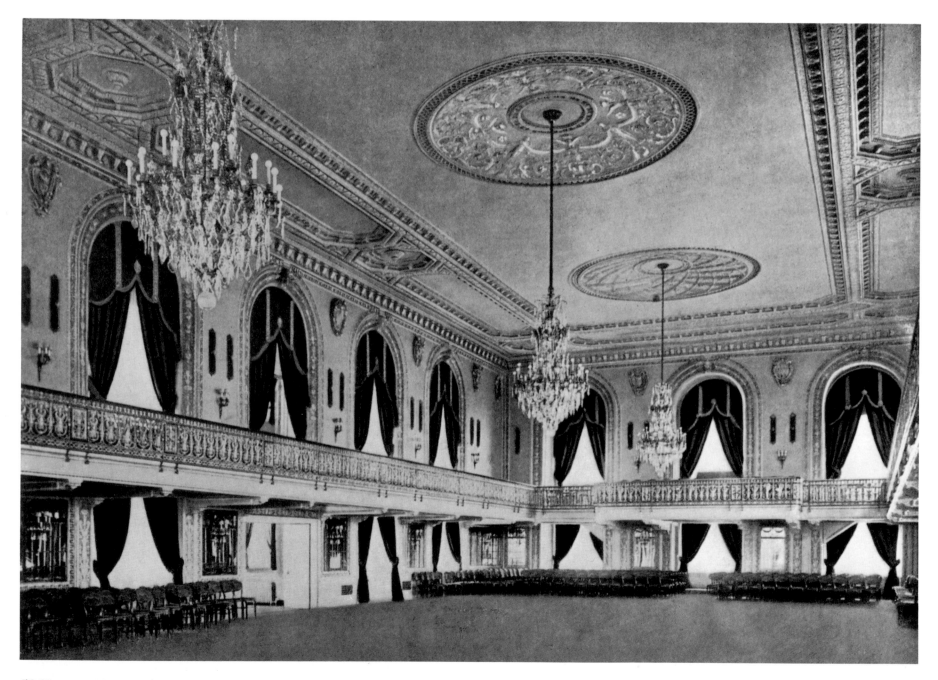

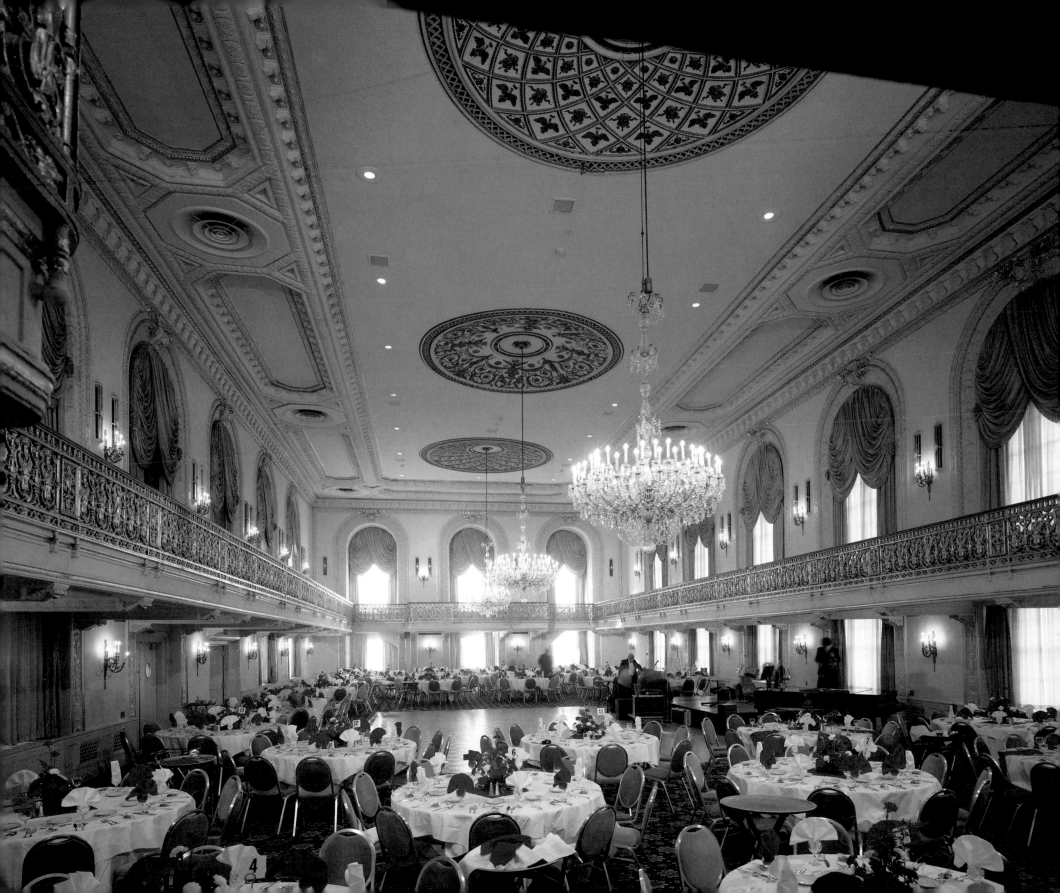

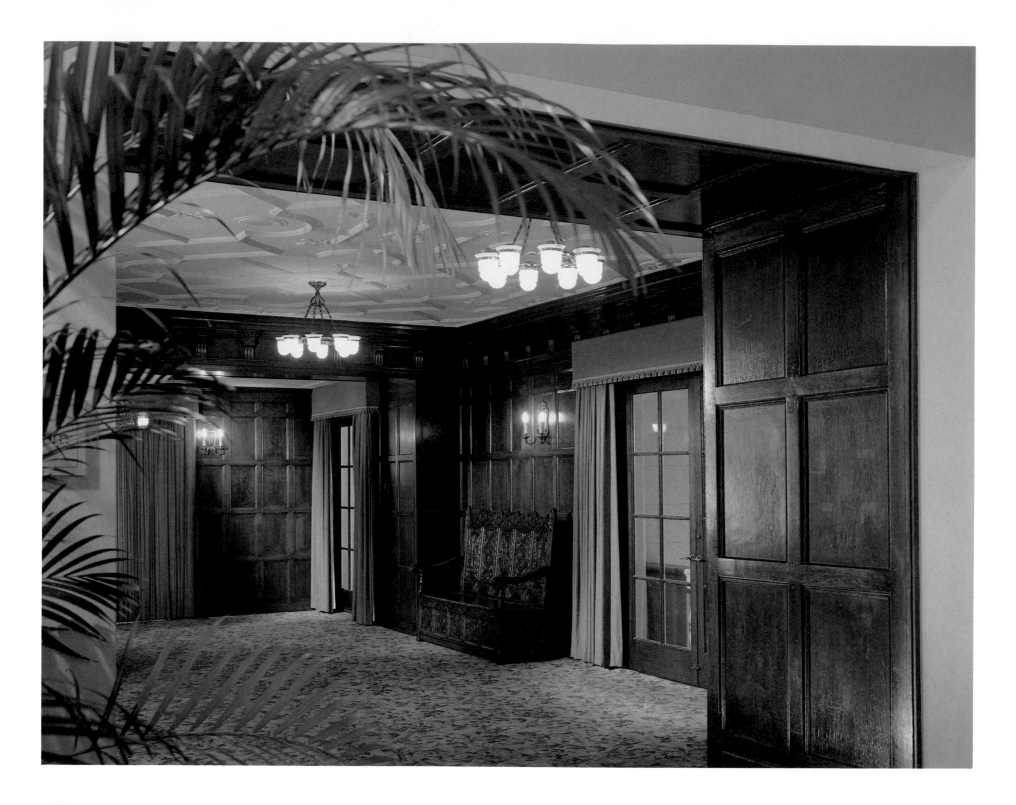

Facing page:
**The Panel Room, Club Floor,
Westin William Penn, today.**

Right:
**Deep coffering in upper lobby ceiling,
1929, recalls Young Men & Women's
Hebrew Association auditorium,
1925, now Bellefield Hall,
University of Pittsburgh.**

Designed solely for bachelors, or at least men unaccompanied by women, the fifteenth floor offered Japanese waiters, a large sitting room, and a library in a time before radio and television. The hotel was divided into five sections of three floors with each section containing about 180 rooms. Operated independently, each section had its own staff of executives, servers, offices, pantries, linen rooms, and so forth. Bathrooms had iced drinking water and bedrooms were equipped with electric clocks; with more than 1,000 timepieces, the William Penn boasted it offered more than any other hotel in the world. The telephone switchboard was fifty-four-and-a-half feet long and the largest between New York and Chicago.

Pittsburgh itself supplied most of the William Penn's construction and furnishings needs. George A. Fuller Company, New York, was the general contractor. The litany of subcontractors is impressive. Furniture, rugs and carpets were installed by Pickering's, Tenth Street and Penn Avenue. H.P. Dawson, civil engineer and surveyor, placed the bases for columns. Robert Mitchell Furniture Company, of Cincinnati, but with an office in Pittsburgh, provided all cabinet work and interior wood finish.

Joseph Horne Company furnished tapestries, paintings, and decorative work with the Hayden Company, New York. C. Reizenstein Sons, 711 Liberty Avenue, designed the William Penn's monogrammed china and glass services. J. Willis Dalzell & Company supplied non-clogging mail chutes. Harrison & Meyer, Oliver Building, was cement contractor for floors and sidewalks. McNulty Bros. was plastering contractor. National Mortar & Supply Company provided

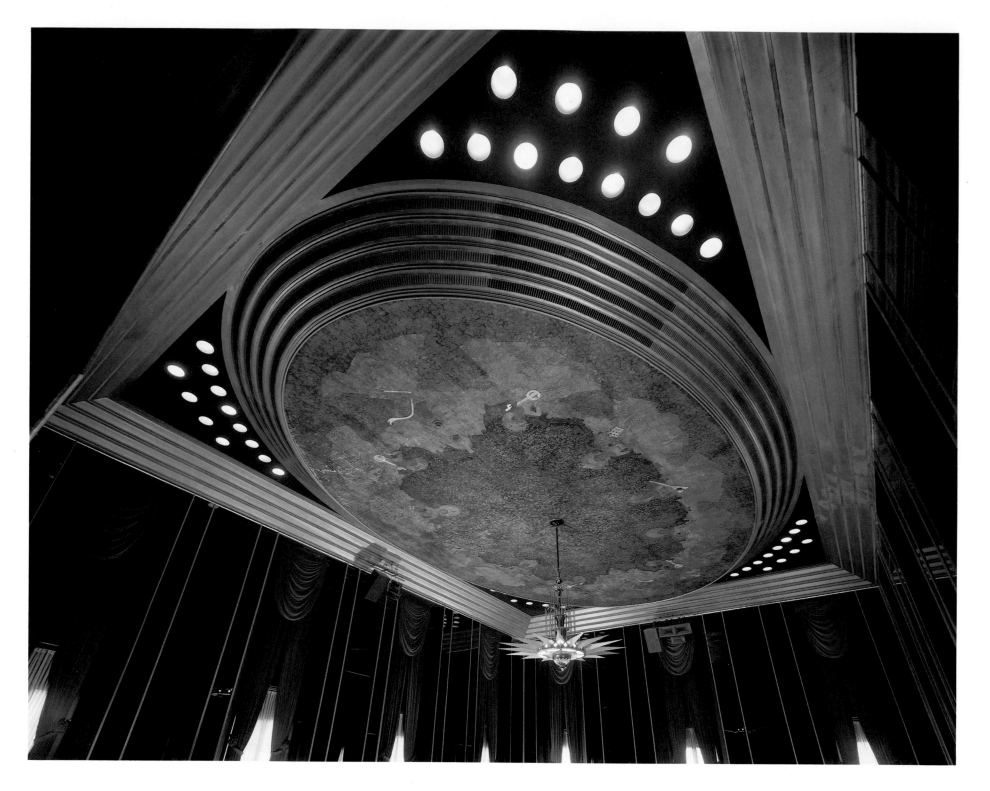

Facing page:
Recently cleaned but unrestored ceiling mural of women musicians, in the style of Ziegfeld Follies, designed by Joseph Urban, Westin William Penn.

Right:
Workmen cleaning Urban Room, 1997.

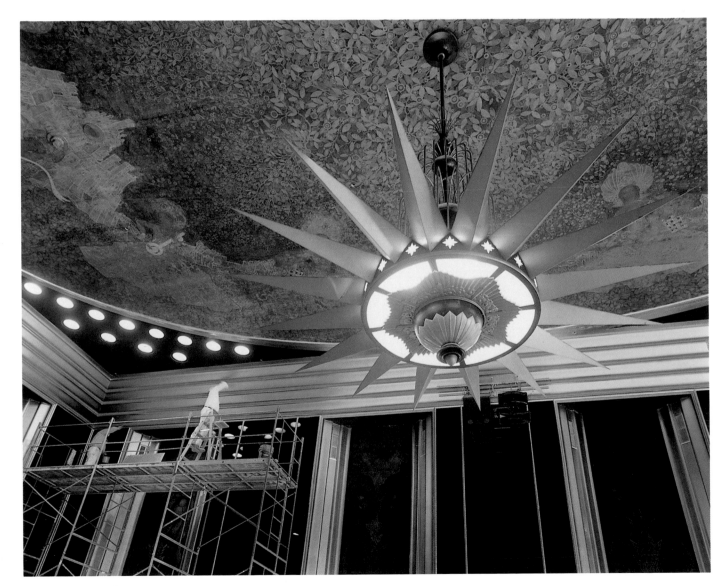

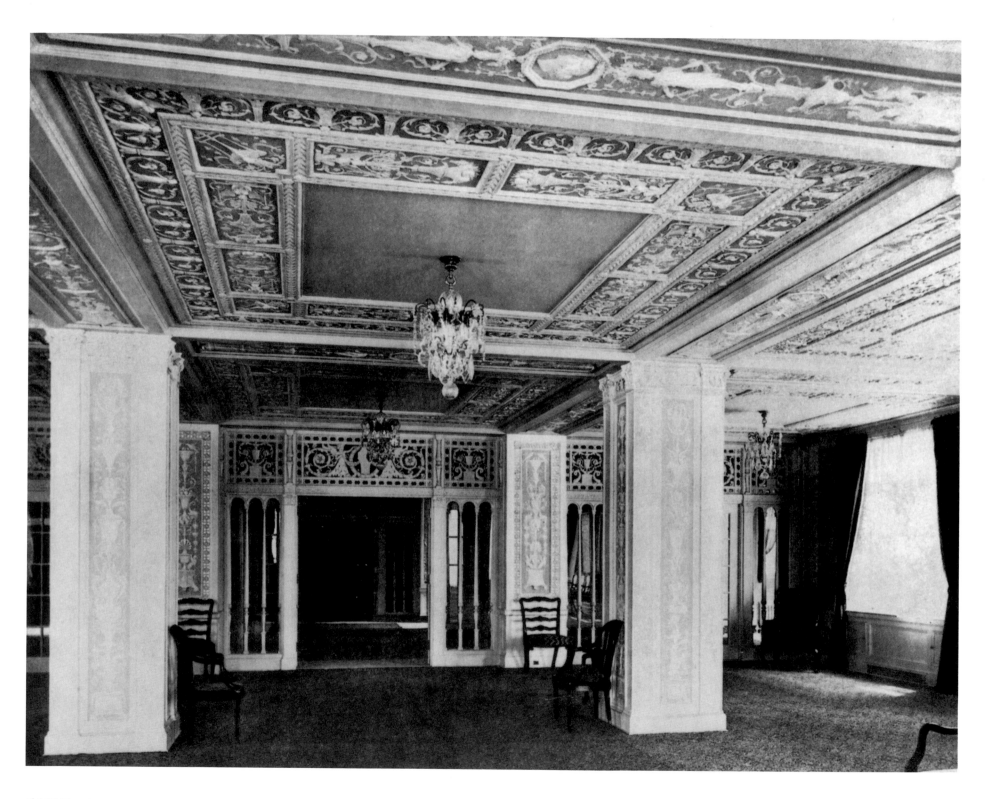

Facing page:
William Penn reception room, seventeenth floor, circa 1929. Decoration gone but flourishes in ballroom.

Left:
Ceiling with exposed fluorescent tubes, The Chatterbox, circa 1933.

Right:
Chatterbox corner.

the Banner Hydrate Lime; and Heppenstall & Marquis, builders' supplies.

Taylor & Dean produced the ornamental iron and wire work. Kitchen ranges and broilers came from Bernard Gloekler Company. Duquesne Light Company supplied electric power.

More than 115 miles of electric wiring, called Tip-Top rubber-insulated wire and costing about $15,000, were installed in the walls. Even the wire was made by Standard Underground Cable Company, Pittsburgh. Booth & Flinn Ltd., Pittsburgh, furnished all of the brick.

Hot-water heat was later replaced by gas. It was just one of many updatings that have kept this grand Downtown monarch a popular place to stay or be entertained in through the years.

Drawing, Young Men and Women's
Christian Association, Wood Street,
Janssen and Cocken, signed, circa 1922.
Now Wood Street Commons.

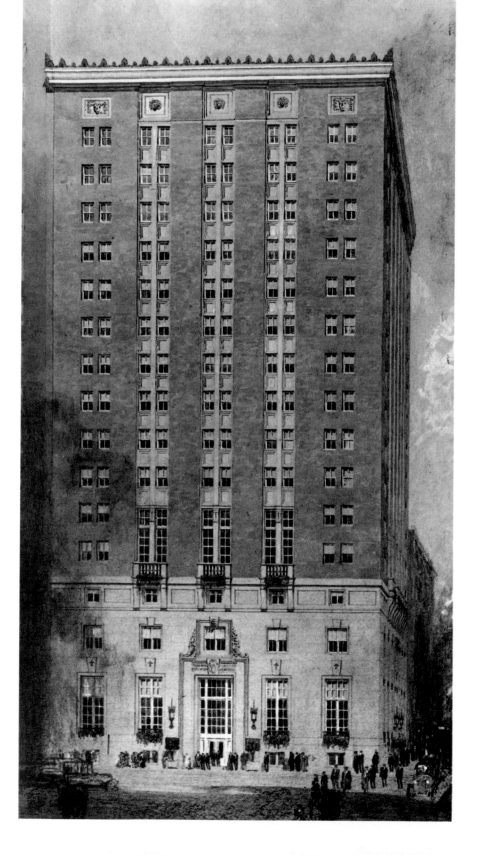

SCHENLEY FARMS

Franklin Nicola's dream for an upscale neighborhood of elegant houses in Pittsburgh's Civic Center dovetailed with Janssen's aspirations. The firm designed at least five different models, illustrated in *The Builder*, for the tree-lined district that now contains 124 houses. Nicola, a Cleveland native, began this plan before Cleveland's Van Sweringen brothers started the similar but larger development of Shaker Heights. There, coincidentally, architect Bloodgood Tuttle's 1920s houses, although unique, suggest Janssen's designs.

Regardless of whom his partners were, Janssen's houses have a quality that is often immediately apparent. Whatever the chosen style, his designs always possess a discernible completeness. Generally the older the house the more elaborate the ornament is. One is left with the feeling that every aspect of design has been studied and integrated into the whole. Nothing is tacked on and much time and effort have been given to details.

If there is a chief characteristic, it is that the earlier houses tend to be more complicated, particularly the exteriors, while the later ones are simpler in form although sometimes more massive. As to specifics, brickwork is of high quality and often distinctive. Roofs are of clay or slate. Anything that makes a house more gracious, such as french windows or wrought-iron balconies, even if only decorative, is often seen. Also in his colonial houses, there is a clustering of small rooms often combined with larger ones, perhaps derived from Jefferson's Monticello. This is seen at the Sewickley Heights house Janssen enlarged for Pittsburgh interior designer Verner Purnell and in the Bellair, Va., house done for the A. Patton Janssens.

If only we could be sure of how many houses the firm designed. But many architects were busy in the district and records are scant. Among Janssen's work in Schenley Farms is the comfortable 1916 Arrott house, 4205 Bigelow Boulevard at Lytton Avenue, designed for the owners of Downtown's Arrott Building (done by Frederick J. Osterling, 1901-02). The elegant half-timbered three-story house of dark red Flemish bond brick and cream stucco has a red clay tile roof, with gables, hip dormers, and a Roman three-arched porch made into an enclosed room. The arches echo the house's round-arched front door.

Janssen and Abbott did a large half-timbered house at 4107 Bigelow Boulevard in 1907 for D.H. Hostetter Jr., maker of Hostetter's Stomach Bitters. The Pittsburgh Historic Review Commission's district tour guide rightly calls this house a striking example of Tudor Revival with its robust chimneys, linked gables, cascading roof, and geometric half-timbering. The brickwork is Flemish bond with a watertable; the eighteenth century style red brick is laid with a stretcher and soldier course.

At 4115 Bigelow Boulevard is an elegant French eclectic house with hip roofs. Its Renaissance-style metalwork is probably by Samuel Yellin. A triple gabled house with twin porches and chimneys at 4123 Bigelow Boulevard has a clay tile roof and dark red Flemish bond brick work. The mood recalls Lutyens.

Houses at 213 and 215 Tennyson Avenue bear strong Janssen and Abbott characteristics: 213 is gabled with bull-nosed brick porch rail, restrained chimneys and jerkin-head, or truncated gable. Several of the dwellings in Schenley Farms Terrace, above Center Avenue and Bigelow Boulevard, in several different styles including Tudor and Georgian, and offering some ornamentation, were probably designed by Janssen and Abbott around 1913.

Janssen and Abbott created one of the district's most romantic houses at 4411 Bayard Avenue, a Tudor designed for Nicola's brother George W. Nicola before 1910. The house rises on a terrace across the street from Bertram Goodhue's First Baptist Church. The dwelling's outstanding features are its massive chimneys, red brick first floor walls joined with stucco on upper floors, a low welcoming side entrance off the drive, and a narrow oriel window facing the street. Many decorative details such as a jerkin-head gable, applied wooden motifs on window boxes, and small wrought-iron lanterns are carefully integrated into the design, creating a nostalgic Olde English mood.

Janssen dwellings in Squirrel Hill, besides those

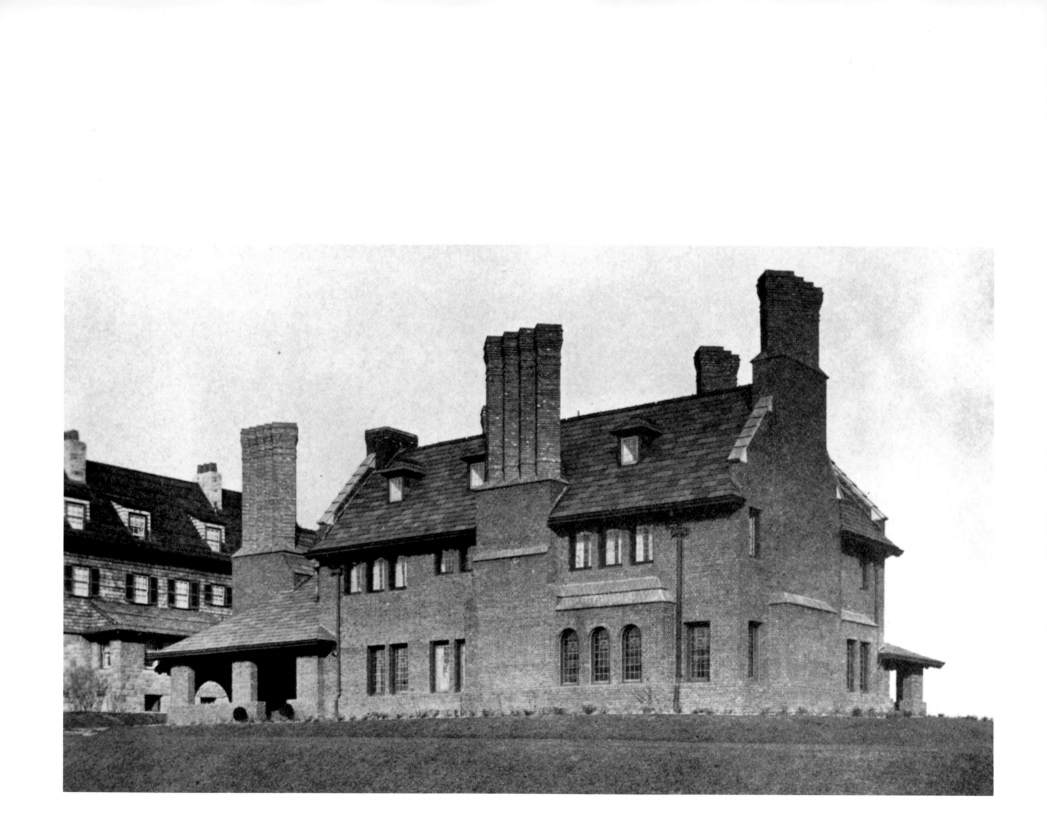

Facing page:

Franklin Abbott house, Darlington Road, Squirrel Hill, overlooking Schenley Park Golf Course, circa 1912. Razed.

Below:

Janssen house, Darlington Road, Squirrel Hill, 1905; architect unknown.

mentioned, include twin English houses at 5150 and 5156 Beeler Street. They offer common bond brickwork, slate roofs, louvered shutters, and four french doors each. Spiral shutter-holders recall those at La Tourelle. Front doors with six panels have limestone surrounds. A common driveway focuses attention on the wide rolling lawn. Windows are primarily casements and second garages have been tucked in at the back of the drive.

Similar to these twins is 6655 Kinsman Road with its off-driveway entrance, limestone trim around the front door and window above it, slate roof, common bond red brick, tall french doors, and louvred shutters with an iron balcony. A three-tiered chimney is of massive width. An early Janssen effort at 6699 Kinsman Road near Dallas Avenue offers a stucco exterior set with toothed brick window surrounds and jerkinhead gable, sometimes seen in Janssen houses of this period. The Roman arched front porch has been enclosed with windows for many years but the side entrance, also off the driveway, was recently redesigned.

These houses are related to the later Thomas Rodd house, 1808 Beechwood Boulevard at Dallas Avenue, with its entrance also off the drive. The dark red brickwork is laid in Flemish bond with cream mortar and Yellin ironwork. Other houses would rise at 5016 Amberson Place and Pitcairn Place, Shadyside; and Negley Avenue and Dunmoyle Place, Squirrel Hill. A trio of fine brick and stone houses (numbers 2, 6, and 8) on seldom seen Robin Road, off Fair Oaks Street, Squirrel Hill, have wooded terraces overlooking Forbes Avenue and the Carnegie Mellon campus.

Drawing, proposed Washington Crossing
Bridge, Pittsburgh. Unsigned, circa 1919.
Obelisk would have honored historic site.

Washington Crossing Bridge today, west of Millvale, Pa.

WASHINGTON CROSSING BRIDGE

Janssen and Cocken oversaw construction of its only public work commission, the Washington Crossing Bridge, from 1919 to 1924. Built by Allegheny County, it soars over the Allegheny River from Fortieth Street, in Pittsburgh's Arsenal district on the southeast bank, to Millvale, Pa., on the northwest bank. Janssen gave his partner Cocken credit for getting the firm through the venture's politics.

This massive yet graceful three-arched span is near where George Washington, a twenty-one-year-old major in the Virginia Militia, and his guide, Christopher Gist, rafted across the river. They were returning from Fort LeBoeuf, now Waterford, Pa., near the mouth of French Creek, to the north, where the Marquis Duquesne, governor of Canada, had built a fort.

Washington carried a message from Virginia Governor Robert Dinwiddie claiming the land of the Ohio River's upper tributaries for Virginia. On December 29, 1753, the Allegheny was not frozen enough to cross on foot, so the men built a raft from which Washington was thrown into the water and rescued by Gist. After making shore, the men camped and rested before continuing their journey. Washington walked most of the way through the forests back to Williamsburg.

The steel and concrete span that Janssen and Cocken designed with engineer Charles Stratton Davis blends a series of soaring neoclassical arches, recalling Giovanni Piranesi's prison prints which Janssen loved and studied, with moderne pier heads. But neither an obelisk for a plaza at the Arsenal portal nor a national sculpture competition for the site, suggested by Homer Saint-Gaudens, Carnegie Institute's art director, was carried out.

The railings of the bridge's level superstructure are embellished by three-foot-by-two-foot metal shields embossed with seals of the American states. They were modeled by John Donnelly & Company, New York, and cast by Michaels Art Bronze Company, Covington, Ky. The bridge continues as a much-used artery.

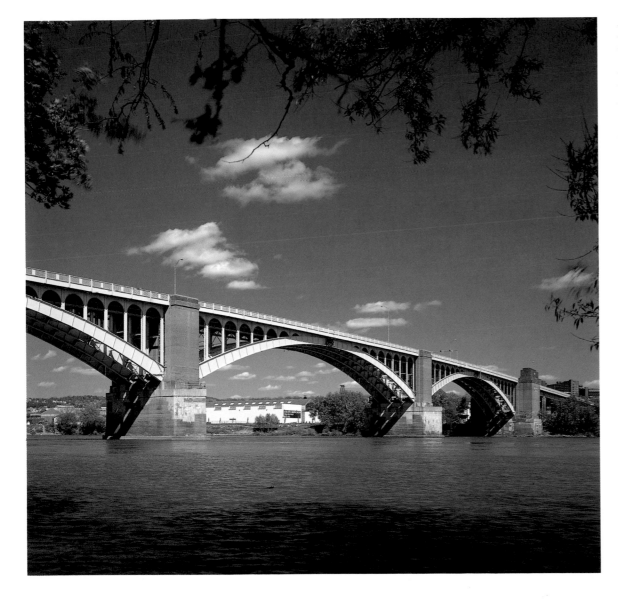

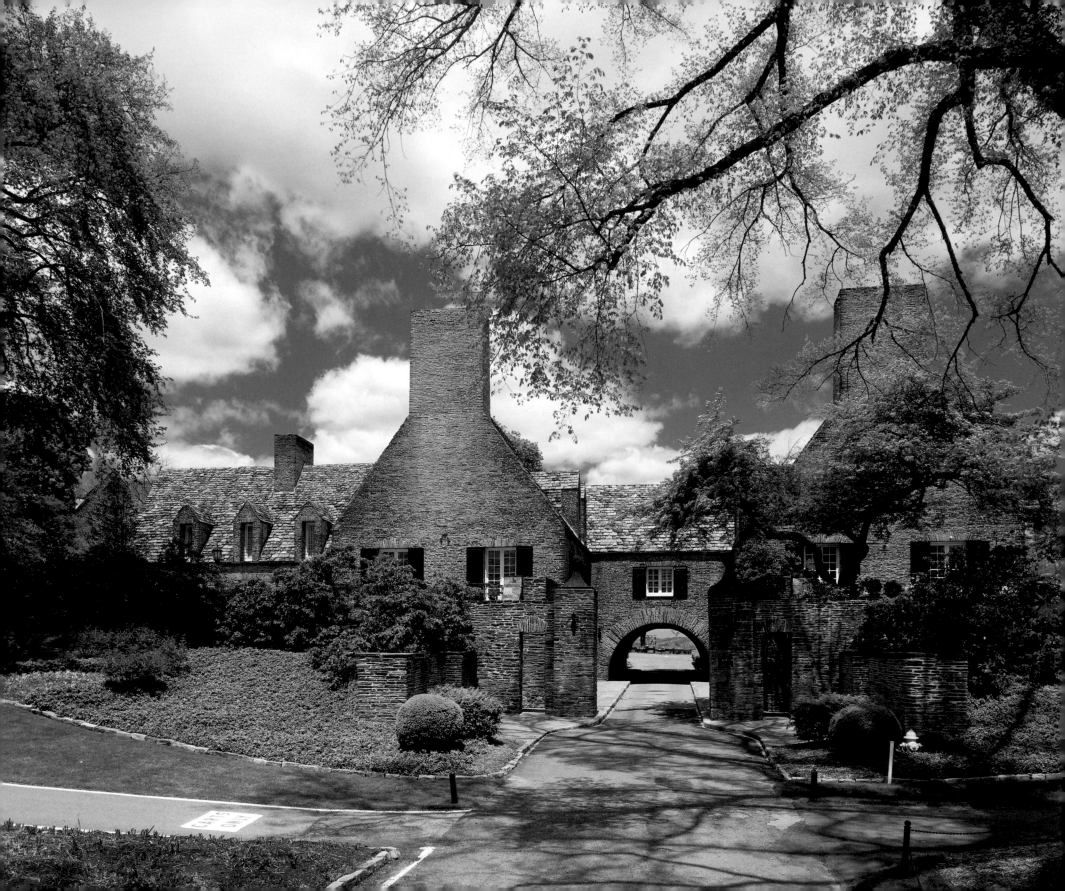

CHAPTER FIVE

THE MIDDLE YEARS
1921-1929

Entrance, Longue Vue Club,
Penn Hills, today.

JOSEPH HORNE COMPANY

Benno Janssen's 1922 north addition to the Joseph Horne department store, more recently Lazarus, now Penn Avenue Place, bounded by Penn Avenue, Stanwix Street and Fort Duquesne Boulevard, brought a large new Venetian exterior to the popular store's less distinguished older structures along Penn Avenue.

For this six-story structure that became the main part of the store, Janssen achieved an elegant block of tan brick, stone and terra cotta ornament. He capped the addition with a cornice crest of standing cream-colored metal anthemions somewhat recalling those on the Doge's Palace. They and the rest of the interior have been retained in the building's recent conversion to offices.

The former store's large first floor sales area with its many impressive columns was commodious yet simple in detail and included brown marble door and elevator surrounds. A small moderne elevator near the right front door went directly to the men's department on the third floor.

There was a pleasant tearoom at the north end of the first floor. A mezzanine over the first floor elevator doors in earlier years allowed patrons to rest in overstuffed chairs. They could also walk a single flight of back stairs to and from the main floor, since the store's escalators did not stop on the mezzanine.

LONGUE VUE CLUB

There are few more beautifully sited golf clubs than Longue Vue, built between 1921 and 1925 and located on about 345 acres 200 feet above a curve in the Allegheny River between Penn Hills and Verona, Pa. Clearly the location, a collection of open and wooded hills of the former Baggaley Farm in Penn Township and several adjacent properties, called for something special. There was also the zeal and importance of the club's wealthy and dedicated incorporators. They included Edward V. Babcock, mayor of Pittsburgh and president of Babcock Lumber Company; Ernest T. Weir, president of Weirton Steel Company; A.L. Humphrey, president of Westinghouse Air

Brake Company; J. Morrison Hansen, president of Standard Steel Car Company; and thirteen other corporative executives who enjoyed the game of golf that was sweeping the country.

They all agreed to underwrite the venture for $150,000. The entrance and road location were chosen in 1921, and Janssen and Cocken was commissioned to prepare plans for a building not to exceed $200,000. Plans were approved in 1922, and building was to proceed with a construction cost of $266,122. The exterior of the clubhouse was completed by December 1923, and the building was in use the next year although not finished until 1925. It soon became known as "the millionaires' club." (A ballroom, upper wings and a ladies' locker room were added later.)

Janssen's design, based on the English Norman vernacular and strongly influenced by Lutyens, easily manages to be both beautiful, welcoming, and unpretentious. In handsome surroundings the club, originally built with nearly 45,000 square feet of interior space, offers members and friends a workout with its rigorous eighteen-hole course, outdoor swimming pool, and skeet-shooting range. Riding and bridal trails, added later, were eliminated in 1941. Yet the cuisine and other amenities in this well-clipped environment continue for Longue Vue's 650 members.

Janssen at Longue Vue established the foundation for his beloved Cotswold style in an idyllic setting. Its elements, particularly the high-pitched roof, the first of its kind seen in the region, reappear at La Tourelle, Rolling Rock stables, the Dravo house, and Elm Court. Typically these roofs are laid with roughly cut Vermont slate of richly variegated colors from blue-gray to tan-pink. Tile thicknesses range to two inches and more, and roofs have narrow gabled dormers set above shallow eaves.

A unique method of construction with wood furring gave the roofs at Longue Vue and Elm Court their heavily textured waviness, redolent of the Old World. Internally, Longue Vue's walls were made of horizontal lath and concrete covered with plaster. Early in the construction Janssen had a whole roof gable reframed at his firm's expense because he decided it was not correct. All of the clubhouse's dormers are in the reduced single gable style Janssen preferred.

Perhaps the club's most unusual feature is its U-shaped driveway that allows visitors to stop automobiles briefly under two low-arched masonry bridges that act as porte-cocheres on entering or leaving. A few steps from them and one is either in or out of the building. The structure's main wings are arranged like an expanded "H" intersected by the horseshoe drive. This unusual design is immediately welcoming but not without logistical problems. Delivery trucks too tall for the arches must back up to a hidden gated service court on the left.

Most visually striking is the clubhouse's extraordinary exterior stonework. The building is faced with thin gray-tan sandstone slabs laid in uniformly horizontal ledges, or layers, between thick continuous beds of white mortar. The stones above windows are set in fan-shaped voussoirs and are virtually the structure's only ornament.

This naturally and perfectly laminated stone was exactly what Janssen was seeking and came from a quarry contractor Dominic Navarro owned a mile and a half away. But Edward A. Wehr, the club's contractor, was less fortunate than Janssen, since laying the stone was expensive and time-consuming. According to club records, he lost a considerable amount of money on the contract. But members, "contributing generously, gave him a substantial check to somewhat offset the loss."

The clubhouse's interior is a collection of large and small meeting and dining rooms. Most prominent is the liv-

One of two bays, each with french doors and transoms, on either side of living room fireplace, Longue Vue Club.

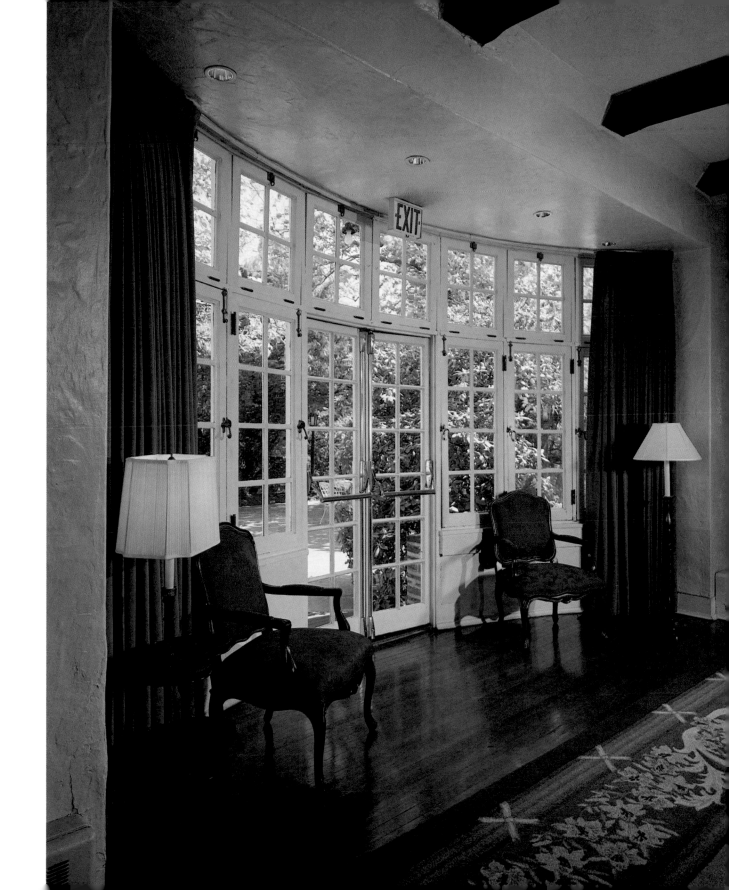

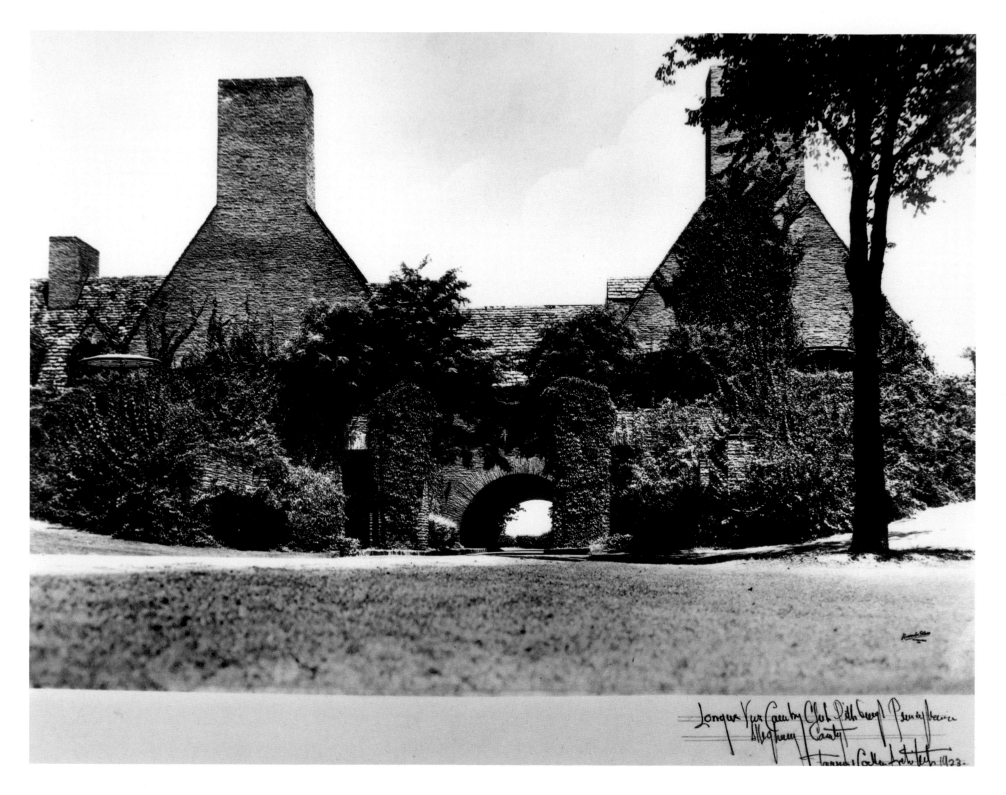

Longue Vue Country Club Pittsburgh Pennsylvania Allegheny County
Benno & Cooke Architects 1923.

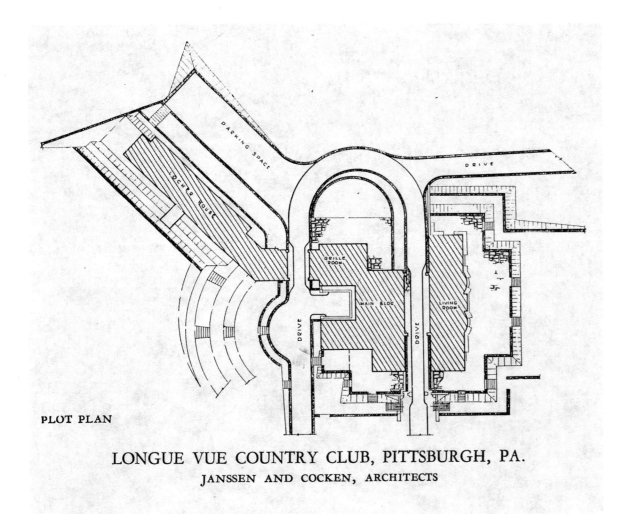

PLOT PLAN

LONGUE VUE COUNTRY CLUB, PITTSBURGH, PA.
JANSSEN AND COCKEN, ARCHITECTS

ing room, sixty-two-and-a-half feet long by twenty-eight-and-a-half feet wide, that originally doubled as the ballroom. Fourteen hewn beams, romantically irregular and darkly fumed, march across the wedge-coved ceiling. The massive and simply carved floor-to-ceiling limestone fireplace is of the type Janssen favored at La Tourelle and 1300 Inverness Avenue, Squirrel Hill (since removed). The hearth contains two freely done six-foot-tall decorative andirons by Samuel Yellin with writhing leaves welded to the shafts, and trumpet-shaped chalices hold large polished brass balls as accents.

The living room is also distinguished by two gracious and beautifully designed fifteen-foot-long convex window bays. Each is set from floor to ceiling with a pair of french doors between six paned casements and beneath eight transom windows, all designed with brass latches meant to be opened in the days before air-conditioning. These lead to the stone-paved Pink Terrace — named for the color of its furniture — one of four terraces with valley views.

The cozy grill room, thirty-three by twenty-five feet, contains some oak paneling and another, smaller Janssenian fireplace surmounted by a large crest. Its hearth exhibits two more large Yellin andirons, this time shaped like Medieval torch-holders. An original dining room contains another fireplace carved on its limestone sides with a linenfold pattern. A large kitchen is notable for a central gabled skylight; and original ventilation here has obviated the need for air-conditioning.

The men's locker room holds 446 green metal lockers with bottom compartments that may have hidden liquor during Prohibition. The exposed white-painted I-beams supporting the roof create a rugged masculine mood. They recall the more extensive trusswork of the horsemen's dormitory under the roof of the Rolling Rock clubhouse, also begun in 1921.

Longue Vue's landscaping was designed by Ralph E. Griswold, legendary Pittsburgh landscape architect. The clubhouse won the Pittsbugh Chamber of Commerce's architecture award for the best institutional building completed between 1925 and 1930, and it is on the National Register of Historic Places.

Longue Vue's Pink Terrace, signed by
Janssen and dated 1923.

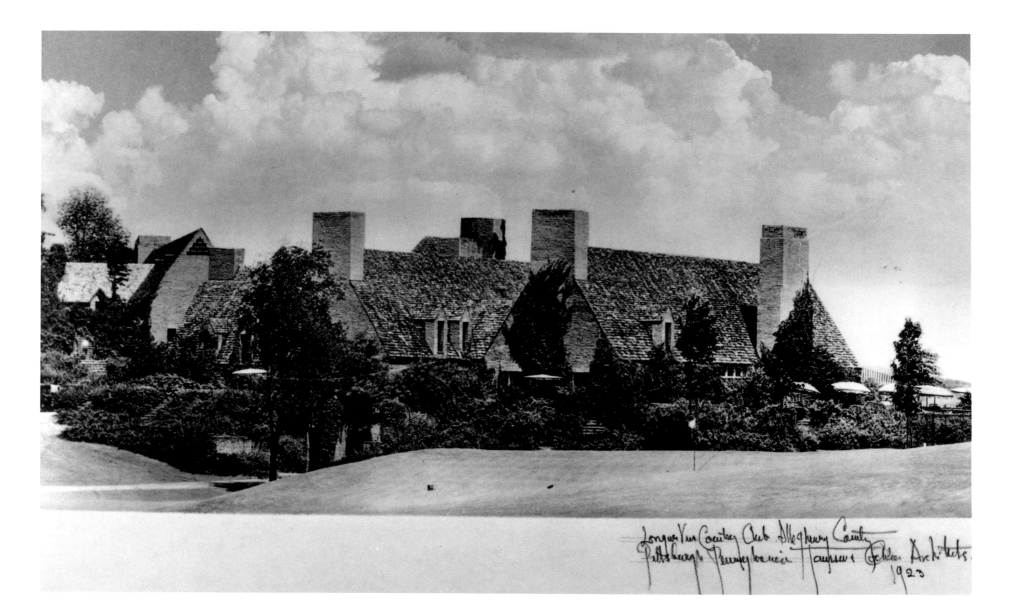

La Tourelle entrance.

LA TOURELLE

Located a few miles north of the Allegheny River, the eighteen-room manor is named for its romantic little tower, an exaggerated conical roof covering a small circular vestibule, empty except for a stone bench concealing a heating ventilator. The turret, recalling real and fanciful French castles, fascinated Janssen with its proportions and the romantic suggestion that extraordinary events might occur there. They did, mostly in the form of the many world figures who visited as the Kaufmanns' guests.

Edgar Kaufmann Jr. wrote in his "Fallingwater: The Story of an American Country House," that the Kaufmanns lived in two rented Janssen houses. He didn't identify them but they were the J. Walton Cook house, 5423 Darlington Road, and the house Janssen and his first wife Edna bought at 5625 Darlington Road, Squirrel Hill.

Kaufmann wrote: "In 1924, [Janssen] built a suburban home for us; it echoed old country houses in Normandy. One evening at that home while my parents were upstairs, Frank Lloyd Wright and I were in the living room having cocktails. Wright looked around at the fumed oak beams, the Samuel Yellin ironwork everywhere, the French & Company furniture. 'Edgar,' he said smiling, 'Something is wrong.' But he didn't say it to his clients."

What was "wrong" was that the house, built at a cost of more than $250,000, was neither designed by Wright nor furnished according to his organic principles. One would like to think Janssen, even though he had little interest in avant-garde architecture, would have been more generous toward Wright. Or Janssen would have said nothing. He of course knew Wright's work, at the least from Wrightian photographs and drawings in Pittsburgh Architectural Club exhibitions.

In 1923, Kaufmann asked Janssen to design a country house on an eight-acre wooded knoll in Fox Chapel. An early sketch indicates Janssen knew what he wanted: an intimate two-story Norman manor with steeply pitched roofs, and massive unadorned chimneys.

Everything was arranged in two, later three, structural blocks: main

Janssen drawing of sunken rear garden
for proposed John Hartwell Hillman
house, 4045 Fifth Avenue, circa 1921,
unsigned. Note Palladian portico in
Cotswoldian design.
Size: 19.5 x 34 inches.

For Hillman house, Janssen drew more
typical facade, unsigned, 1921.
Size: 20 x 33.5 inches.

Janssen drawing, rear garden, La Tourelle,
circa 1924. There would be no balustrade, but
reflecting pool, lower left, stayed in different
treatment and chimneys became more massive.
Tourelle entrance, extreme right.
Size: 18 x 27.5 inches.

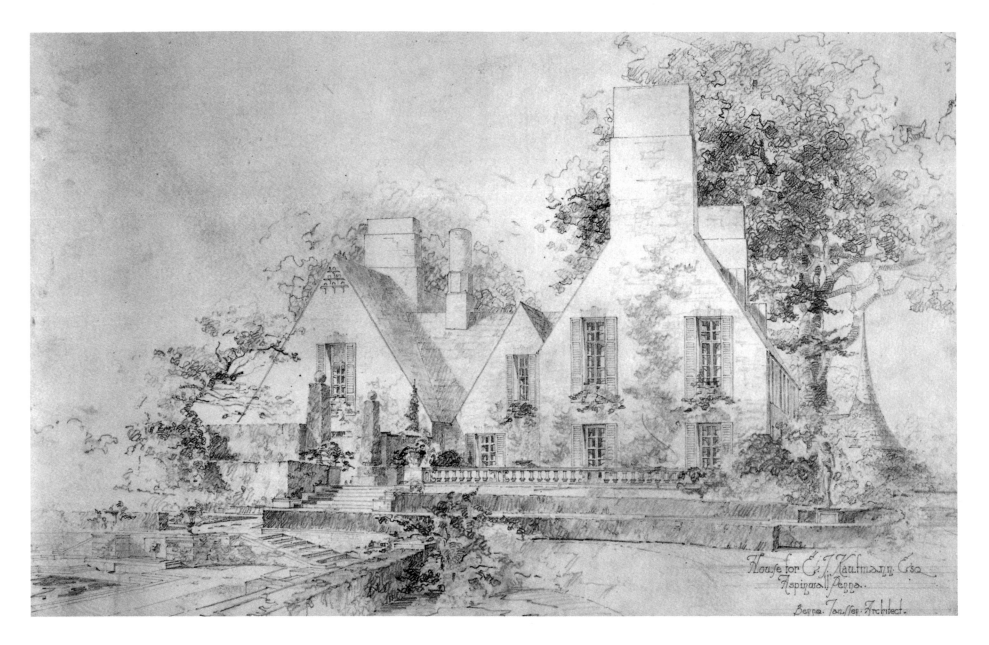

Evolution of Janssen's turreted designs in pen and wash drawings:

Above:
"Sketch for House in New
Brunswick, N.J." 1923, initialed B.J.

Right:
Imaginary "Country House and
Stables near Pittsburgh," dated 1923,
initialed B.J.

Above:
"Country House for
Mr. and Mrs. Edgar J. Kaufmann,
Pittsburgh, Pa., Benno Janssen,
architect, 1924."

Facing page:
La Tourelle in photograph signed by
Janssen, dated 1923,
but taken later.

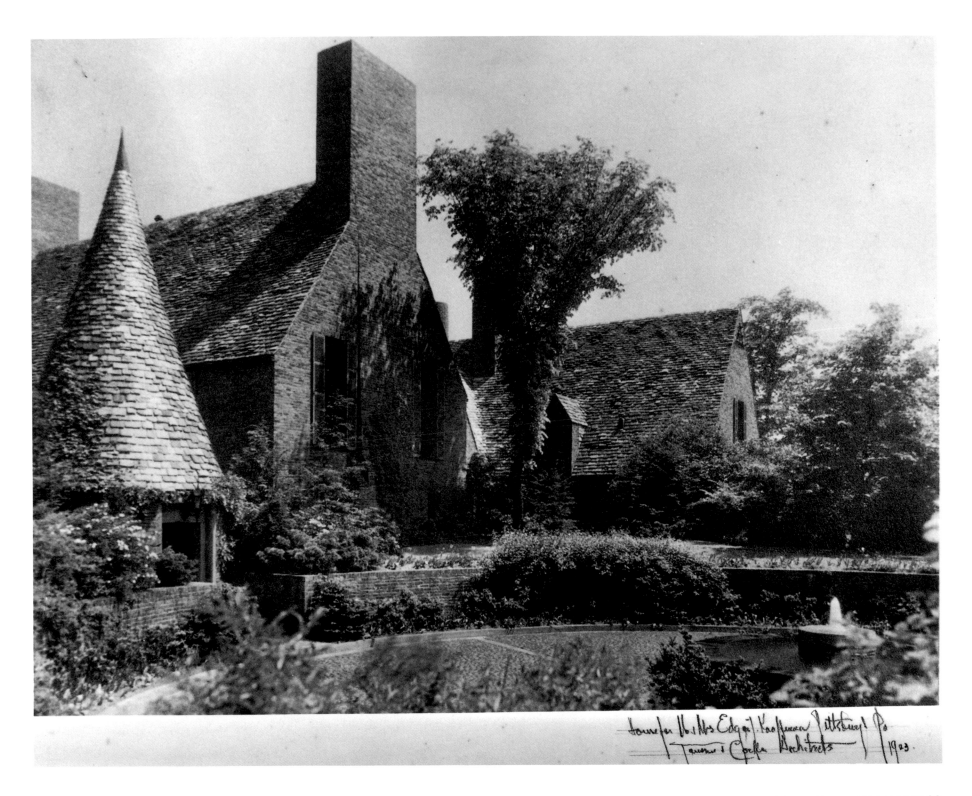

House for Mr. & Mrs. Edgar J. Kaufmann, Pittsburgh, Pa.
Janssen & Cocken Architects / 1923.

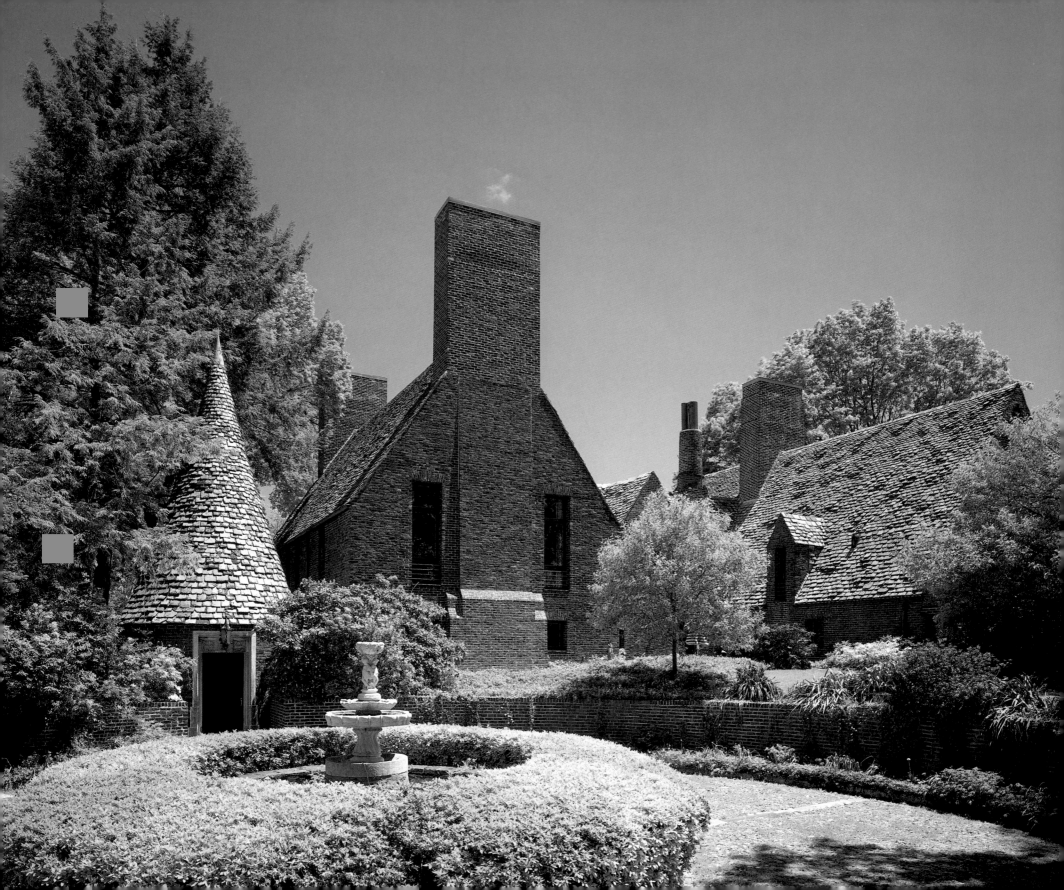

Facing page:
La Tourelle, Fox Chapel, Pa., today.
Janssen and Cocken.

Plot plan for La Tourelle before inclusion
of garage, *Architectural Record*,
July 1930.

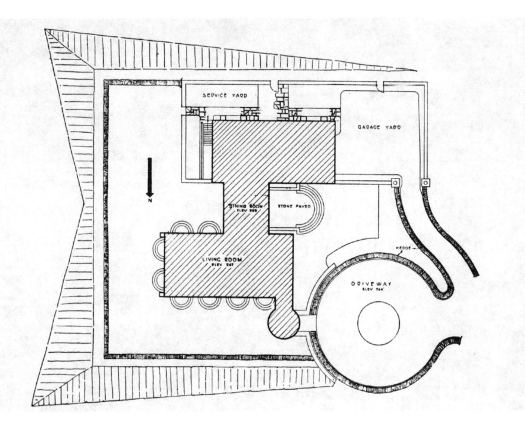

Aerial view of La Tourelle, with garage,
at left. *The Architect*, August 1928.

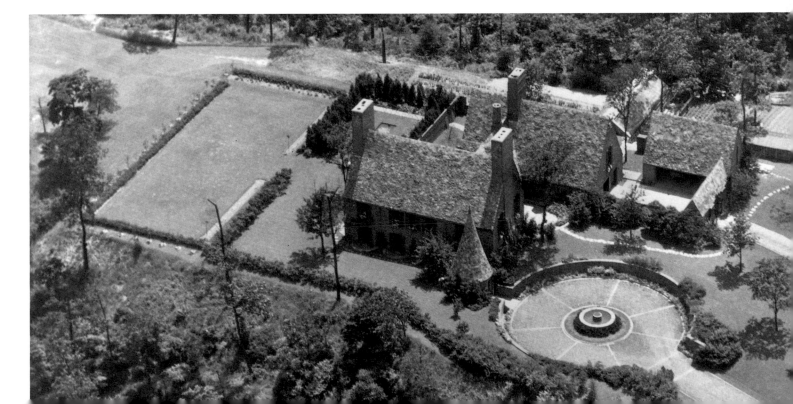

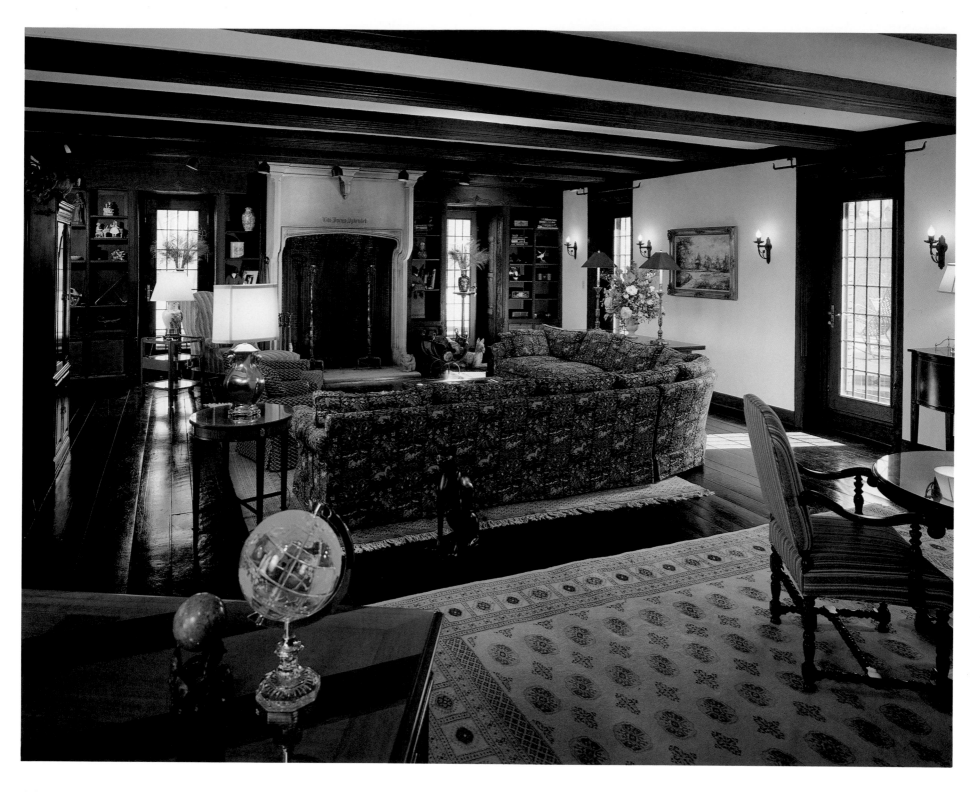

Living room, La Tourelle, today.

house, guest and servant wing, and semi-detached four-stall garage with second floor chauffeur's apartment that would become a painting studio for Edgar Jr.

Janssen designed a circular forecourt with round river stones and low walls partly enclosing a central wellhead. A tourelle was set off-center to the left, allowing one to enjoy the whole facade while approaching the elaborately iron-hinged and studded front door equipped with a large viewing hole.

The limestone door surround is decorated on both sides at the top with the picturesqely phrased carved dates, "nineteen & twenty-four/nineteen twenty & five," that is, 1924/1925, in Gothic letters. A Vermont slate roof joins the exterior of handmade English bond red brick and white mortar.

Inside the circular tourelle is a low carved slate bench with iron grilles concealing a radiator on the slate floor. The conical ceiling rises to a distant point overhead. Up a few steps to the right is the main hallway, also paved in slate. To the left nearby is the large sunken living room accented by walnut-stained Dutch red oak linenfold paneling. Seven rough-hewn beams cross the low forty-by-thirty-foot ceiling. In a front wall are dark-stained red oak book shelves. A dry bar occupies a corner near the raised dining room at right.

The living room derives natural light from eight pairs of narrow french doors, with four more pairs in the moderately sized dining room. Pegged oak floor planks lead to the tall fireplace, a form the architect would use in the Hays house, 1300 Inverness Ave., Squirrel Hill, and elsewhere. The walls are finished in rough plaster. This block of the house contains a breakfast room, kitchen, and butler's pantry.

At the other end of the front hall in a corner near a small powder room is one of La Tourelle's most unusual features, an equestrian sink with a large solid slate basin, single brass spigot and brass wheel handle on the wall at right. On the left is a hinged wooden shelf that can be raised to hold boots for cleaning and wiping, or buckets of water for the steeds. In the 1920s, the Kaufmanns were avid riders and entered their horses in important races.

A wrought-iron staircase leads to the second floor. The east-facing master bedroom is designed with a barrel-vaulted ceiling, two windows, two niches, an ogival archway, and three similar doors linked to a sitting room. The bathroom sink is of carved travertine with massive brass fittings. A built-in mirrored medicine chest is placed in a double ogival arch while white marble benches have radiators beneath them. The walk-in shower still has its very large brass cascade sprayhead and fixtures.

The west bedroom, once Mr. Kaufmann's, is small but has a fireplace and coved ceiling. There is a small adjoining sitting room, also facing west. Both rooms look down on the forecourt. The back of the house offers a formally stepped lawn and garden as well as a rectangular reflecting pool, and there was once a greenhouse on the hillside below the main buildings. A stone patio in the rear has a counterpart in a curving outdoor retreat in front, between the main house and guest wing.

Before the living room's oak floor was laid, Samuel Yellin ran a flue up the living room chimney and forged all of the house's hardware, costing $36,000, on the spot.

Detail, Dutch oak linenfold doors, living room, La Tourelle.

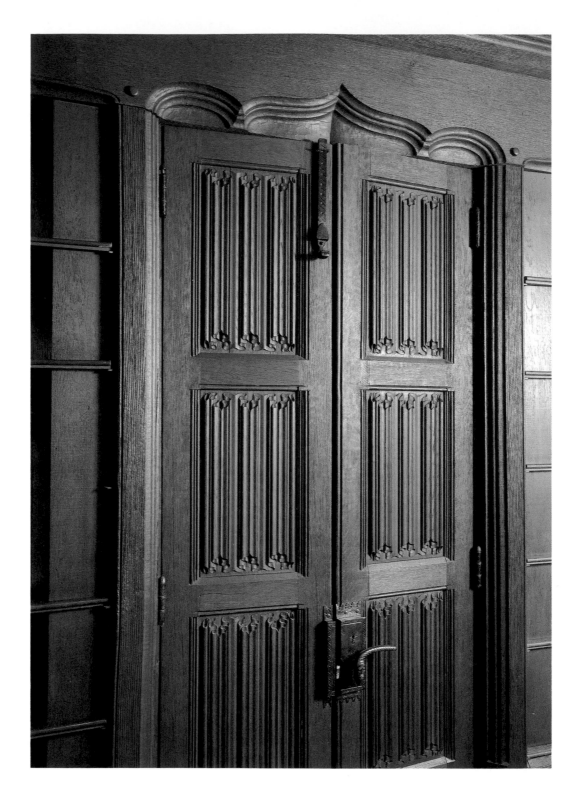

Equestrian sink, fold-down shelf, first floor, La Tourelle.

Below:
Original shower fixtures, La Tourelle.

Yellin railing, La Tourelle.

Yellin also made Edgar J. Kaufmann an unusual iron bedstead like ones he had done for himself and a few clients who asked for them, his granddaughter Clare Yellin recalls. The headboard, consisting of seven spindles, had figures from mythology and the New Testament surmounting the crest rail and end posts.

Each figure, from Christ on the cross ("INRI") to three-headed Cerberus, canine guardian of Hades, had its name engraved in the rail. Edgar and Liliane Kaufmann were Jewish, first cousins, and Liliane had an interest in Roman Catholicism. Yellin was Jewish, too, but, as an eclectic artist, was interested in many cultures, evident from the body of his work. The bedstead was a cultural, rather than a religious, object.

The Kaufmanns lived at La Tourelle fifteen years before moving to a large suite in another Janssen building, the William Penn Hotel addition. The S. Eugene Bramers bought La Tourelle from Kaufmann and lived there from 1940 to 1950. Bramer was president of the Copperweld Company, Pittsburgh. Kaufmann urged that when the Bramers sold the house Yellin's work should go to a museum but this was not done.

The late Milton Porter, a friend, recalled that Betsy Bramer retained the bedstead after moving out. It was damaged in a fire and its fate is unknown. The house has been sold many times since and at one period was owned by the University of Pittsburgh. At that time the driveway that also served the house next door was redesigned. The fairy-tale dwelling is now reached by a twisting lane.

Detail, Samuel Yellin's iron bed, n.d.;
copy made for Edgar J. Kaufmann, lost.

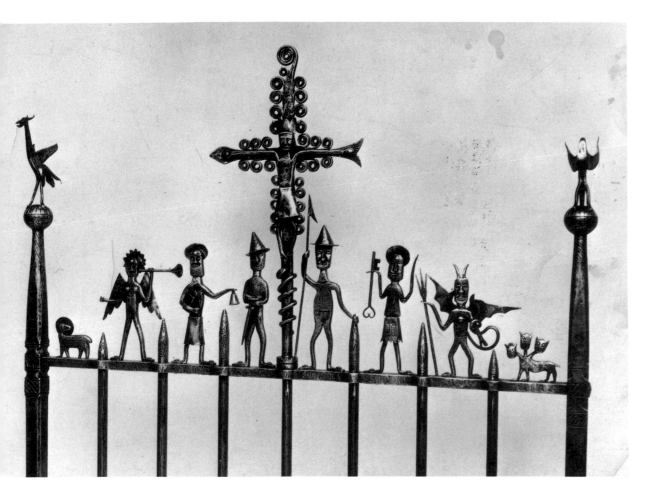

Over the years, tourelles sprang like mushrooms from Janssen's many tracings of house drawings that he sent as gifts to friends and clients. He was not alone; many architects of the period loved such touches. Lindeberg used tourelles for secondary doorways but not as a main entrance. Mellor Meigs and Howe in the early 1920s used turrets in many structures: houses, barns, even in a drawing for a pool house. Janssen's largest tourelle is the Rolling Rock stables' former trophy room.

A test of any architect is his influence on others. This is difficult to define with Janssen, since the style for grand period houses changed with the Depression. However, William Simboli, of Roller & Simboli, Alliance, Ohio, did a series of three conceptual sketches in 1930-31. As Christopher Monkhouse, former curator of architecture at the Heinz Architectural Center, Carnegie Museum of Art, related in a 1995 letter to the author, the Simboli sketches resembled La Tourelle. The Simboli house was for Mr. and Mrs. Robert Purcell, Fairway Hills, Alliance, and blueprints were signed July 25, 1930.

Drawing, Penn-Lincoln Hotel, Wilkinsburg, Pa., Janssen and Cocken, n.d. *Facing page:* Drawing, Hotel Penn-McKee, McKeesport, Pa., Janssen and Cocken, n.d.

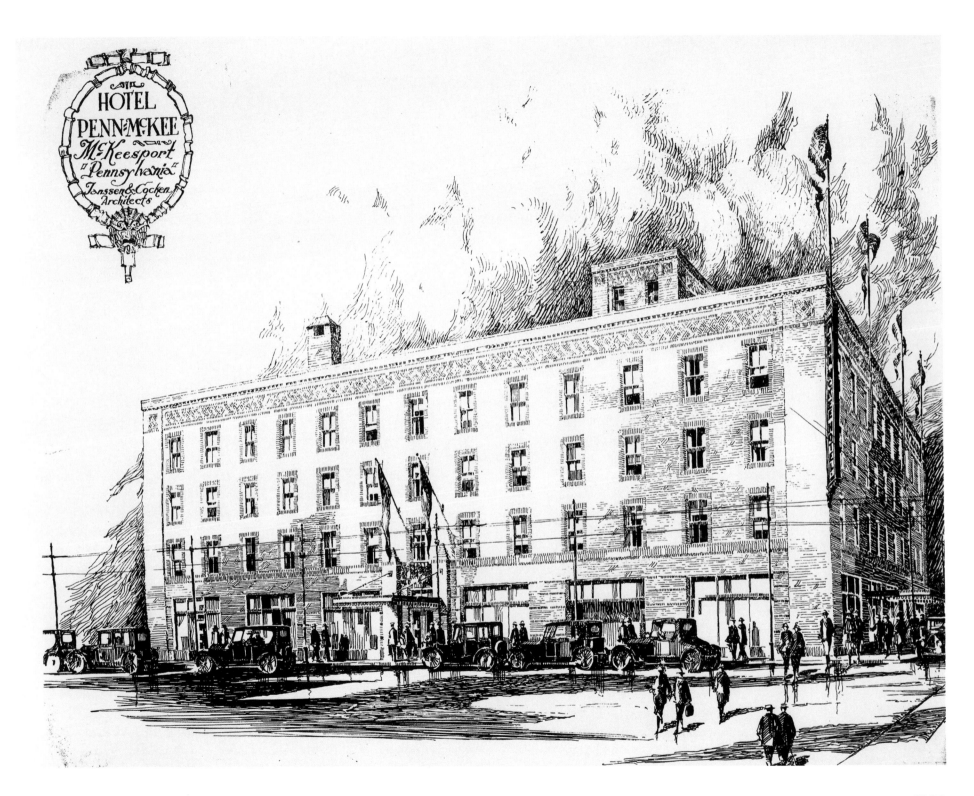

HOTEL
PENN·McKEE
McKeesport
"Pennsylvania"
Janssen & Cocken
Architects

STOUFFER'S RESTAURANTS, KEYSTONE ATHLETIC CLUB

Janssen and Cocken, in 1927, created three attractive Downtown restaurants for Stouffer's Incorporated: on Smithfield Street near Sixth Avenue, Wood Street and Forbes Avenue, and Penn Avenue near Horne's. The Penn Avenue Stouffer's, most elaborate of the three, was done in a pleasantly modern American Colonial style.

Its best space was the two-story barrel-vaulted Viking Room (it may have reminded Janssen of the Norse Room), although there was nothing Nordic about the pale cerulean walls, leather seats and banquettes or blond wood trim. A blueprint survives in the Carnegie Mellon University Architecture Archives. The Viking Room was lost in a general redesign in the late 1950s or early '60s. But the building's facade, a soft red brick laid in Flemish bond, is still visible. The totally altered interior now contains county welfare offices.

The Keystone Athletic Club, Wood Street and Third Avenue, was a promising project of 1926-28 that was doomed by the Depression and the premise it could compete with the Duquesne Club. The tower's red brick and terra cotta exterior is decorated with Mediterranean-style flourishes, including ogival arches, varicolored accents, spiral corner pilasters, heraldic crests and more, all within a restrained moderne ambiance of stepped-back ribbed walls and parapets.

The large lobby with elevator bank led to a fine dining room and a wide and handsome stairway rising to a ballroom on the second floor. There were of course a swimming pool, gymnasium, and ballcourts as well as floors of guest rooms, much like Janssen and Cocken's 1923 YMCA across Third Avenue, although on a more lavish scale. The building later became the Sherwyn Hotel and is now the David L. Lawrence Hall dormitory of Point Park College. The tower has a later addition at the Boulevard of the Allies corner (there was apparently a holdout landowner on that site). The current entrance is through a bridge from the main college building across Wood Street.

ROLLING ROCK CLUB STABLES, KENNELS

In 1921, a barn or stable stood on the site of what would become in 1928 The Rolling Rock Club's Norman-style stables and kennels. R.B. Mellon founded the club in 1916, and the clubhouse was designed by his nephew, architect Edward P. Mellon, of New York, who receives credit for it. But A. Patton Janssen remembers that his father was retained to design the stables as well as the clubhouse's English-style oak-paneled living room; a large dining room; the rustic Log Room — a tap room resembling a Pennsylvania cabin with large fireplace — and R.B. Mellon's imported English Arts and Crafts suite on the clubhouse's second floor.

E.P. Mellon designed the rustic seventy-five-foot-tall fieldstone-clad water tower at the back of the clubhouse and was co-architect or consultant on Mellon Bank's principal office, the Gulf Building, a handsome Renaissance-style

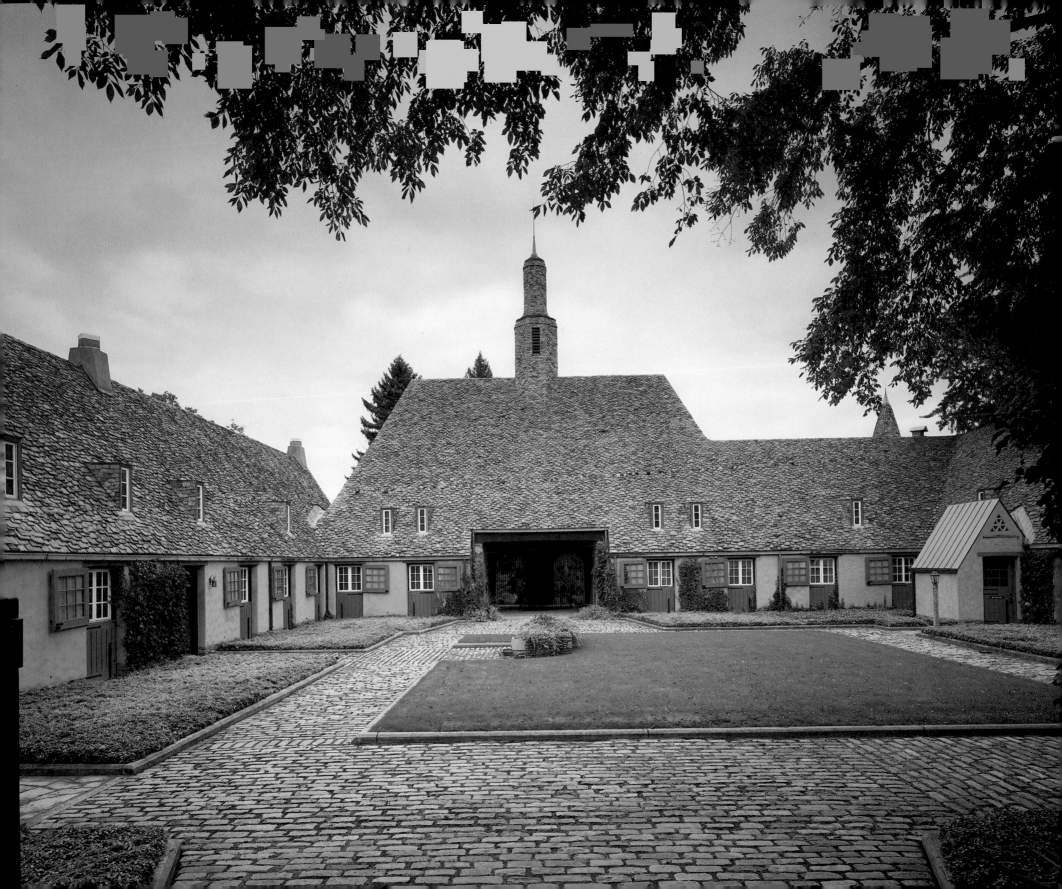

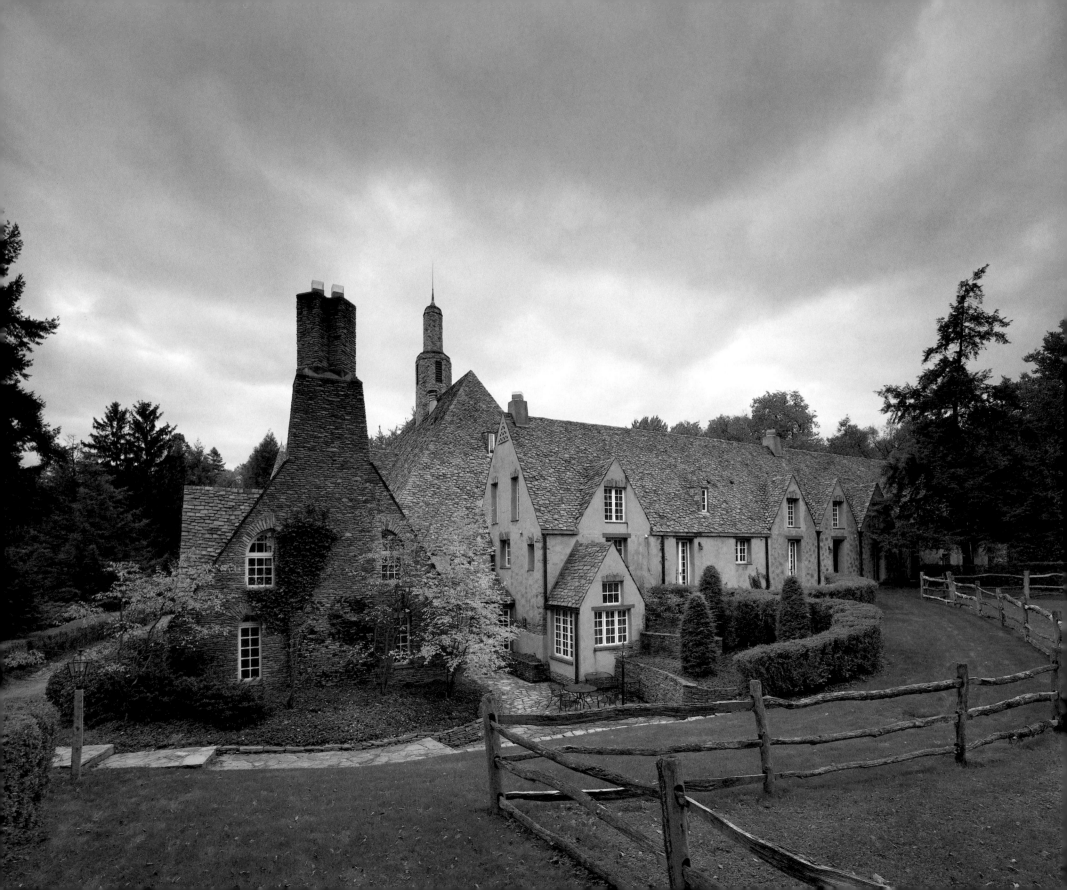

Rear view of Rolling Rock stables
condominiums today.

Below:
Stables from the rear, circa 1930.

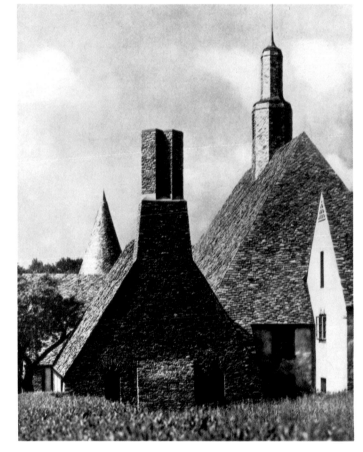

Mellon Bank branch in Oakland, the Park Mansions Apartments, and other projects.

But R.B. Mellon asked Janssen to design the stables of twenty-eight stalls for his and others' hunting horses. This large structure of fieldstone and stucco is dominated by an enormous deeply pitched asymmetric slate roof. A tall cupola originally ventilated the second story hay loft, and wings enclosed a central exercise yard for the horses.

The stables also held a tack room, veterinarian's area, grooms' quarters, food storage, equipment rooms, and the trophy room to display the Mellons' racing prizes. As part of a framed photograph that Janssen gave to R.B. Mellon on December 12, 1950, is this unattributed printed statement:

"The value of this tall cone shape to the general composition is obvious. Here is an opportunity to realize the play which is given to the wall and roof surfaces through the expert manipulation of stone and slate. The ceiling of the trophy room goes up into the conical roof."

The room was paneled in oak. Deer feet held riding crops on the ogival door leading down a staircase of about eight feet to the trophies.

The stables' wide main entrance near the clubhouse gate is flanked by twin pillars topped with limestone owls similar in style to one in the crest of Elm Court's facade.

This massive building was the most magnificent stable in Western Pennsylvania. Its steeply pitched roof, as well as that of Elm Court, Butler, Pa.,

may perhaps be traced to the sixteenth century Manoir d'Ango, near Dieppe, Normandy, that, according to Margaret Henderson Floyd, Boston architectural historian, was well known to many American architects who traveled in the nineteenth- and early twentieth centuries between Paris and London. McKim, Mead and White used it as the model for The Casino, 1879-81, in Newport, R.I.

R.B. Mellon's son, Gen. Richard King Mellon, and other family members kept horses at the stables until the General's death in 1970. With working stables no longer needed, the Mellon Family Trust, after considerable study, commissioned the Pittsburgh architectural firm of MacLachlan Cornelius and Filoni in 1984 to convert the building into ten unusual condominium apartments. Designed for weekend retreats from the city, they average 2,400 square feet per unit. The largest apartment on the first floor contains three bedrooms and three and a half baths.

The Trust's intent was to preserve as much of the original architecture as possible. This has been done successfully. Stall doors and grilles that once were structural elements are now interior vestibule doors, and the grilles are used as motifs throughout. The geometry of the hay loft beams has been maintained, augmented by loft platforms and sleeping areas.

The cupola tower now naturally lights a cathedral ceiling, and the former trophy room is a circular living room. A new bay was added to the original narrow

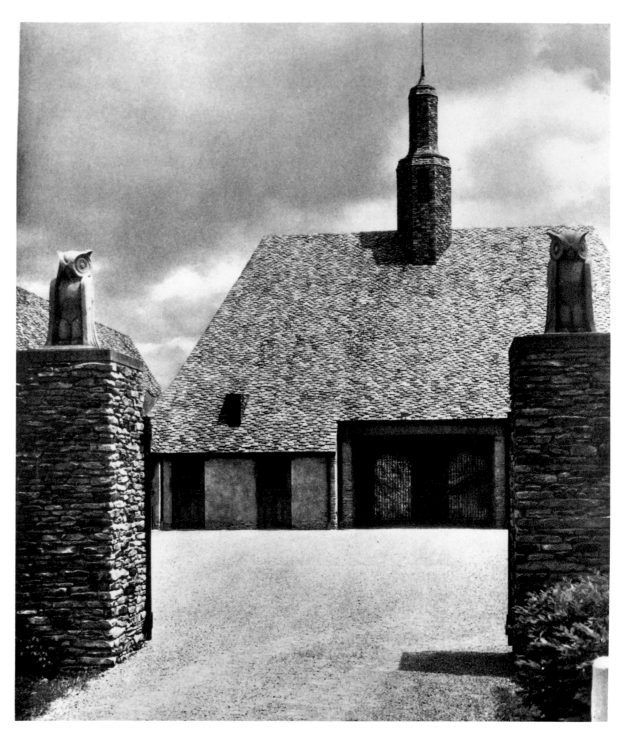

clear vertical windows set with small stained-glass hounds and fox. The Mellon family endowed the Rolling Rock Club, which is now independent with a 21-member board of governors.

Janssen and Cocken also produced a charming Norman-style kennels at Rolling Rock. Built some distance from the stables and like it made of stone and stucco but with the addition of battered walls, the kennels resemble a picturesque cottage with turret entrance. Besides fenced runs it had a kitchen for the imported English foxhounds. The structure has been converted into the Mellon family's private museum of hunt and racing trophies once in the tower room. It also contains carriages, albums, photographs, and other family memorabilia.

Rolling Rock stables before conversion to
condominiums, Ligonier, Pa., 1984.
Janssen and Cocken.

Below:
Rolling Rock stables' rustic stonework, 1984.

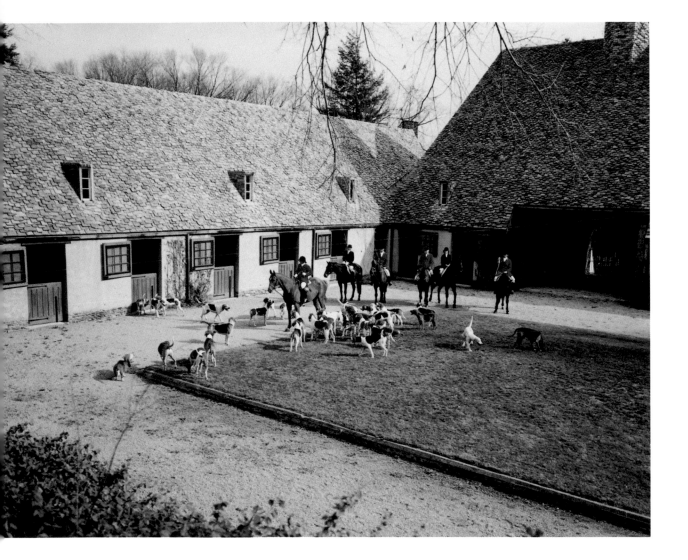

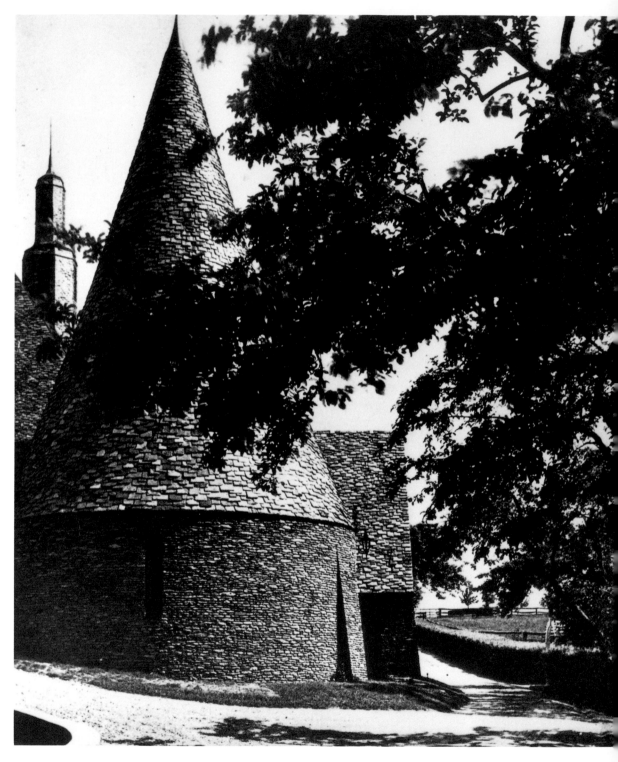

Facing page:

Top left: Doorway to trophy room. Deer feet on door held riding crops, 1984.
Bottom left: Trophy room interior, 1984.
Near left: Exterior, Rolling Rock stables trophy room, circa 1930.

Below:
Drawing, "Kennels for Rolling Rock Farms,"
Janssen and Cocken, unsigned, n.d.

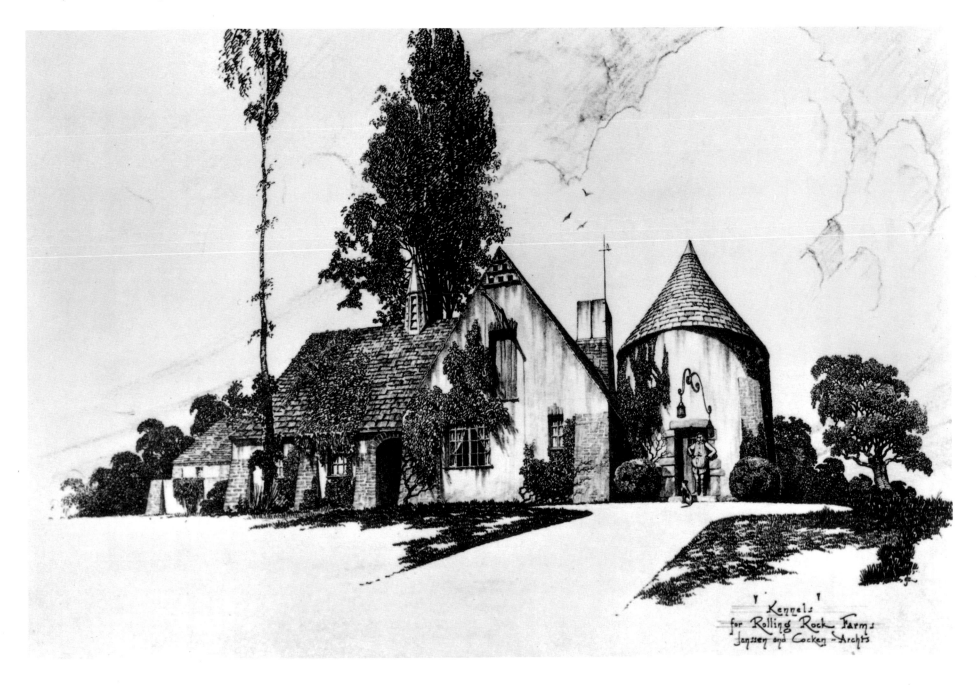

Kennels
for Rolling Rock Farms
Janssen and Cocken - Archts

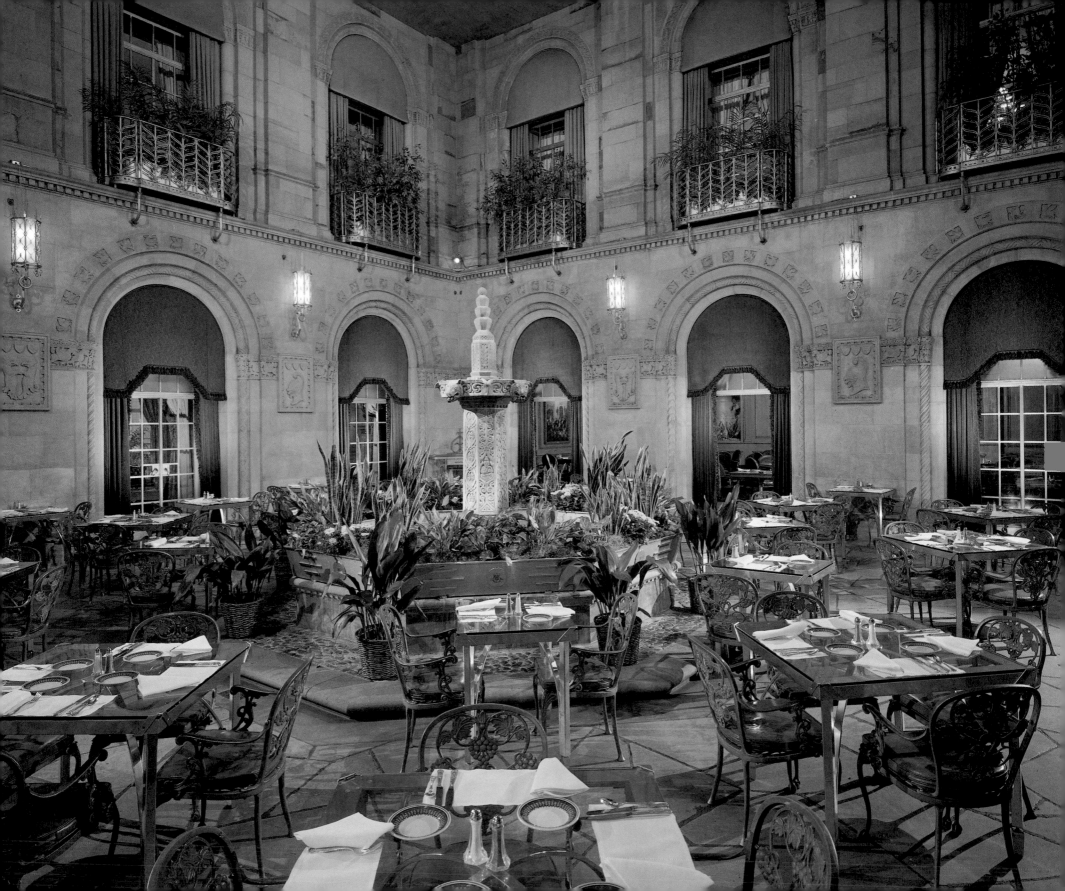

Facing page:
Garden patio, Duquesne Club, Janssen and Cocken, today.

Right:
Detail, garden patio, Duquesne Club.

DUQUESNE CLUB ADDITION

Long before so-called invisible, or fill-in, architecture was so designated in the 1970s, Janssen and Cocken designed a seldom seen twelve-story wing to the Duquesne Club, then and now Pittsburgh's most important meeting place for businessmen. As early as 1917, however, Janssen had provided plans for remodeling the club's kitchen. The firm's red-brick wing of 1929-1932 has a simple fortress-like exterior with moderne ribbing.

It was placed at the rear of the club's joined buildings of 1890/1904 (Longfellow, Alden & Harlow were the original designers). The Janssen and Cocken tower has a U-shaped plan that offered an open light well with a garden patio on the first floor. (Outside, a tall brick wall enclosed an actual garden.) The garden patio's walls were faced in limestone for several stories. Beautifully carved Romanesque and Celtic patterns combined with a moderne mood enriched arches and windows looking into the patio that features a stone fountain.

The patio was later roofed for year-round use, and the upward view that allowed the viewer to see how the decreasing stone joined with the brick was lost. With its aluminum glass-topped tables and chairs (Kensington Ware), the garden patio quickly became, and still is, one of the club's most enjoyed spaces. The walled garden was asphalted, and instead of a garage, as once planned, the club much later solved its parking needs by placing a bridge from its sixth floor over Strawberry Way to the former Gimbels garage.

As "The History of the Duquesne Club" (1989) by

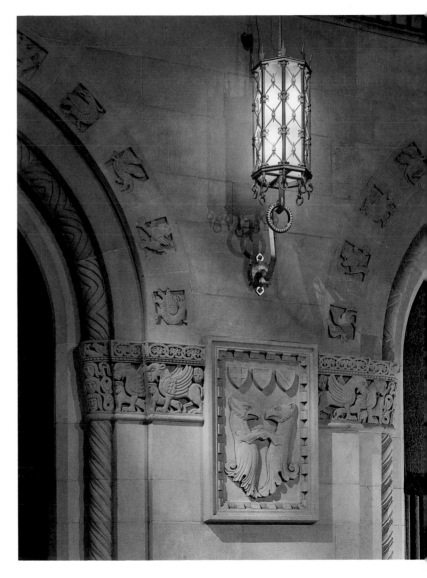

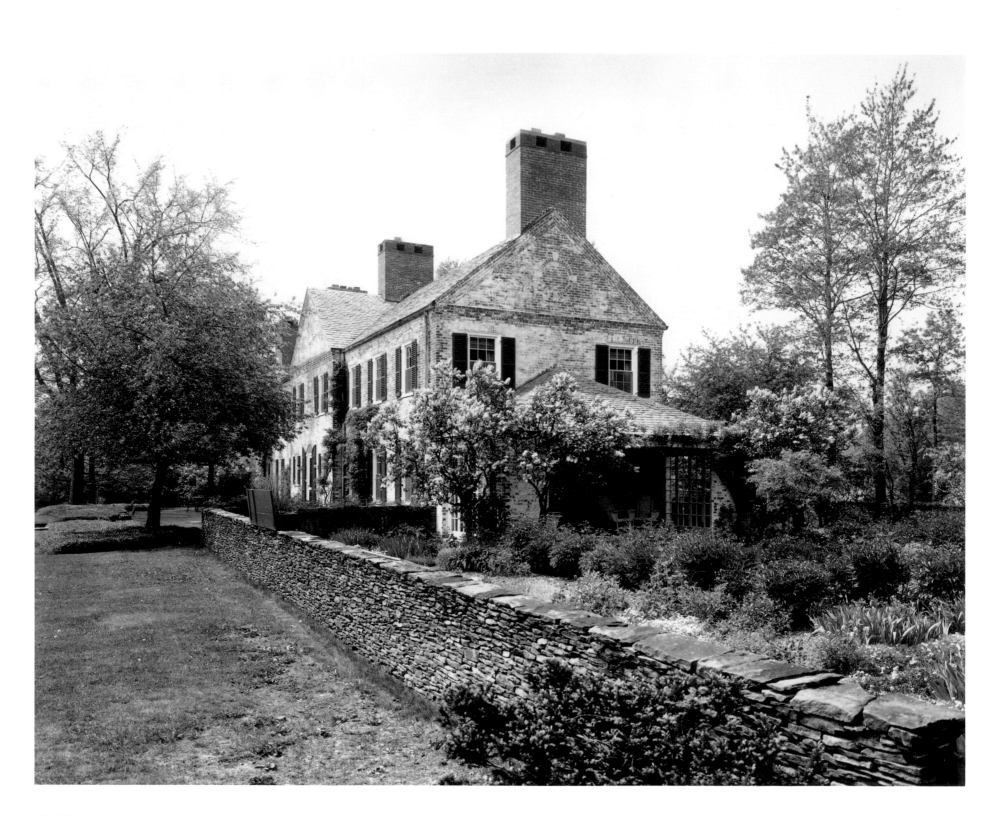

William Watson Smith house, Laughlintown, Pa., Janssen and Cocken, circa 1931. Massive chimneys appear in Colonial painted brick house.

Pittsburgh art and architecture historians Mark M. Brown, Lu Donnelly, and David G. Wilkins states, the tower is a fairly typical skyscraper of the period joined to the Alden & Harlow building.

"The addition rises to the twelfth floor, where it steps back to form a tower and elevator shaft. Because it is so far from Sixth Avenue [the club's facade] the addition itself is invisible from the street. In a city of skyscrapers, this gives the club the illusion of small-scale intimacy, of tradition and stability."

But the tower can be seen easily from the side and rear at Strawberry Way and Liberty Avenue in the vicinity of the Benedum Center Rehearsal Hall. The addition bears a resemblance to the more elaborate exterior of the Keystone Athletic Club seven blocks away. Completed in late December 1931, the Duquesne Club annex greatly increased facilities and, the historians noted, "With the exception of the conversion of many bedrooms to member suites, the basic layout and usage of the addition have changed little. The Founders', Adams, Pine, Georgian, and Walnut Rooms still serve their original functions."

There were other changes. A new laundry was installed in the basement. After Prohibition's repeal, the new first floor oyster bar became today's grille. New and larger kitchens were constructed on the third floor; an extensive health club and barber shop joined the fifth floor; the sixth contained employee lockers. Floors seven through eleven held sixty-five bedrooms. The twelfth floor never became a penthouse as intended but instead was used for storage. The architects' fees were $137,438. With the addition's completion, the club was largely redecorated to strengthen the connection between the new and old buildings.

A new club seal, designed by William York Cocken, was adopted in May 1931. It displays the plan of Fort Duquesne, three stars for the city's rivers, thirteen more for the original colonies, and two cannons. But instead of the Marquis Duquesne's arms, a rampant black lion with red tongue and paws on a white field, Cocken chose that of a different family branch, containing a tree; it became the official seal. Like the Keystone Athletic Club, the Duquesne Club was hit hard by the Depression. But unlike its rival it was able to withstand its problems by having a banker who was a member, and then leasing rooms to members' large companies, a still current practice.

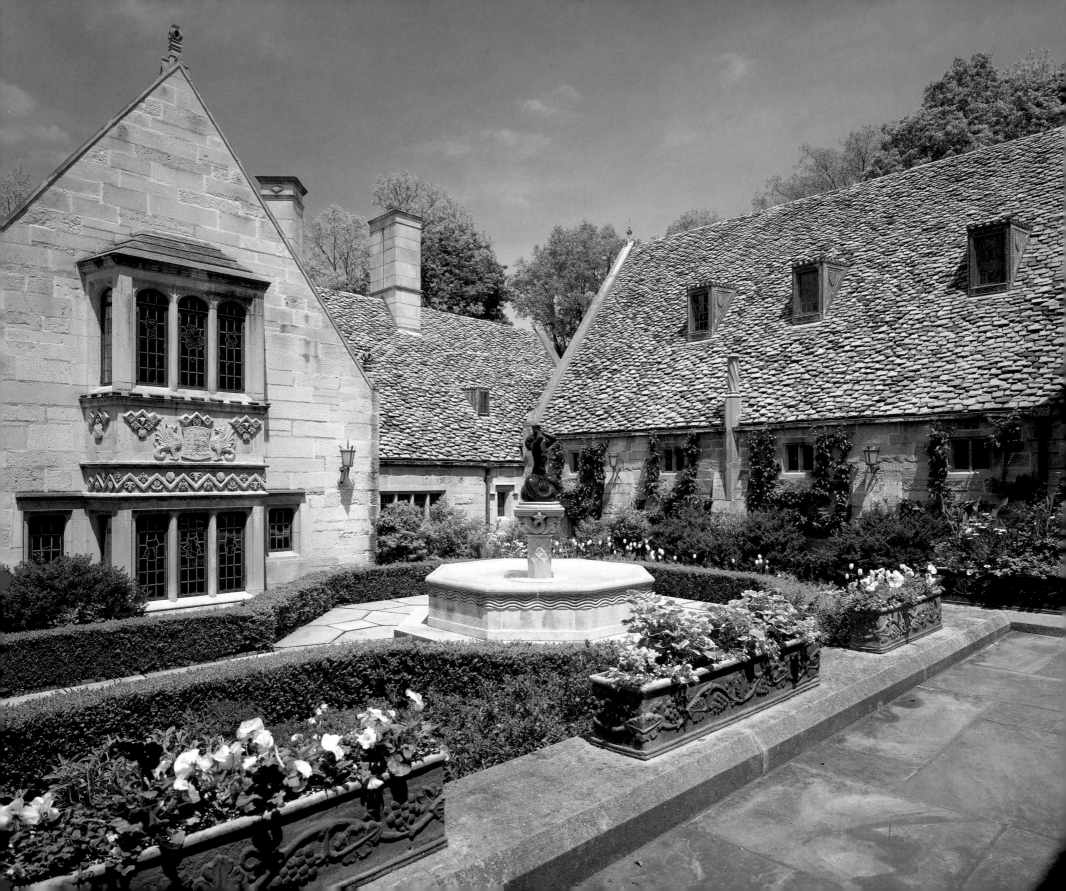

CHAPTER SIX

THE LATE YEARS 1930-1964

Fountain courtyard, Elm Court.

Janssen and Cocken received a pleasant reinforcement for its work when the Pittsburgh Chamber of Commerce held an exhibition of the work of Pittsburgh and Allegheny County architects in the Chamber's auditorium on April 8 to 12, 1930. Its purpose was to give encouragement and recognition to local architects for producing "better designed, better constructed, and better planned buildings," *The American Architect* magazine reported. The Chamber of Commerce awarded bronze medals for residential, institutional, and commercial structures within a radius of 100 miles; there were 120 entries.

Janssen and Cocken received medals in all three classes, based on Longue Vue, the Keystone Athletic Club, and the Rolling Rock stables. Honorable mention was also accorded for the excellence of design of La Tourelle's exterior.

Owners received certificates, and contractors of the buildings were awarded octagonal medals modeled by sculptor Frank Vittor. In the jurying, exhibits were identifed by contractor and owners but not the architects' names. The competition was judged by a combination of public vote, honorary jury, and active jury. About 5,000 people visited the exhibition and approximately half cast ballots.

The public's vote was decisively for Longue Vue, William Penn, and the Kaufmann house. The honorary jury selected the Church of the Most Holy Sacrament, William Penn, and the Col. H.W. Coulter house. The active jury agreed with the public on Longue Vue but chose the Keystone Athletic Club and Rolling Rock stables for the balance of the awards. Newspapers and radio covered the event reasonably well. The Chamber and architects issued small contest announcement labels for their letters.

Janssen was certainly not without important friends on the non-public juries. The honorary jury consisted of: Taylor Allderdice, president, National Tube Company; Dr. John G. Bowman, chancellor of the University of Pittsburgh; Howard Heinz, chairman, H.J. Heinz Company; J. H. Hillman Jr., Hillman Coal Company; Edgar J. Kaufmann, and R.B. Mellon. The active jury members were: C.H. Hammond, FAIA, president of the American Institute of Architects; Harrie T. Lindeberg, New York; Frank J. Forster, AIA, New York; and William S. Miller, Builders' Council of the Pittsburgh Chamber of Commerce.

First floor, Kaufmann's Department
Store, with Boardman Robinson
murals. Janssen and Cocken,
circa 1930.

This experience, while not unexpectedly favoring Janssen and Cocken, gave the firm some much needed recognition as well as awakening the public to the kind of architecture being created in Pittsburgh at the time.

KAUFMANN'S FIRST FLOOR

Spectacular ideas by Joseph Urban for the redesign of Kaufmann's Department Store's first floor in 1930 were not realized, possibly for budgetary reasons because the plans were complicated. But Urban inspired the space that Janssen and Cocken created. Urban was a Viennese-born architect and designer who, after immigrating to the United States, had a fine hand in everything from Ziegfeld Follies sets and costumes to Hearst's Cosmopolitan films. He also designed the fantastic Spanish Colonial tower at Mar-a-Lago, Marjorie Merriweather Post's eighteen-acre Palm Beach Xanadu.

According to Urban's drawings for Kaufmann's, he would have clad the first floor's black Carrara glass pillars, beginning several feet from the ceiling, with lighted sconces resembling upturned trumpet flowers. At eye level the pillars would have held small display cases. Urban also conceived an elaborate geometric ceiling in a delicate pattern that the terrazzo floor would have echoed. Instead Janssen restyled and simplified the room's design. While keeping the black glass treatment, the space became a more strictly architectural experience but still a chic background for sales.

The ceiling was left plain but its indirect lighting high-lighted the large salesroom's angularity. The use of metalwork of nickel-silver alloy on inner and outer doors, stair railings, drinking fountains, and ventilator grilles created a dramatic linear contrast against the lustrous black glass. The General Bronze Company, now Allied Bronze Company, of Long Island, N.Y., made the metalwork.

The room's honey-colored wooden showcases and cabinets had rakish but not extreme angles, and the total effect told visitors this was a special and glamourous place to shop. Customers were greeted with a Hollywood-style opening. But the space was almost completely redone sixteen years later, shortly after the May Department Stores Company bought Kaufmann's in 1946, when Edgar and Oliver Kaufmann were invited to join the May board of directors. Much of the old metalwork remains in place, memorials to an era.

INDUSTRIAL PROJECTS

Janssen and Cocken made at least four excursions into industrial architecture. One is the former headquarters building of Union Switch & Signal Company on Braddock Avenue, Swissvale, just east of Squirrel Hill. Later owned by American Standard Corporation, the five-story structure was redesigned in 1992 for Oxford Development Co. and is now the Towne Centre Offices Building, part of Edgewood Towne Centre shopping mall on what was Switch & Signal's old industrial site.

Resembling a fortress, the rather severe building of red

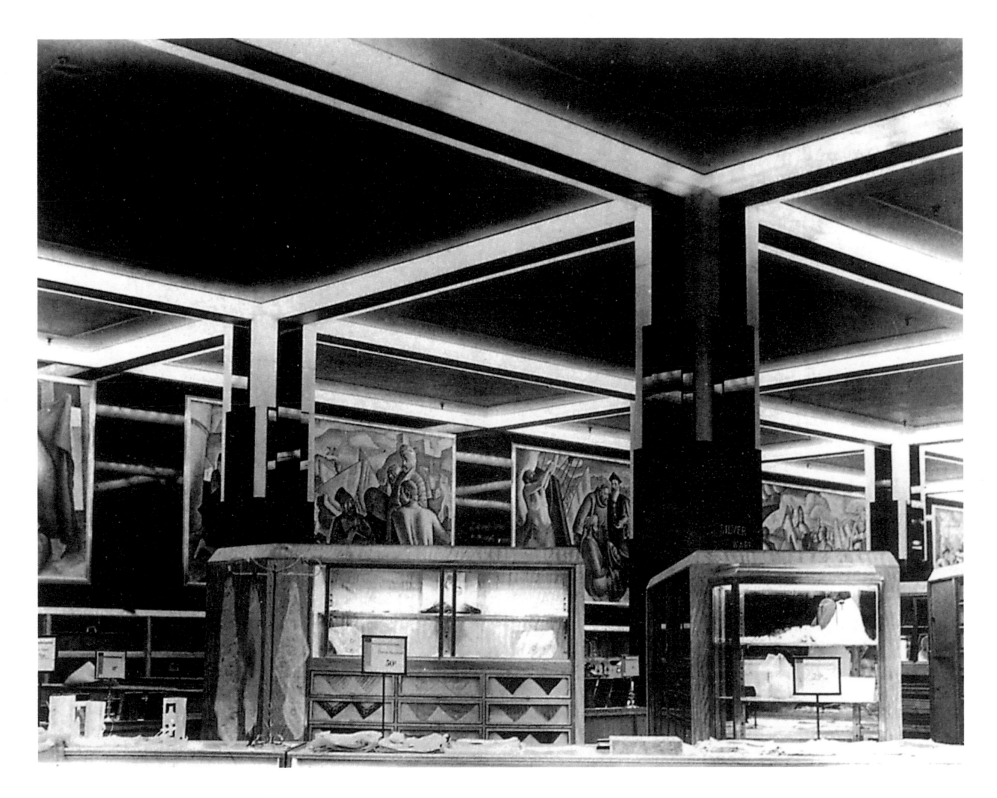

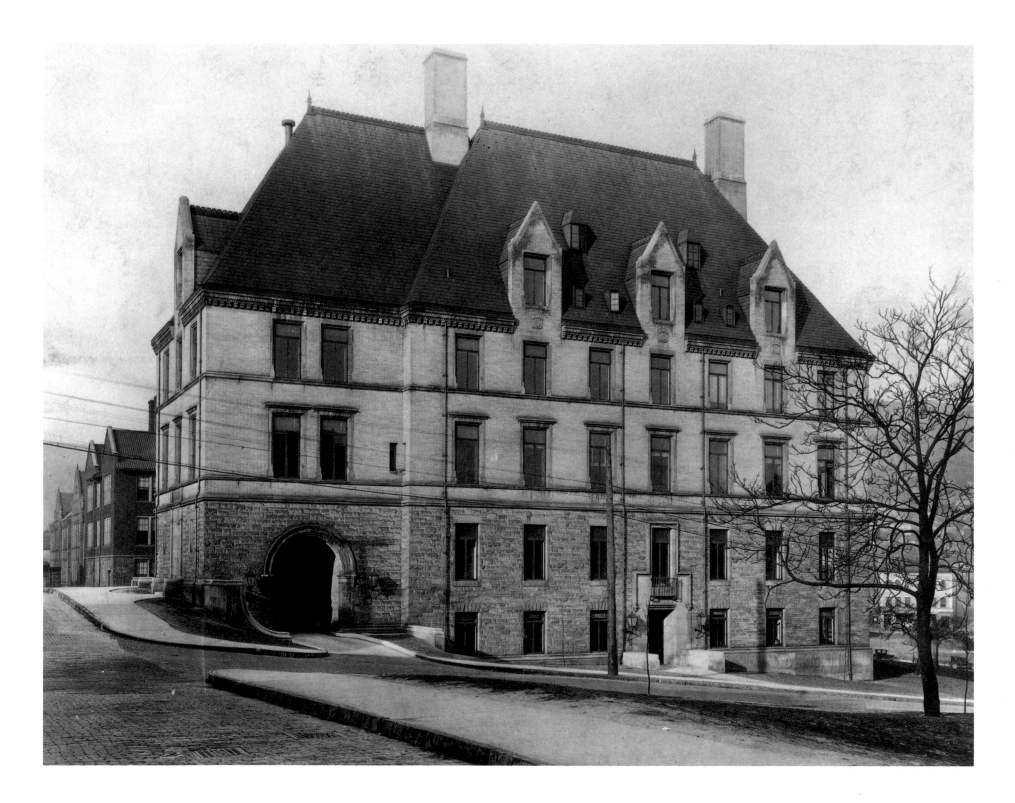

Executive office wing, Westinghouse Air Brake Company, Wilmerding, Janssen and Cocken, circa 1932.

brick and white mortar was simply updated by Design Three Architects, of Monroeville, Pa., with new windows and an entrance from the rear parking lot that is contiguous with the mall. But the structure's crenellations remain on the fifth story cornice and atop the seven-story central tower of this basic yet authoritative building.

It is likely this project came to Janssen through a social connection, perhaps from lunching at the Duquesne Club with Herbert A. May, vice president of Union Switch & Signal, a company founded by inventor George Westinghouse Jr. (1846-1914). May, unrelated to the May Department Stores, was a friend of Richard King Mellon. Later, from 1958 to 1964, bon vivant May was the fourth husband of cereals heiress Marjorie Merriweather Post (1887-1973), who lived briefly in Pittsburgh.

Janssen's friendship with Herbert May could also explain the firm's being called on in 1927 to design the former executive office building of Westinghouse Air Brake Company in Wilmerding, Pa., in the Turtle Creek valley. George Westinghouse's original office building, called "The Castle," needed to be expanded to meet the firm's commitments to the railroad industry.

Janssen studied the sturdy building, a late Victorian structure of gray-beige Roman brick and stone that had replaced an earlier library and office building that had burned. Westinghouse's office, its most distinguishing mark a deep bay window, was in the tall clock tower on The Castle's west side.

Rising from a high terrace, the imposing pile looks down on the industrial valley below. Janssen's task was to present a plan that would appear as a logical part of the design. He designed a five-story, somewhat simplified Louis XIV-style addition, with steep slate roof and tall windows. It did not match the original structure but greatly enhanced it.

Janssen chose quarried stone for the lower floors. For the upper ones he used the same elegantly narrow Roman brick of the older building. Near the rear of the addition's east wall Janssen inserted an arched stone and brick porte-cochere, just wider than a standard automobile, which executives could use in inclement weather. The driveway leads to the back of The Castle. The wing is beautifully finished. There are stone string courses, dentiling below cornices and gutters, and tall lucarnes (dormer windows) jut above the roof line.

The visitor will detect exterior differences between the two parts of The Castle, suggesting the add-on nature of many European fortresses. This is even more evident inside where the older building was renovated after the addition of the wing. The high quality of Janssen's east wing adds grandeur to the whole structure. Inside, against the older building's smaller rooms and heavier ornament, the east wing offers more space for halls and offices. There are several fine oak-paneled offices, conference rooms, executive dining room, and a larger dining room and kitchen for other employees in the building.

The fourth floor's executive spaces contrast four fireplaces with quarter-sawn rectangular oak panels in the plain English style. Three of the fireplace surrounds are of limestone and one is of gold-veined black marble. All have the tall fire boxes Janssen favored. Each fireplace is simply but

Mellon Securities Building,
525 William Penn Way, Pittsburgh.
Janssen and Cocken, circa 1936.
Razed circa 1949 for United States
Steel Mellon Bank Building, 1951.

Drawing by John Richard Rowe of
Janssen and Cocken's central
hydroelectric powerhouse for
Alcoa, Quebec Province, Canada.
Circa 1931.

beautifully carved. One honors Westinghouse's memory while another contains on the overhang two small reliefs of women in medieval dress.

Carved linenfold oak doors enhance the large conference room. The hardware, including door handles and several sets of fireplace grates and tools, were forged by Samuel Yellin. His name is minutely stamped into the rim of a multi-toggled light switch escutcheon.

The large employee dining room is notable for its high square-coved ceiling, dozens of plaster bosses of plants, animals, fish, snails, and crossed duelling pistols. From the ceiling hang nine Yellin tambourine-shaped chandeliers. The large kitchen contains its original and commodious Universal Chef gas range. The elevator is, of course, a Westinghouse.

Four rooms in the first floor of the older building contain the George Westinghouse Museum. It presents objects, photographs, and memorabilia from the inventor's life as well as a bronze bust by Daniel Chester French. (The George Westinghouse Memorial, with French's bronze sculpture of a boy transfixed by a wall displaying a record of the inventor's many accomplishments, was dedicated in Schenley Park, Pittsburgh, in October 1930.)

The museum is operated by the George Westinghouse Museum Foundation, an independent volunteer non-profit organization established as a memorial to the inventor's achievements and contributions to society. Because of his military service in the Civil War, Westinghouse and his wife, Marguerite Erskine Walker Westinghouse, who survived him by three months, are buried in Arlington National Cemetery.

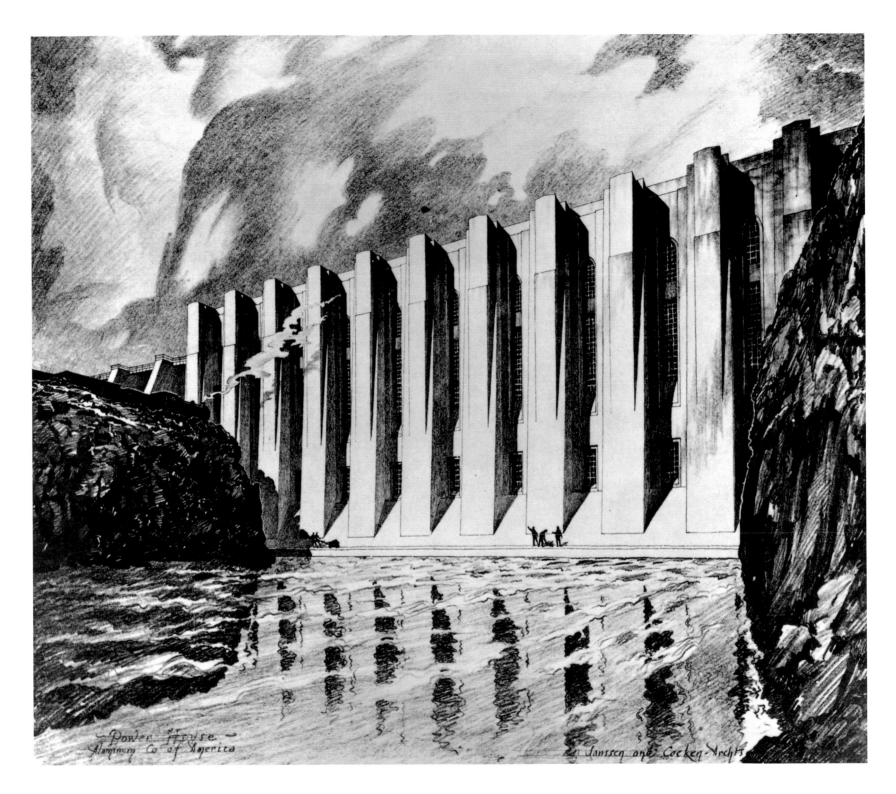

Powder House
Aluminum Co of America

Janssen and Cocken Archts

ELM COURT

Roy Hoffman, an associate since about 1917, was project architect for several Janssen and Cocken structures but most particularly Elm Court and Mellon Institute. His fine hand is in many special details. As project architect, Hoffman assured the continuous flow of Elm Court's development that Janssen had first defined in loose sketches and then oversaw from the Pittsburgh office.

A romantic Tudor-Gothic fantasy in Indiana limestone, this rambling three-story mansion of forty rooms was built in the city of Butler, north of Pittsburgh, between early 1929 and 1931. The price was nearly $1 million.

Elm Court's first owner was Benjamin Dwight Phillips (1885-1968), president of the T.W. Phillips Gas and Oil Company of Butler. A sharp businessman, Phillips was also a pious Christian, philanthropist, and a part owner of the Pittsburgh Pirates in the 1940s. A lover of nature, trees, and wildflowers, Phillips hunted small game, had a fine stamp collection, a well-stocked library, and a notable jade collection. With an eye for beauty, he wanted not only a handsome place of business, which Janssen and Cocken provided in the form of a Florentine Renaissance palace on Butler's Main Street, still occupied by the company, but also a beautiful house.

College-educated and heir to a fortune established by his father, Phillips was proud of his English ancestry. The family's documented beginnings were traced back to the twelfth century and to Thomas Phylyps, "chief builder and supervisor of buildings in the Town and Marshes of Calais."

According to a 1969 biography commissioned and published by Mildred Welshimer Phillips, his widow and second wife, Phillips was determined to spare no expense in erecting a manor house of distinction. He was also a stickler at business. On the day he died at 82, Phillips checked on the status of 2,000 gas wells recorded on a board at the office.

A member of the Duquesne Club and Pittsburgh Athletic Association, where he may have met Janssen, Phillips was much impressed with views of the older areas of Hampton Court Palace, Moreton Old Hall, Cheshire, and Oxford University's Corpus Christi and Magdalen Colleges as well as the king's gateway and great court at Trinity College. Janssen probably showed Phillips illustrations of all of these.

Janssen himself had pored over photographs and plans illustrated in the monograph on his great contemporary Sir Edwin L. Lutyens and his fine work at such places as: Munstead Wood, Surrey; Little Thakeham, Sussex; Lambay Castle on an isle off Dublin County, Ireland; Papillon Hall, Leiscestershire; and the entrance front of Daneshill, Old Basing, Hampshire. All of these manors — large, quietly dramatic, deeply roofed, richly chimneyed, and gabled — held elements that excited Janssen.

For his part, Phillips knew many old manor houses in the England of his ancestors were Tudor, but he also enjoyed the Gothic mode for its churchly allusions and had already paid for such a church in Butler. He wanted a grand house, Phillips told his architect, but not a palace. Janssen was his man.

The 9.3-acre estate is nestled in a hillside and shares a

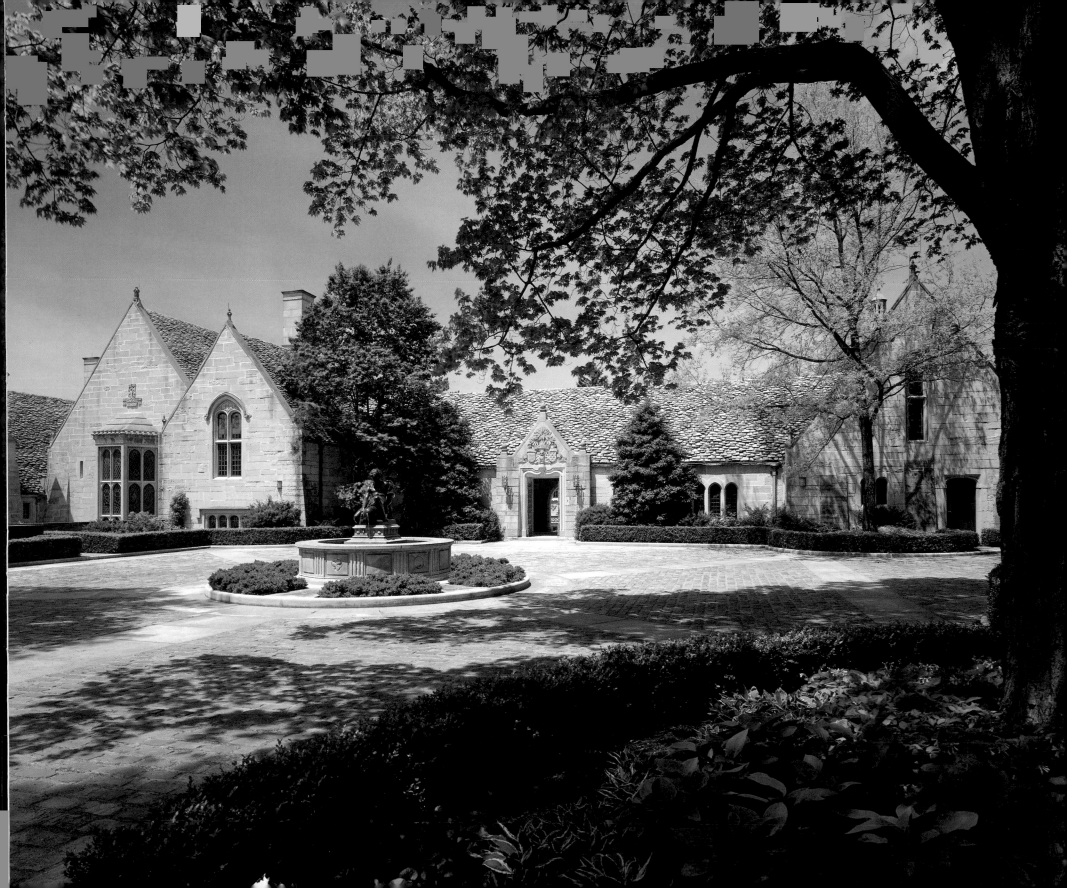

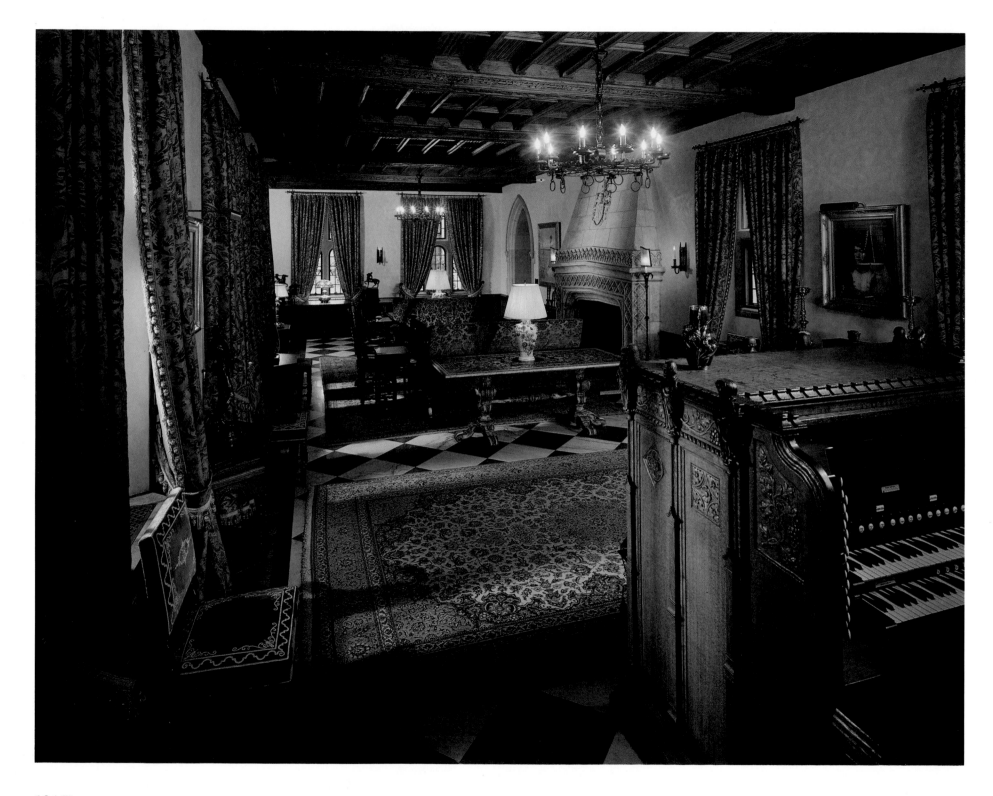

Left:
Great hall with carved organ console,
Elm Court.

Great window and staircase,
Elm Court.

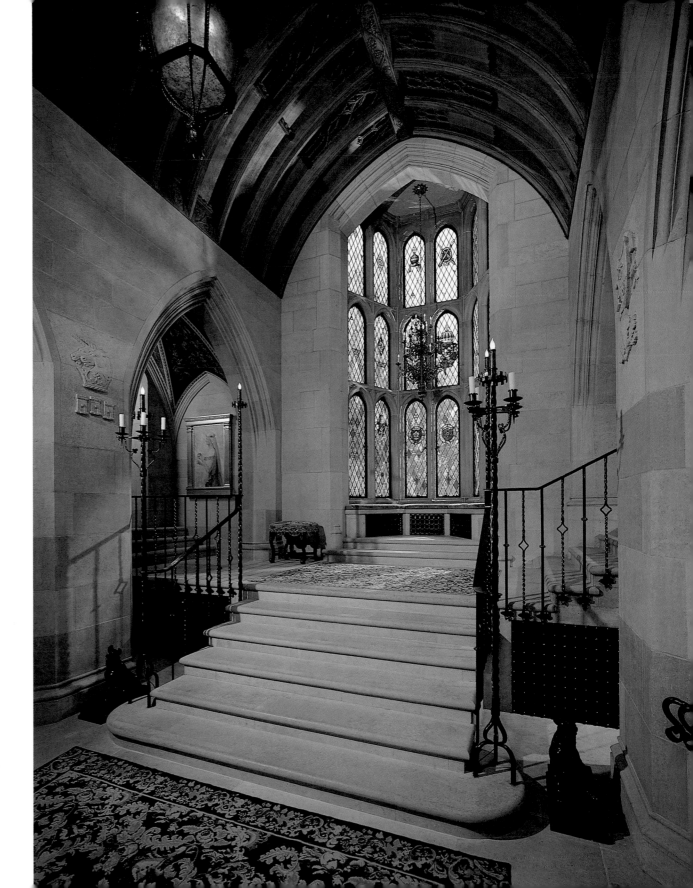

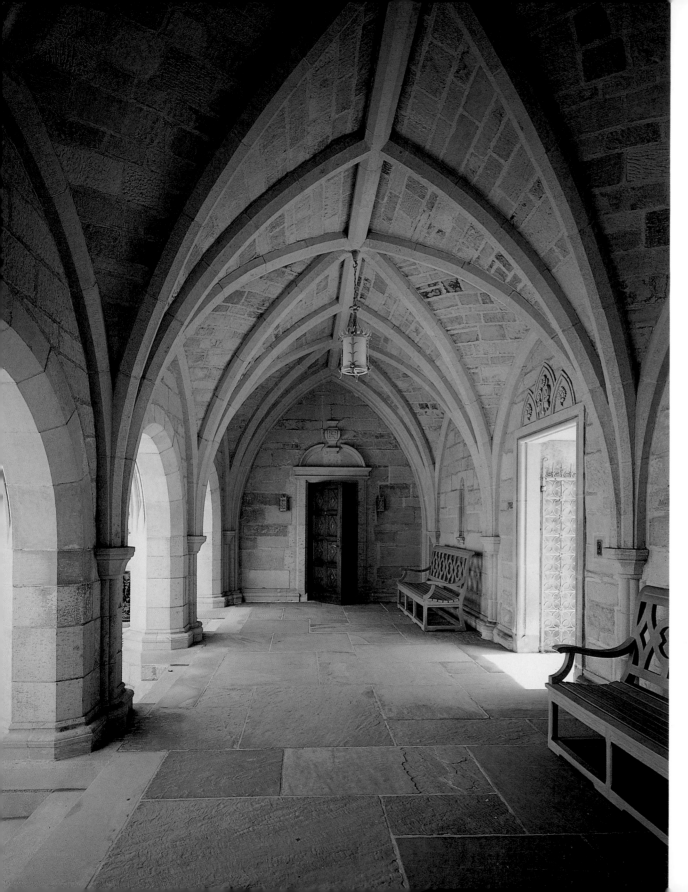

Cloister leading to servants' wing,
Elm Court.

Facing page:
Drawing room with English fireplace
from house of Anne of Cleves,
Elm Court.

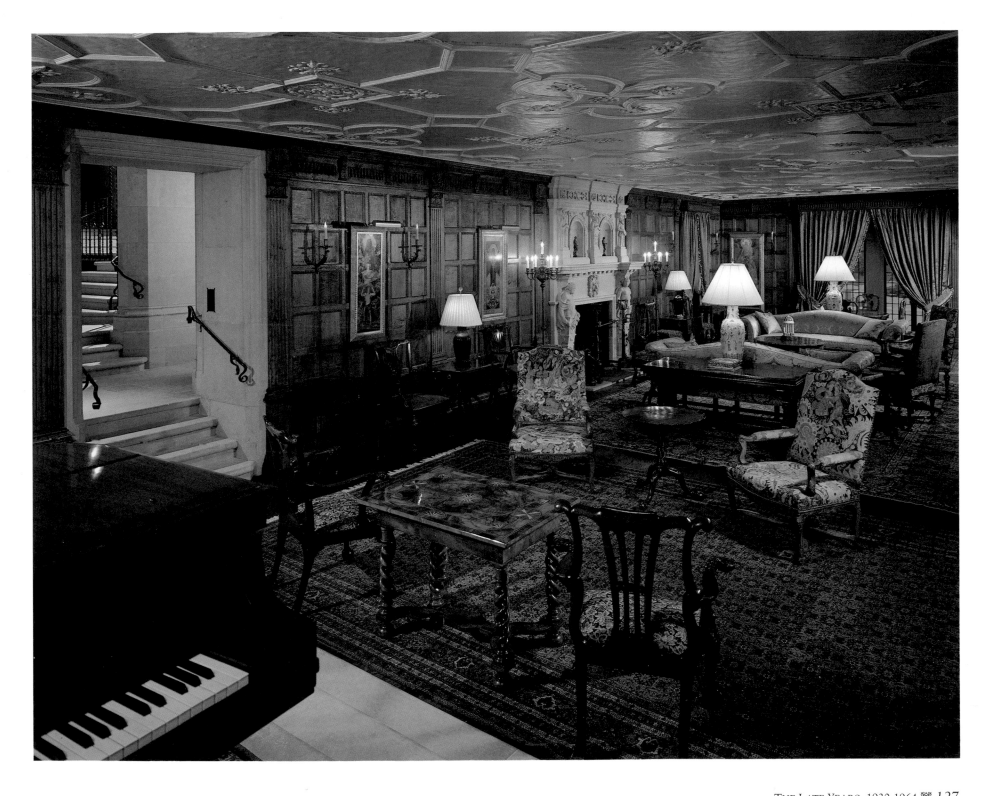

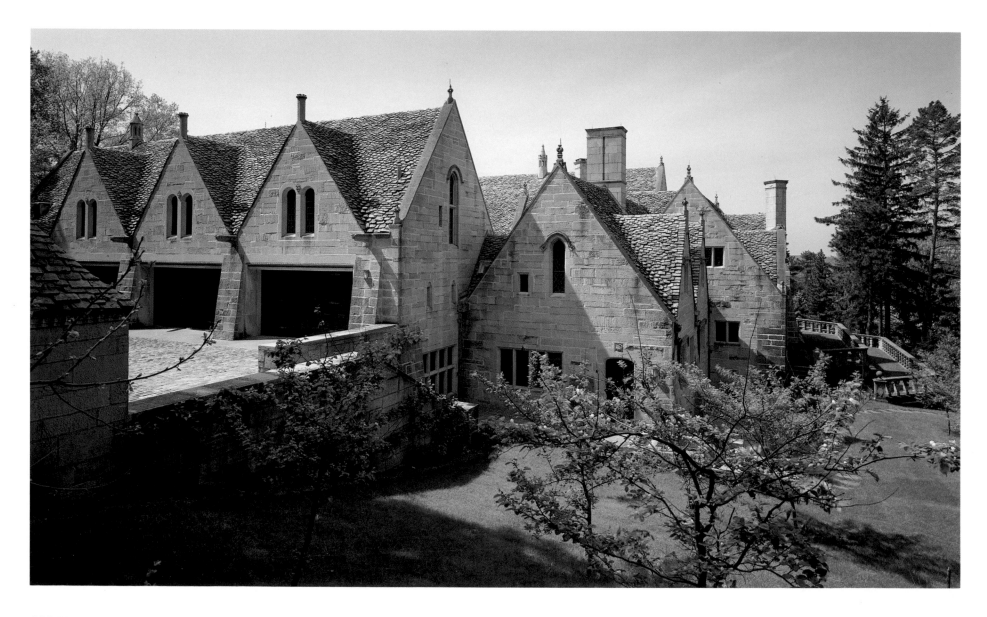

home of Mary Flinn Lawrence, daughter of the politically powerful contractor William Flinn. The long limestone house, set on a wide plain far from the main road, has dark oak interior paneling. The carved stone crest above the front door is dated 1929. A handsome 1926 stable made of textured concrete block is near the park's entrance. Hartwood derives grandeur from its site, surrounded by 639 open and wooded acres. Allegheny County purchased the property from Mrs. Lawrence. Today the house is a museum in the popular park.

The other similar dwelling was Penguin Court, 1938-1966, the Laughlintown (Ligonier) estate of Alan Magee Scaife and Sarah Mellon Scaife. Alfred W. Hopkins, of New York, best known for his prisons, was the architect of both it and Hartwood. In view of earlier work done on behalf of the Scaifes, it is not known why Janssen and Cocken did not design Penguin Court. Since the Lawrences were socially prominent, the Scaifes may have visited Hartwood Farms and later selected Hopkins.

Since R.B. Mellon was happy with the pavilion for the Scaifes' wedding reception, it is likely that he asked Janssen to renovate the Lawrence Dilworth house (Alden & Harlow, 1889-1904) at 1047 Shady Avenue, abutting Mellon's estate, for the newlyweds. Proof is not conclusive but the house has Janssen touches, and James Johnson recalls the firm once did over a large East End house. The half-timbered, stone, and pink stucco makeover left the original roof and gables but obliterated the shingled, wide-porched design that in 1927-28 would have seemed dated.

As redone, the Scaife house's oak-paneled living room, to the left of the entrance, extended from front to rear. The central hall was paved in black and white marble similar to floors in the Marshall Dravo house and Rolling Rock clubhouse. A large window with stained-glass heraldic insets dominated the stair landing. For the stairs Samuel Yellin made a beautiful rococo railing in polished bronze and black enamel, and sent an invoice to Alan Magee Scaife in 1928. Since the late 1940s, this structure has been the Pittsburgh Center for the Arts' Scaife Classroom Building. Much altered inside, it retains its exterior, stair railing, marble hall floor, and landing window.

Leaving this house for the 7,000 square foot penthouse in the more private Park Mansions Apartments, by the Carnegie Mellon campus, the Scaifes asked Hopkins for a country house. Janssen inspected it while it was being built. In December 1939, the Scaifes moved into grand but cold Penguin Court. Named for pet birds the Scaifes once kept there, the house is now recalled in a miniature room display at the Carnegie Museum of Art. Alan Scaife, businessman and chairman of the University of Pittsburgh's board of trustees, died in 1958. The house was razed shortly after Mrs. Scaife's death in 1965, its sumptuous main rooms and six bedrooms no longer needed. Son Richard M. Scaife placed a formal garden on the site.

Facing page:
Philip A. Fleger house, Fox
Chapel, Janssen and Cocken,
circa 1935.

Fanny Edel Falk School,
University of Pittsburgh,
Allequippa Street, North
Oakland, Tudor, Janssen and
Cocken, 1931.
Note sunken entrance.

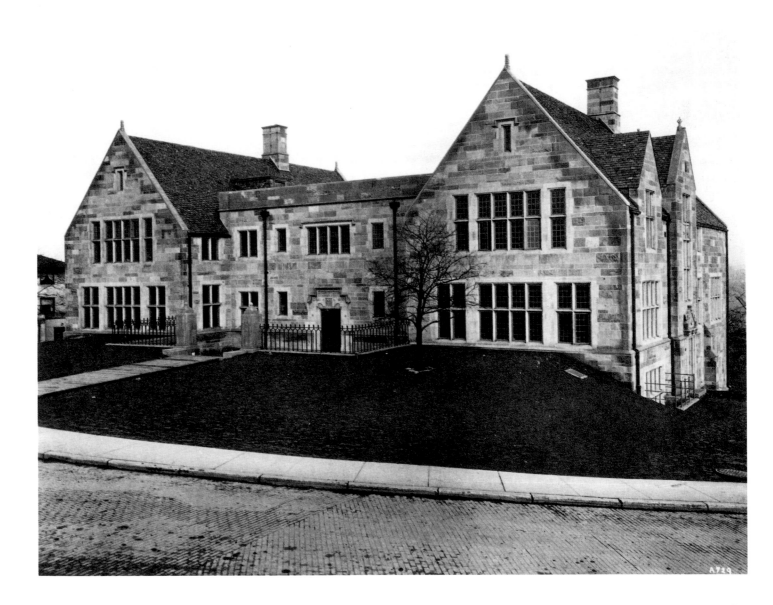

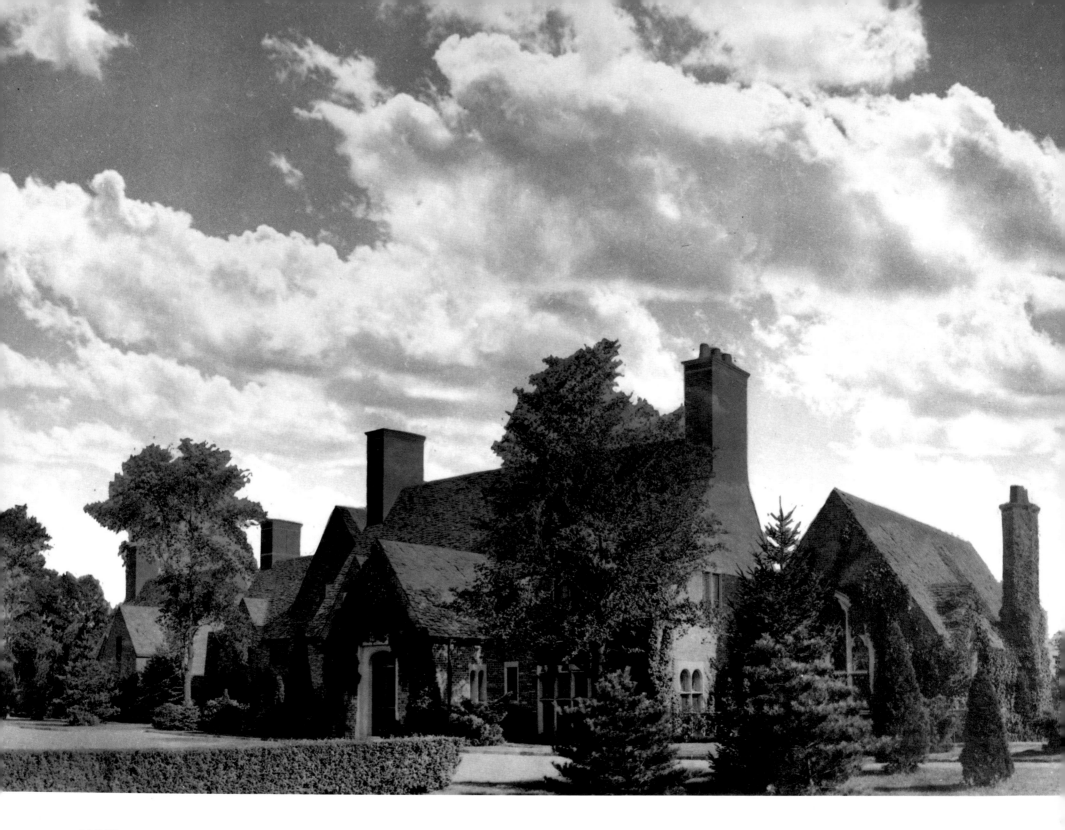

MARSHALL DRAVO HOUSE

In the 1930s, Janssen and Cocken designed several fine houses in Sewickley Heights. Among them are the Marshall Dravo house, the Darlington house, Trainer-Wardrop house (red brick now painted gray and with a rear stone balustrade recalling the one in La Tourelle's early drawing), Higgins house, and Purnell house.

Located near the Allegheny Country Club, the Dravo house of 1930, originally set on thirty acres, offered the firm many delightful challenges. Janssen again chose his massive gabled blocks for a rose red brick Tudor manor of large proportions, particularly a huge drawing room with cathedral ceiling. Perhaps most memorable, however, is the fifty-foot-long interior loggia with Gothic vaulted ceiling, floor-to-ceiling ogival windows and matching french doors leading to a rear court.

The house extends 100 feet or more from east to west. On the outside of the loggia and elsewhere, jambs of doors, windows and arches are made of simply dressed limestone. The curving drive extends several hundred feet before coming alongside the facade. The graveled forecourt can hold thirty cars or more.

Designed with simple but massive gable-end chimneys and steeply pitched slate roofs, the house contains five bedrooms and servants quarters. Although simpler than Elm Court, it not only shares some of the latter's Gothicizing but similar attention to grand spaces. The living room's magnificent beamed cathedral ceiling looms over a very large room illuminated by tiered and ogival windows. From a gated vestibule, with a butler's room immediately on the left, a short hall leads to the sunken loggia which extends through the center of the house, ending with the living room at right. At the left side, a wide staircase of theatrical proportions, also arched, just beyond a baronial dining room, ascends to the second floor bedrooms.

Janssen thought often about great houses. In the 1920s, he had tried to bring wealthy industrialist John Hartwell Hillman to his version of a Cotswoldian Renaissance mansion that would have replaced a large red brick 1870s Second Empire house with thirteen-foot ceilings at 5045 Fifth Avenue. Instead, Hillman had E.P. Mellon produce a mixed French-English neoclassical renovation (1924-26) out of the existing house. Mellon, preserving much of the interior and its trim, added a large drawing room and covered the building in limestone. The house was turned into five condominium apartments in 1980; one of them is in the former drawing room.

Superb drawings for Hillman in the Carnegie Mellon University Architecture Archives show what Janssen had in mind. His drawing of the proposed house's rear with parterre and sunken garden recalls, despite stylistic differences, La Tourelle's back lawn.

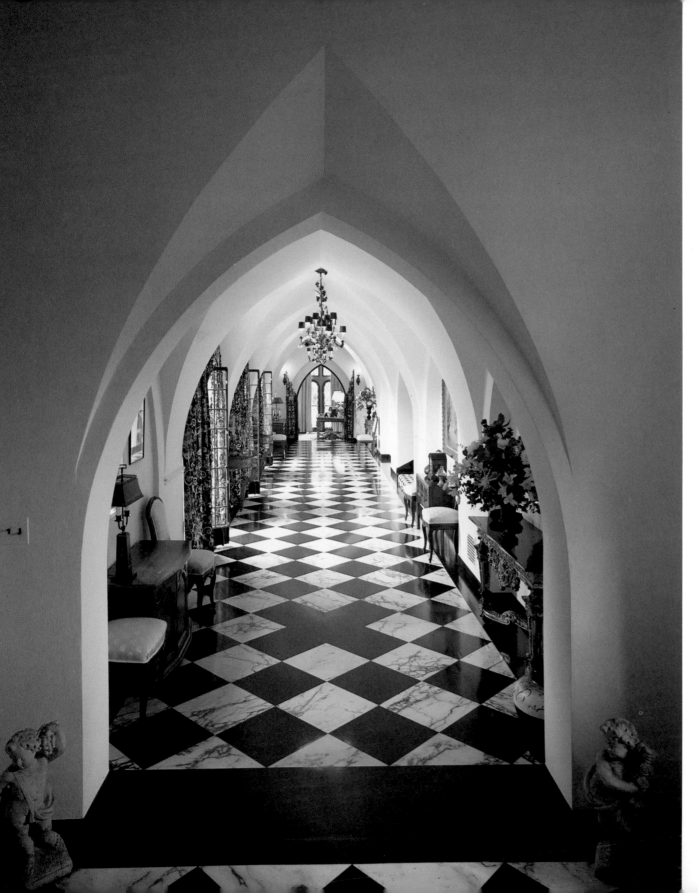

Loggia, Dravo house, leading to living room.

Facing page:

Top:
Loggia drawing, Dravo house,
probably by Benno Janssen, circa 1930.
Another loggia drawing depicts a maid.
Size: 5 x 21.6 inches.

Bottom left:
Living room, Dravo house, with
tiered window; fireplace added later.

Bottom right:
Master bedroom, Dravo house.
Verner Purnell painted the headboards.

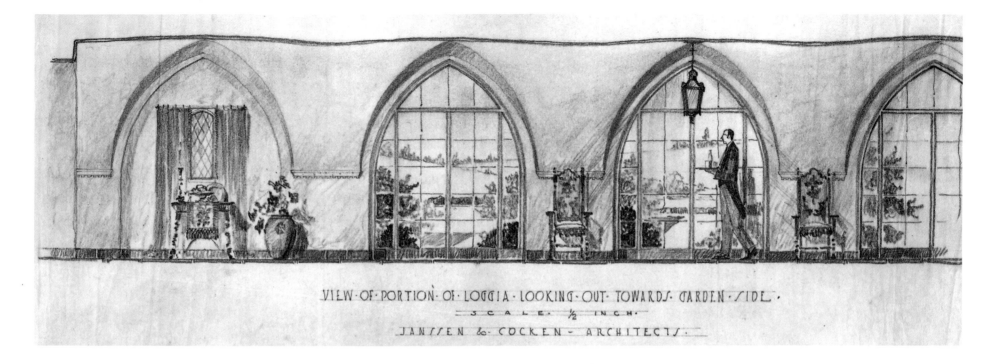

VIEW·OF·PORTION·OF·LOGGIA·LOOKING·OUT·TOWARDS·GARDEN·SIDE·

SCALE· ½ INCH·

JANSSEN & COCKEN - ARCHITECTS·

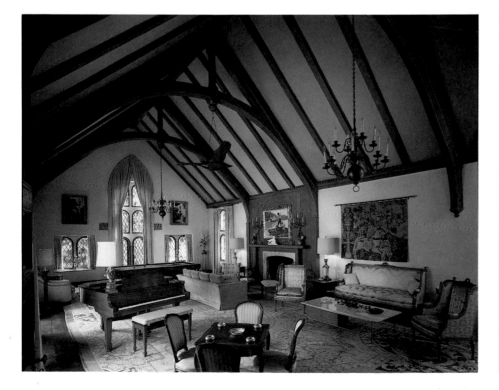

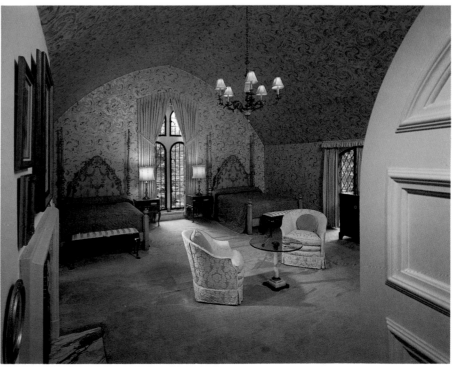

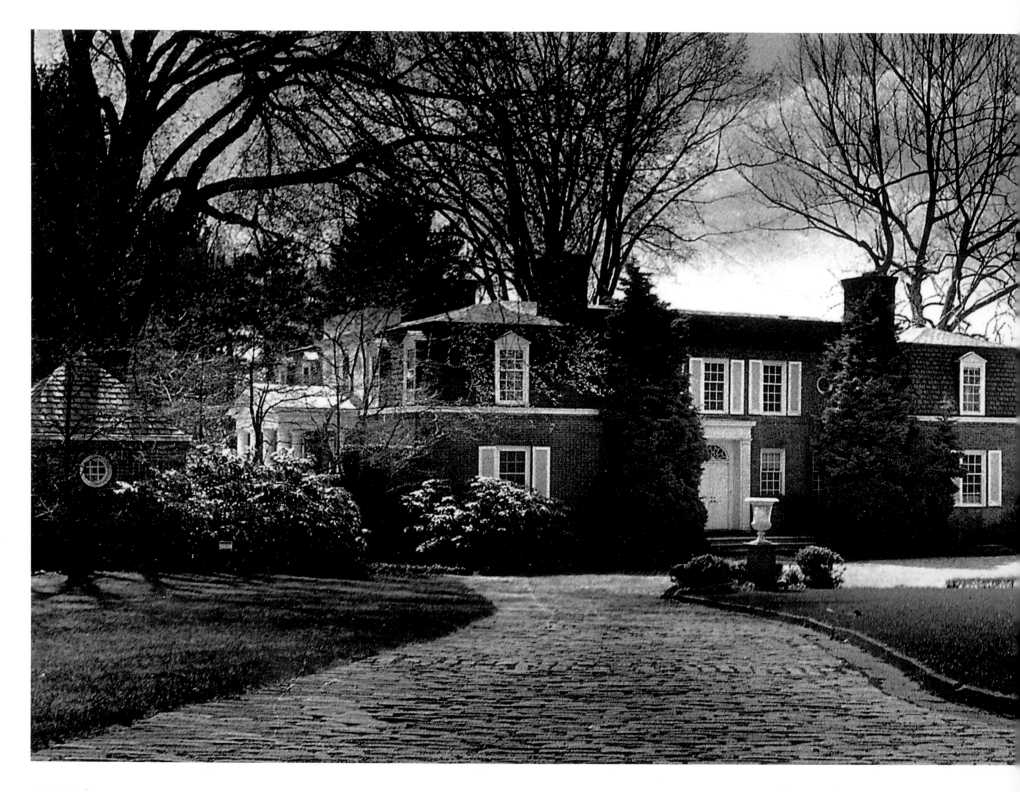

Verner Purnell house, Sewickley Heights,
Janssen and Cocken; 1989 photograph
after sphinxes were removed.

VERNER PURNELL HOUSE

Janssen produced another fine renovation in the 1930s. He considerably upgraded the Verner Purnell house, Sewickley Heights, from its farmhouse origins by joining his Jeffersonian ideas of red brick and white trim with a mansard roof and a fine Italian garden. All this was much abetted by the late interior designer Verner Purnell, whose father had been a successful Pittsburgh banker. The interior contained Janssen's customary cluster of small spaces at the entrance, seen in the house he did later for son Pat and his family in Charlottesville, opening into a large drawing room with french doors.

The Purnell facade suggested a *petit chateau* but it was also Janssen's subtle homage to Monticello. Low steps, flanked by stone sphinxes with heads styled after Madame de Pompadour, rose fetchingly from a large forecourt.

Purnell studied in the late 1920s at Laurelton Hall, Louis Comfort Tiffany's art nouveau palace on Long Island Sound near Oyster Bay, N.Y. He was a Tiffany Fellow, as were several other Carnegie Tech arts graduates advanced by jewelry professor Frederic Clayter, a board member of the Tiffany Foundation. In 1970, near the end of a busy career, Purnell designed the red, white, and gold interior of Heinz Hall for the Performing Arts, Sixth Street. The former Loew's Penn, with its movie theater baroque handsomely updated by MacLachlan Cornelius and Fosner, is the Pittsburgh Symphony's home.

Purnell bequeathed funds to Carnegie Mellon for completion of its College of Fine Arts' long unfinished front niches, and also for the university's performing arts center that is named for him. Purnell collected miniature sphinxes, hence his entrance, and blue Bristol glass that matched his eyes.

Adept at chinoiserie, Purnell told the author he once covered a wall in his house with a delightful motif freehand, as he similarly painted a pair of headboards at the former Dravo house. It was easier, he said, than repairing the wall before a party.

Despite a steep location in Schenley Farms, fronting on Bigelow Boulevard and extending up Parkman Avenue diagonally across from the rear of Soldiers and Sailors Memorial, the Twentieth Century Club is one of the most beautiful beaux-arts buildings in Oakland. Founded in 1894, the exclusive women's club moved from its first clubhouse Downtown to a new neoclassic brick and terra cotta structure designed by Pittsburgh architect George H. Schwan on this site in 1910.

This building proved to be too small, and in 1930 Janssen and Cocken doubled its size by encapsulating it in carved and rusticated limestone. The original structure remained, but its exterior was transformed and enriched into the building known today. Interestingly, Janssen maintained the structure's Renaissance design with its large pedimental windows but found brilliant ways to redefine it as he enlarged it.

The new building, like that of the Pittsburgh Athletic Association, has detailing traceable in style to the late Renaissance. As Pittsburgh architect David J. Vater has determined, Janssen drew his exterior in essence from Michelangelo's encasing of the twelfth century Palazzo del Senatore. About 1536, the artist-architect partly laid out the middle palace of three in Rome's Piazza del Campidoglio on the Capitoline Hill.

Janssen took his lead from the Italian master's challenge to solve his own problem. He chose a similar rusticated base, colossal Roman Corinthian exterior pilasters, a piano nobile (main floor above the ground floor), and windows with stone frames and pediments.

Among the club's other grand exterior details is the double ceremonial staircase, or perron, on Parkman which leads to the club's main entrance. Above this is the center bay with curved broken pediment. In its tympanum is a large cartouche bearing the club's monogram along with a triumphal ribbon. In the frieze above is carved the Latin credo: "*Non Nobis Solum Sed Toti Mundo*" (Not for Ourselves Alone but for the Whole World).

In a lecture to club members, Vater has explained the symbolism of the six snake-handled urns atop the building's fine and unusual stone entrance screen, now the main entrance, on Bigelow Boulevard. Snakes are attributes of the goddess Pallas Athene, daughter of Zeus and equivalent of the Roman Minerva.

She personified what the snake represented in the classical world, wisdom and prudence. (Her birth is recorded in sculptor C. Paul Jennewein's marble relief, "The Creation of Scientific Knowledge," above the inner lobby arch in Mellon Institute, q.v.) Another attribute is the olive tree, symbolizing peace and plenty. The club's snakes are lovingly entwined, Vater notes, and bear olive branches in their mouths to reinforce the combined significance.

The building's interior is a collection of majestic rooms, large and small, with floors linked by elevators and beautifully curving staircases. The second floor's entrance hall is set with a circular banistered opening that looks down on the earlier floor, opening the lower space while admitting light.

The most significant room is the sixty-six foot-by-seventy-four-foot ballroom/auditorium. The large proscenium stage is flanked above by square panels of the masks of comedy and tragedy, and there is balcony seating on three sides. High on the walls are fourteen moderne mural panels by Carl Hollem depicting stylized fountains which beaded chandeliers echo. The fountain motif, Vater suggests, is an analogy to the Hippocrene, where Athena visited the muses at their home on Mount Helion, the whole an analogy to a high-minded women's group.

The main dining room, with a frieze of anthemions, contains a hand-carved pine mantel and overmantel in an English floral design. The office of Marian H. Gheen, of Chicago and New York, which also did the Women's Athletic Club of Chicago and the Country Club of Madison, Wis., designed the Twentieth Century Club's interiors.

Stone screen, Twentieth Century Club, Oakland.

West facade, Twentieth Century Club, Oakland, Janssen and Cocken, 1930.

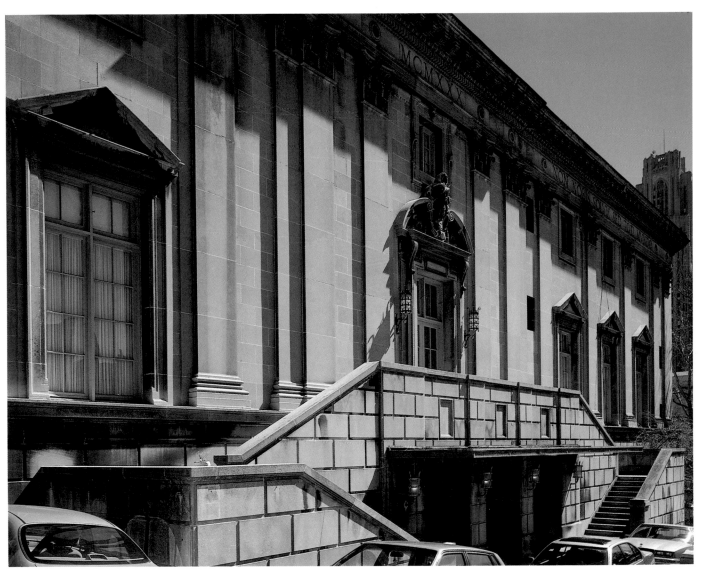

MELLON INSTITUTE

Construction of Mellon Institute of Industrial Research, at 4400 Fifth Avenue, Oakland, kept an army of workmen busy in the depths of the Depression. Completed in 1937 at a cost of $10 million, it was the third home for the institute, which the Mellon brothers formed in 1913 at the University of Pittsburgh.

The institute's purpose was to conduct investigations into problems within the fundamental and applied natural sciences. This was done to stimulate research, train scientists, and create advantages for industry. The institute became independent with this building. But when Carnegie Institute of Technology and Mellon Institute merged in 1967, becoming Carnegie Mellon University, the institute joined the university.

Paul Mellon, Andrew's son, was then chairman of the institute's board of trustees, and he and other family members largely made the decision to give the institute to the university. Since then, some aspects of the old research program have been transferred to the Carnegie Mellon Research Center in the Pittsburgh Technology Center, Second Avenue. The institute now contains the university's departments of chemistry and biology and other offices.

Designed for practical laboratory work, the new Mellon Institute's experimental nature was deliberately hidden behind a giant four-sided colonnade. Although based on Athens' Parthenon, world symbol of civilized thought in a birthplace of scientific inquiry, the institute was never intended to re-create an ancient building. For one thing, it is far larger than any Greek temple. The light gray structure, wider in the front than rear, has a trapezoidal form that fills an urban block. If built vertically it would equal in height and volume the thirty-two-story Koppers Building in Downtown Pittsburgh.

Sixty-two Indiana limestone monoliths, each thirty-six-and-a-half feet tall and nearly six feet in diameter at the bottom, line the exterior walls above two stylobates, or podiums. There are sixteen columns on the east and west facades, eighteen on the north front, with two behind front columns at the entrance, and twelve on the south, fewer because of the narrowed lot.

They are believed to be the largest solid columns ever made. Janssen wanted them for their singular effect; unlike other shafts they are uninterrupted by masonry breaks. Indiana Limestone Company, Bedford, Ind., turned each unfluted column from 125-ton blocks on giant lathes. In making the columns, only one failed because of a weakness in its structure.

"When this great size and length are considered," Janssen wrote in his unsigned but recognizable seventeen-page description of December 28, 1936, "it seems nothing short of wonderful that such accuracy was attained. There were only two or three men at the quarries who had the knowledge, experience, and skill to turn these columns.

"...Too much credit cannot be given to the great skill which was used in the erection of the stonework, and the almost mathematically perfect setting of the columns. The jointing of the plain masonry is remarkable, the joints being one-eighth of an inch thick, and the perfection of these joints is very fine."

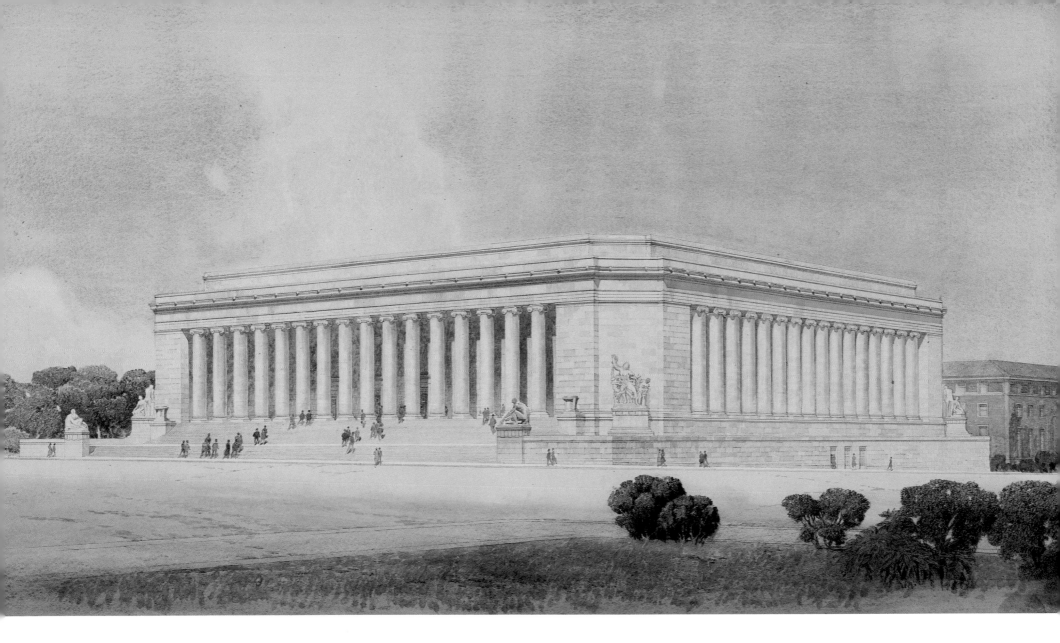

Drawing of proposed Mellon
Institute of Industrial Research by
J. Floyd Yewell, circa 1931.
Size: 25.4 x 48.9 inches.

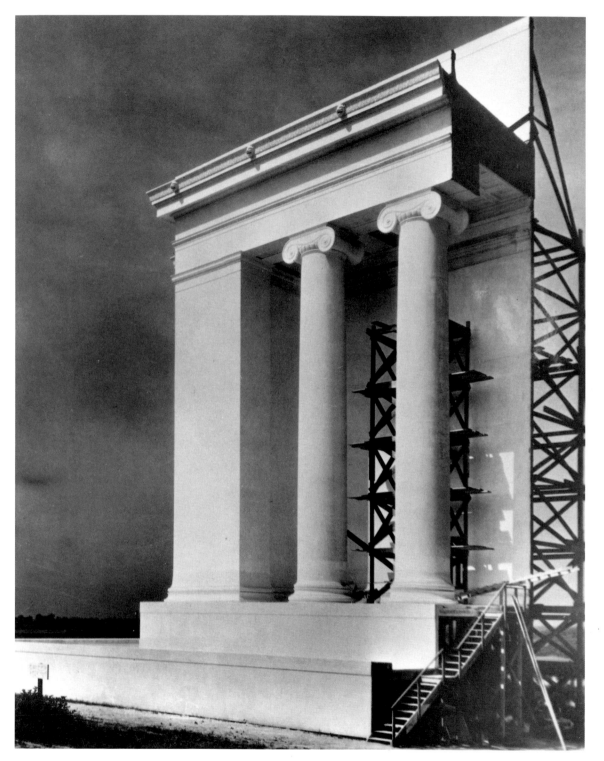

Full-sized plaster mock-up of Mellon Institute corner, circa 1932. The lionheads were eliminated. Mellon Stuart Company was general contractor of Mellon Institute, the National Gallery of Art's West Building, and East Liberty Presbyterian Church.

The columns came by rail to Pittsburgh's East Liberty station and were lowered into a special cradle between two trucks, each equipped for the load with five wheels in front and back. The Mellons had an agreement with the city that if streets and sewers were damaged they would pay for repairs. There were sixty-two trips from East Liberty to the site until all the columns were installed without incident or splitting of stonework at joints. To give a smooth seating, each shaft was set on a huge pin anchored to a lead plate.

Adding grace to the building are chamfered piers at corners. Diagonally placed, they seem perhaps more derived from France than of ancient Greece, where they were rare. The piers were necessary because the lot is trapezoidal rather than equally rectangular.

"The difficulty was solved by building the columns as heavy and the piers as light as possible," Janssen wrote. "The capitals, in proportion to the size of the column, are smaller than is found in conventional Ionic design. The main cornice is also much smaller than a conventional Greek one and in the design preserves a quiet, simple mass in which none of the details disturbs the general outline of the building."

The institute was the fourth of the Mellon brothers' 1930s gifts to Pittsburgh after the Gulf Building, Cathedral of Learning and East Liberty Presbyterian Church. The Mellons requested that the institute suggest a low profile, even though it contains nine floors, six above ground and three below. It and the University of Pittsburgh's nearby forty-two-story Cathedral of Learning were under construction at the same time.

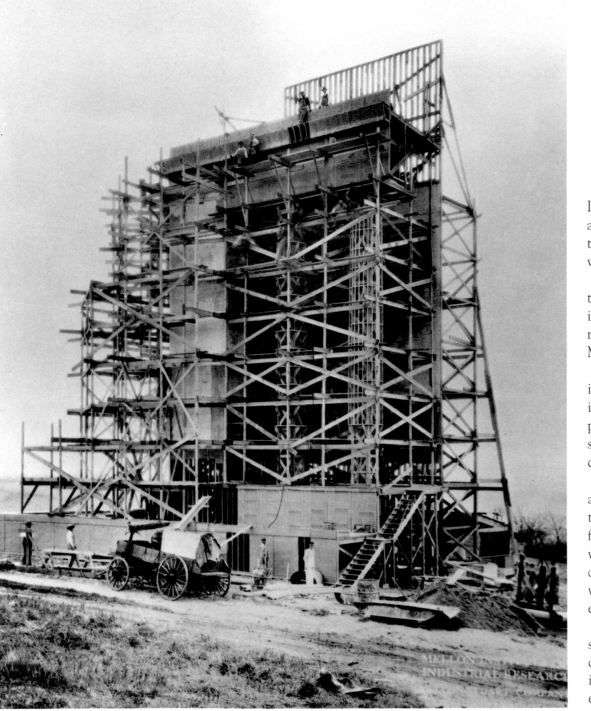

Mock-up during construction, circa 1932.

Even though derived from the ancients, Mellon Institute is one of the most unusual structures to be built in an American city. Its basic style, Janssen wrote, came from the small temple of Nike Apteros on Athens' Acropolis as well as the temple of Sardis in Syria.

"The [Ionic] capitals of the columns at Sardis were particularly fine as an inspiration for the proportions of our capitals," he wrote. "The large bed molding under the main cornice was developed from an old Grecian fragment in the Metropolitan Museum of Art, New York."

Roy Hoffman worked on the building extensively, creating many of its thousands of details. Shortly before his death in Ligonier at ninety-seven, Hoffman told James Johnson, partner in a Hoffman & Crumpton descendant firm, he considered the institute the most important challenge of his career and his finest work.

Nevertheless, his floral designs for a series of exterior aluminum window screens were never used, possibly because they would reduce natural light. Plate windows in aluminum frames look out through the colonnade; the mighty columns were deemed sufficient screening. On the inside, most windows face four internal air courts divided by cruciform hallways. To increase light to laboratories, court walls are covered in cream-colored terra cotta tile with classic reliefs.

"On account of the monumental exterior it was necessary to procure all the light for the rooms from interior courts," Janssen wrote. "No [laboratories] face the outside as it would have made it practically impossible to secure enough light and also preserve the monumental character."

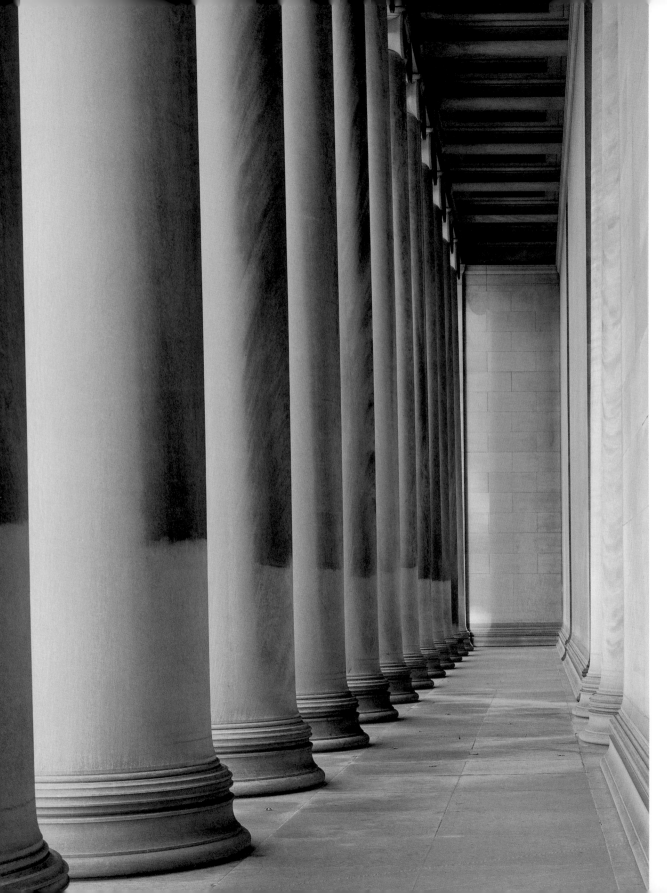

Front colonnade, Mellon Institute,
Janssen and Cocken, today.

It also meant placing corridors immediately behind exterior walls.

Everything about the project was stupendous. In Janssen and Cocken's drafting room, as large as the Duquesne Club's main lounge, the staff built a massive table and on it plotted the columns full-size. Each shaft, nearly six feet in diameter, weighs 60 tons and exhibits entasis, a slight convexity allowing its outlines to be seen as parallel; in normal perspective they would appear to be coming together.

"To preserve their beauty and effect, it was necessary to have all other details harmonize with the columns and to permit no feature to overshadow them," Janssen wrote. "A colonnade was chosen with a simple entablature and stylobate, with a deep porch behind the columns, a beautiful classic feature that was used on almost all the Greek temples.

"The impressive flight of steps at the main entrance rises from the street to the broad lower stylobate, built of granite, surrounding the building on three sides. A second flight of steps leads from the lower to the upper stylobate which supports the colonnade."

Janssen recalled, "Mr. Mellon allowed us to build a full-sized model of one of the end piers and two columns, including the two stylobates and the entablature, and the porch with its attic above. We built seven or eight columns by trial and error method, and finally chose one in which the diameter is contained into the height of the column about seven and a half times. The usual proportion is the diameter about nine times into the height... The facades become a monu-

Model of Mellon Institute facade
with Robert Ingersoll Aitken's
allegorical maquettes. Lost.

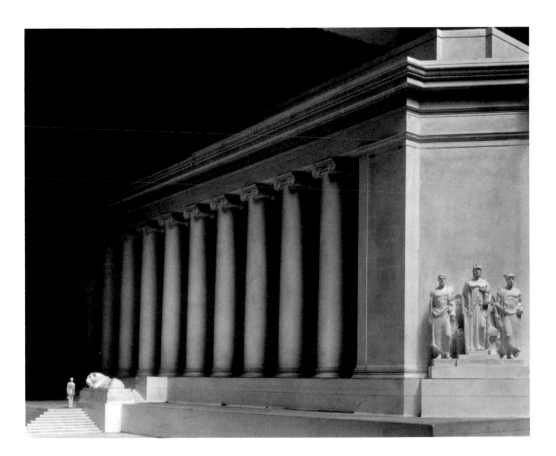

mental screen which surrounds the great mass of small laboratories and other rooms..."

The building's volume is six million cubic feet, the floor area more than 400,000 square feet, and there are 488 rooms. Construction required 269 carloads of limestone, sixty-two carloads of granite and 932 tons of reinforcing steel.

The plaster mock-up, erected in a cornfield near Dorseyville, Allegheny County, for $50,000, was inspected thoroughly and almost immediately pulled down. Janssen and the Mellons studied the proportions before erecting "the world's most beautiful laboratory." In simplifying the design, lionheads on the cornice, echoing those on the Masonic Temple, were eliminated.

Janssen loved the large front lobby at the fourth floor, "carried out in very simple Greek Ionic architecture, of which, perhaps, the most outstanding feature is the beautiful heavy marble masonry, which is in good harmony with the weight of the exterior architecture. The detail of this room is very beautifully done."

He praised the marble bas-relief, "The Creation of Scientific Knowledge," by German-born New York sculptor C. Paul Jennewein (1890-1978), whose classic-modernity was similar to Paul Manship's. Athena, Greek goddess of knowledge, springs fully armored from the brow of Zeus. The panel is both literal and mysterious, suggesting science's eternal qualities. The tablet is a fine example of how artists in the 1930s restyled mythological imagery to suit science and energy, soon to fall away in World War II

and become a memory in the nuclear era. Today's world of computers has no such cast of characters or apparent need for them.

"An unusual feature of this hall," Janssen wrote, "is a very fine ceiling in which the coffers are all cut from solid blocks of Botticino marble, there being no joints apparent, as the joints between the coffers are hidden in a bed molding. Sixty-three coffers in the hall and twenty-seven in the vestibule are so heavy they are attached to a steel super-structure with bronze fittings.

"The floor is of thick Botticino marble with thin stripes of Nebo marble accenting squares in the floor. Botticino is used extensively and the metal of choice throughout is aluminum, produced by Alcoa, a Mellon property."

Twelve different marbles glorify the building, and everywhere one is aware of aluminum that the Mellons helped develop commercially. The building contains more of it than any other of its time: much of the roof, 400 doors, window frames, stair handrails, trim, laboratory fittings, door frames, doorknobs, escutcheons, switch plates, grilles, and pipe for distilled water. One of the most attractive decorations is Hoffman's series of window grilles in a diamond pattern on two sides of the lobby, less elaborate than his rejected one, of which there is a drawing.

From the grand exterior staircase, the visitor enters through the glass doors and vestibule and descends three wide steps to the hall. The Botticino walls and floor are a polished light tan. Aluminum plaques honoring scientific organizations are set in the floor. Despite ancient precedent, the lobby has an uncluttered moderne apppearance. A more routine entrance is at ground level on the building's Bellefield Avenue side.

Janssen described the lobby: "The lighting of this hall is splendid, being produced from four standards [marble torchieres, one in each corner] which throw the light on to the walls and ceiling in an evenly distributed effect that appears similar to sunlight. A fine part of this entrance hall consists of the twelve monolithic piers [i.e., pillars] which form the sides of the room and between which the windows occur, facing into the courts."

The light standards are carved with axioms appropriate for the time:

If there is one way better than another it is the way of Nature. — Aristotle.

The first and last thing required of genius is the love of truth. — Goethe.

Scientific education is an essential condition of industrial progress. — Thomas Huxley.

Science and peace will triumph over ignorance and war. — Pasteur.

In his essay, Janssen takes the reader on a tour of the building's features, floor by floor. These include the fourth floor's fine Renaissance-style library of English and Austrian oak with Nebo marble fireplace, and the second floor's lecture hall, designed in what he called Neo-Grec style. Walls paneled in "African wood" are inlaid with aluminum strips, Greek key patterns, and a repeating motif of two seahorses supporting a scallop shell. The stage's apron is faced in black marble flecked with tan, and dressing rooms are in each wing. A plaster coffered ceiling has running Greek key bands and soft indirect lighting.

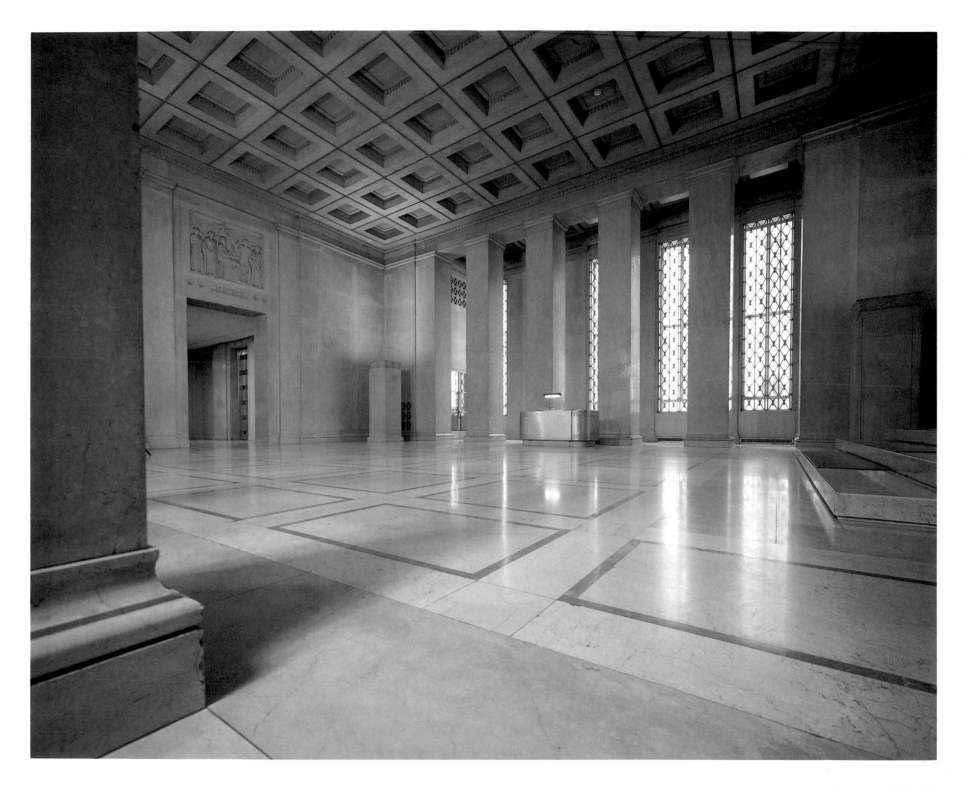

These are the institute's most beautiful spaces; but, of course, there was far more at issue in this great work committed to the sciences.

"Many problems were encountered in designing a roof for the building," Janssen wrote. "The monumental architecture of the exterior demanded a very simple plain roof without penthouses, hood flues, fume flues, pipes, etc., that necessarily must extend above the roofs of laboratory buildings. A happy solution of the roof problem was worked out... by providing what the architects have named fume gutters, approximately six feet wide, entirely surrounding the building immediately back of the attic wall and extending longitudinally over the center wing into which all exhaust flues and pipes have been extended. This arrangement gives a symmetrical roof when looking down upon the building. By placing all elevator machinery at the bottom of the elevators penthouses have been eliminated."

Janssen described the laboratories as generally of two types: small or "two-window laboratories," twelve by nineteen feet, and large, or "three-window laboratories," nineteen feet square.

"Connected with each large laboratory is a small office, six feet four inches wide by fourteen feet long, with an entry space from the corridor to the laboratory and office. The small laboratories are entered directly from the corridors.

"Laboratory floors are six inches by six inches vitrified ceramic tiles, a warm gray in color. All walls except removable court walls of the laboratories are ivory-colored matte-glazed architectural terra cotta. The removable court walls, covering the service pipes, risers, chemical drains, steam-heating pipes, and electrical conduits are one-fourth-inch thick transite with a baked-on enamel finish to match the architectural terra cotta walls."

How did the architects keep such a building beautiful but still equip it with the laboratories' needs? They developed easily accessible service pipes and electrical conduits to laboratory tables while at the same time concealing unsightly mechanical features as far as possible from view. Janssen wrote:

This was accomplished by placing all the service pipe mains in the ninth floor mechanical space, and on the first floor ceiling from which risers are extended down and up in the court walls.

Horizontal service pipes connecting with the riser pipes are placed on pipe supports in the space between the floors and the window sills. Branch pipes are valved under the tables, then extend up through the table tops and along the wall on pipe supports over the wall tables. No pipes are visible over the free-standing laboratory tables.

In these instances the pipes are valved at the court wall end of the tables and carried on pipe supports longitudinally under the center line of the tables to aluminum turrets at each end of the table top through which the service pipes extend to the valves mounted against the sides of the turrets.

Electrical conduits are carried on the same pipe racks as the service pipes. The chemical drain risers are in the court walls and the branch pipes are concealed in the laboratory tables.

Detail of library, Mellon Institute.

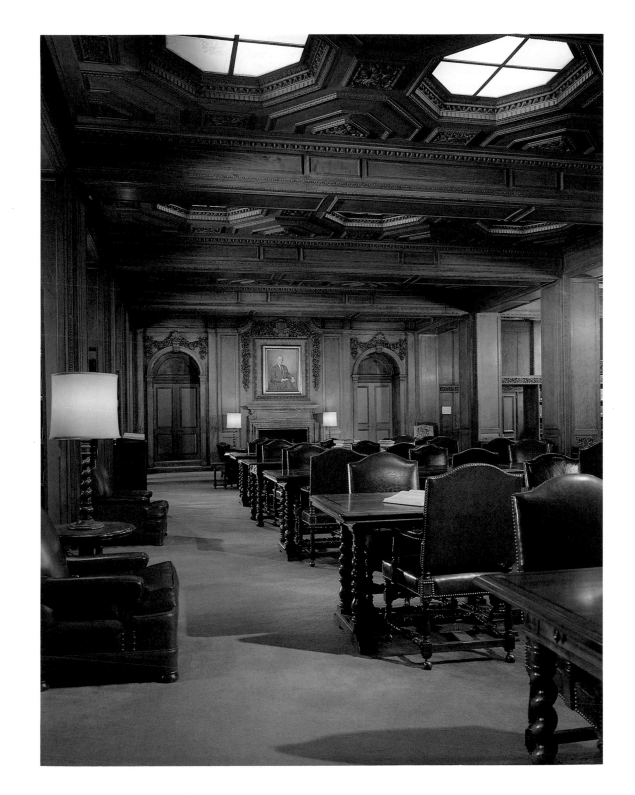

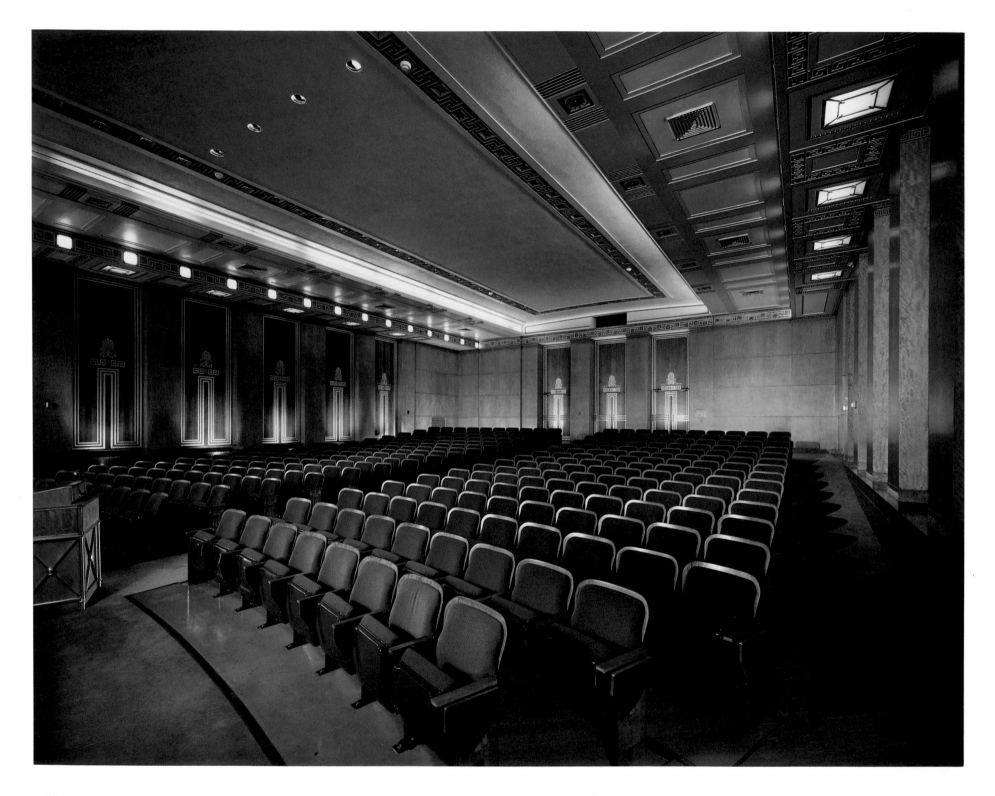

Janssen insisted on doing everything possible to make the building and its laboratories adaptable for the future. But no one could have anticipated the nuclear age, let alone the computer era. Today many of the laboratories are considered out-of-date and await conversion possibly into offices and classrooms.

As early drawings of the Mellon Institute show, grand exterior statuary had been included, however vaguely, in its plans. But the sculptures were never realized and the building's corner pedestals remain empty.

Robert Ingersoll Aitken, N.A. (1878-1949), of New York, prepared a number of allegorical maquettes. Among his accomplished works were pediment figures on the Supreme Court Building of the United States, Washington, D.C.; a bronze bust of painter George Bellows in the Metropolitan Museum of Art; and a heroic seated bronze of Benjamin Franklin Jones, founder of Jones & Laughlin Steel Corporation (1929, B.F. Jones Memorial Library, Aliquippa, Pa.).

But Frank Vittor (1888-1968), Italian-born Pittsburgh sculptor, told the author in the early 1950s that there was such a wrangle between him and others over the commission that finally R.B. Mellon threw up his hands and declared against any sculptures. Vittor did many works in Pittsburgh, but this loss, and others, were bitter disappointments.

Even artist Malcolm Parcell, no modernist but an admirer of James L. Stuart, general contractor of this and the other Mellon projects, placed imaginary abstract sculptures on the building's steps in his painting, "Mellon Institute" (Westmoreland Museum of American Art, Greensburg, Pa.).

Years later Richard King Mellon favored a plan to place on the plinths large pieces of coal and other raw materials, reflecting institute activity. That was never done, much to the relief of Janssen and others concerned with the building's design. Exterior sculpture was not placed at the National Gallery of Art's West Building, either, suggesting the fall from fashion of allegorical motifs in the modernist 1930s.

Hoffman told James Johnson, "No building has been built like Mellon Institute before and no building will be built like it again."

The Mellon brothers built well. But no architecture, at least in this country, can withstand for long the devouring nature of new ideas. One can only hope Mellon Institute receives a part of the care and attention in the future that it was given at its birth. One senses nothing was spared in its creation, and probably nothing made of masonry will be designed as supremely in our lifetime.

Facing page:
Elmhurst library, Bellefield, Janssen
and Cocken, today ...

Below:
... And as it was, circa 1938.
"Carcassonne" mural is still in place.

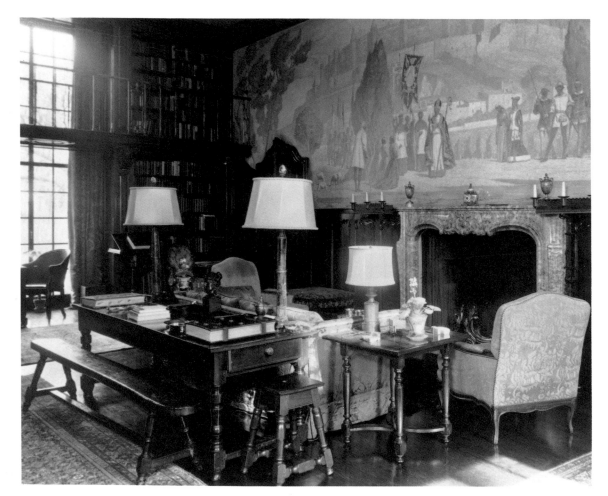

HUNT LIBRARY AT ELMHURST

This large personal library built for Mr. and Mrs. Roy A. Hunt Sr. in 1937 was an addition to Elmhurst, an Alden & Harlow Georgian house on Ellsworth Avenue, Shadyside, Pittsburgh, that the Hunts bought in 1926. One of Janssen and Cocken's finest spaces, its Edwardian stateliness seems deliberately older than it is. A balcony on three sides gives access to book shelves on two levels. The room, forty feet long, twenty-two feet wide, and fifteen feet tall, is paneled in gorgeously grained French walnut. Tall windows offer pleasant views of the gardens — designed by Janssen with Mrs. Hunt's guidance — and enough natural light to read by.

Besides books, the room is dominated by "Carcassonne," a large medieval-style mural on canvas by San Francisco native Ernest Peixotto, N.A. (1869-1940), who stayed with his wife at Elmhurst at the time of the mural's installation over a Louis XV marble fireplace. The painting's theme is based on a French poem, "Carcassonne," by Gustave Naduad, about a peasant who longed to visit but could never leave his vineyard.

Mrs. Hunt once said, "Is that not the story of each of us? Who has not had his Carcassonne or a wish or a dream that has never been fulfilled?" The walled city's turrets must have excited Janssen's memories of his visit there as much as it did Rachel McMasters Miller Hunt of hers.

After Mrs. Hunt's death, the library's priceless contents became in 1961 the heart of the 23,000-volume collection of Hunt Institute for Botanical Documentation, for which she was the driving force. The institute occupies the penthouse of the library building the Hunts gave to Carnegie Mellon University. A son, Alfred M. Hunt, razed Elmhurst but incorporated its library into his new house built around it.

The room had been fitted with two pairs of paneled aluminum doors with repeating motifs of moderne-classical figures from Alcoa's onetime headquarters in the Oliver Building, Downtown. Torrence Hunt, after his brother Alfred's death, gave the doors to the university, where they are permanently displayed on the first floor of Hunt Library.

152 ❂ THE ARCHITECTURE OF BENNO JANSSEN

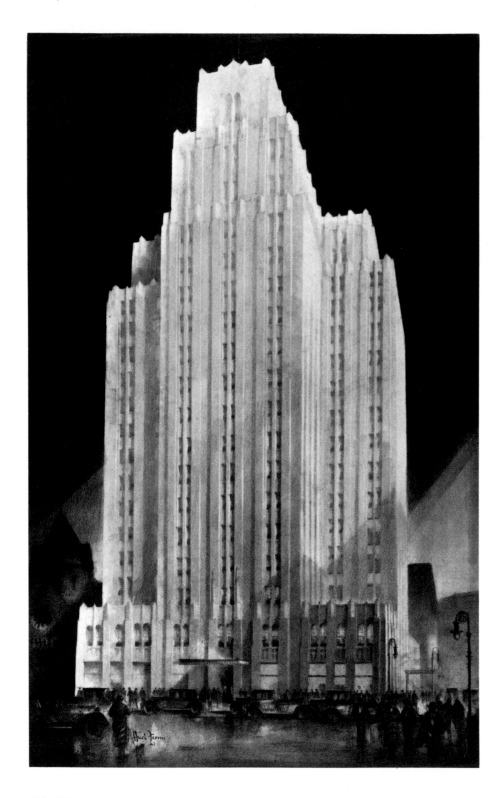

Facing page:

Left: Hugh Ferriss' drawing for proposed
Schenley Towers apartments, Fifth Avenue, Oakland,
circa 1933.

Right: Birch Burdette Long's drawing for proposed
Pennsylvania Railroad building, Pittsburgh,
circa 1929.

Right:
Drawing by J. Floyd Yewell of proposed lobby,
Pittsburgh Plate Glass Company headquarters,
circa 1937.

Below:
Yewell's drawing of proposed headquarters,
Pittsburgh Plate Glass Company,
Fifth and Bellefield Avenues, Oakland,
circa 1937.

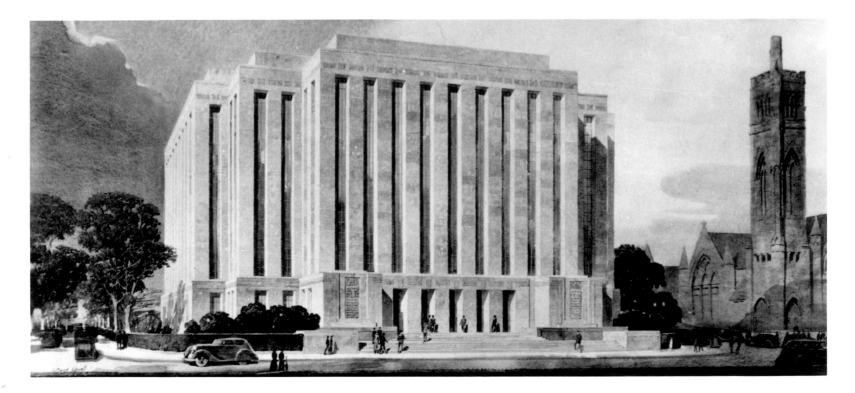

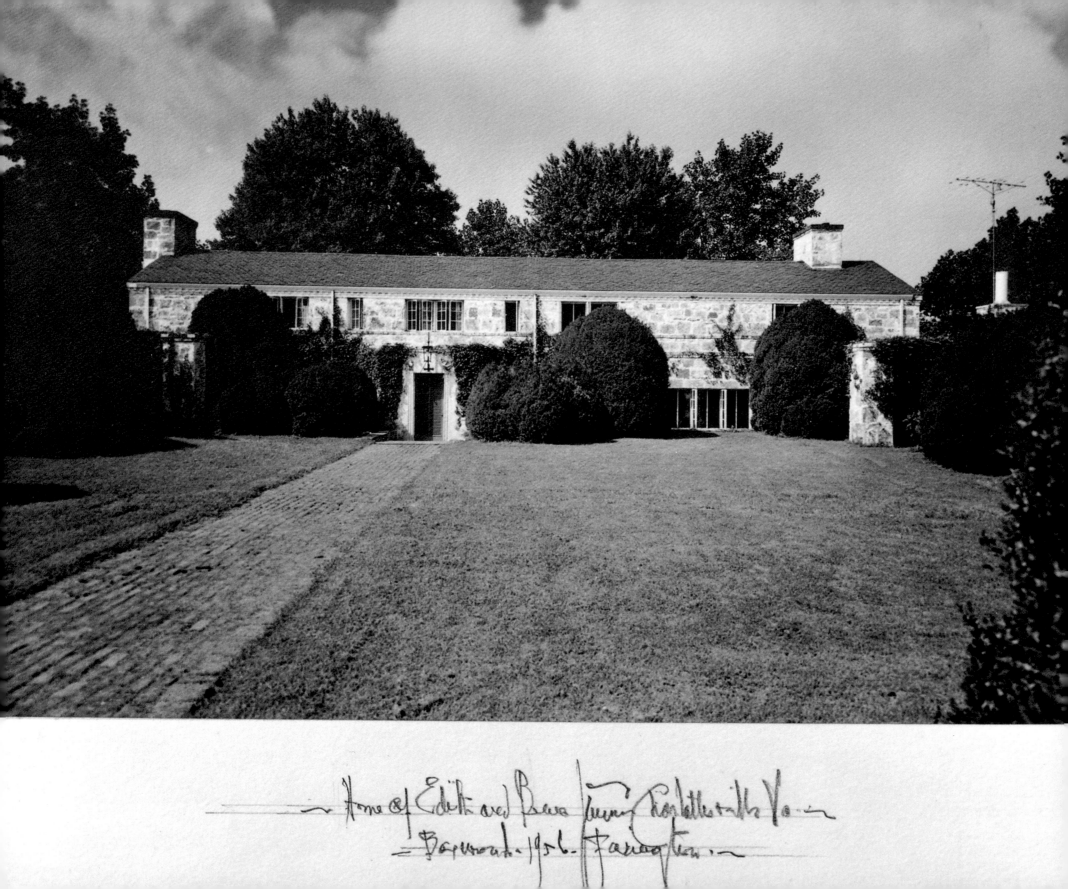

Home of Edith and Bruce Ivory Charlottesville Va.
Boxwood 1956 Farmington

Boxwood, 1940, Benno Janssen.

Benno Janssen in his seventies, about 1949.

BOXWOOD

The transition for Benno Janssen from heading a prominent office in Pittsburgh to taking on squire-like ways in Farmington must have been difficult at first. But he soon busied himself in what he loved best, architectural design. Living in a rented house with his family, Janssen would complete their retirement home in 1940. The property is within three miles of the University of Virginia.

The dwelling is comfortable and quietly refined. Janssen selected hand-cut quarried stone from Virginia's northern valley for its soft texture and hues from brown to burgundy. The roof is Buckingham slate, and the soffit is set off by simple dentiling. Windows are metal casements with brick sills and cornices. The low eighty-foot-long gable roof's horizontality is anchored by two chimneys. The one in the living room, at right, extends through the ridgepole a short distance into the roof; the one at left goes through a second floor bedroom.

The twelve-by-eighteen-foot study, Janssen's "Pittsburgh Room," extends many feet beyond the living room at right front and has its own door at the rear. Outside, a short free-standing enclosing wall in front thrusts back toward the main entrance and is matched by an identical wall off the

maid's room. A short hallway separates the study from the twenty-by-thirty-foot living room.

Brick paves the walk, and three steps descend near the front door to accentuate the approach. Inside is an eleven-by-fourteen-foot entry hall leading to the fourteen-by-twenty-foot dining room with a window bay at the rear. The living room, to the right of the entrance hall, was given large casement windows in front and rear.

On either side of the living room fireplace are two doors, the space around them lined with narrow bookshelves over cabinets. To the left of the dining room are the kitchen, pantry, laundry, storage, and two rooms for a maid. The latter rooms are one story and match the study in height. Upstairs Janssen designed four fourteen-by-twenty-foot bedrooms and three full baths. The basement holds a large storage room, laundry, and bath. The architect thought of everything, although air-conditioning would come later.

The Janssens' furnishings were eclectic and fine, mostly American and Italian antiques. A Victorian sofa with curving crest rail and exposed turned feet dominated the living room. This room also contained two overstuffed lounge chairs near a black marble fireplace and several other chairs in various styles, from seventeenth century to Windsor. The

dining room held a long two-plank Italian table with curving legs. Its chairs had similar splats and rush seats.

Then as now, the front door's limestone surround is flanked by simple fluted channels surmounted by reliefs of a standing rooster and swan on the cross lintel, on either side of a lantern by Samuel Yellin. Janssen wrote to him on October 8, 1940 about a slight problem.

> *Dear Yellin,*
>
> *Your beautiful iron lamp arrived in fine shape and it is now over the door. I will take a picture of it for you. I have never seen anything I liked better & it is a work of art. It has for companions two large boxwoods, one on each side, 14 ft. high & 15 ft. round, so they make a beautiful setting for your ironwork.*
>
> *I hope you come down to see me some day and I think the place will look pretty good in a couple of months.*
>
> *I cannot thank you too much for your kindness & interest.*
>
> *I do not see your name on the ironwork & I am sorry as I wanted that very much.*
>
> *Thanks again & hope to see you here soon.*
> *Sincerely,*
> *Benno Janssen*

He would learn from Yellin's son, Harvey, the lamp bore Yellin's small stamp where an arm joined the frame. There was also devastating news, which the architect followed with this note:

> *My dear Mrs. Yellin,*
>
> *Since writing your husband yesterday and thanking him for the beautiful lamp he made for me I have learned of his death and it is a great shock to me, as I have always been a great admirer of him and have always tried to be a good friend to him.*
>
> *The great loss to you and the children is not all as we all have lost a great artist & friend and there are so few men like him in America today. I have known him for twenty-five years and I liked him so much and had the greatest admiration for his ability & character.*
>
> *When I was in Philadelphia the first of April I sat down with him in his room at 5520 Arch Street & together we worked out an idea for my lamp. We then had lunch in his room and afterwards went out to see a beautiful house by Mellor Meigs & Howe which we both admired very much. I then left for Pittsburgh and have since corresponded quite often with him. We had a splendid time together that day and we had many others in the past.*
>
> *If I can help at any time when Harvey wants to go to work, I would love to do so when he is through school & I would very much like to meet Harvey as I have never seen him, but your husband showed me some of his lovely drawings & I had hoped to see more of them.*
>
> *Sam did so many beautiful things in Pittsburgh for us in years past, but the lamp he just made for me is really beautiful & I treasure it greatly & will always keep it…*
>
> *I feel as if so much is gone in his passing away & I*

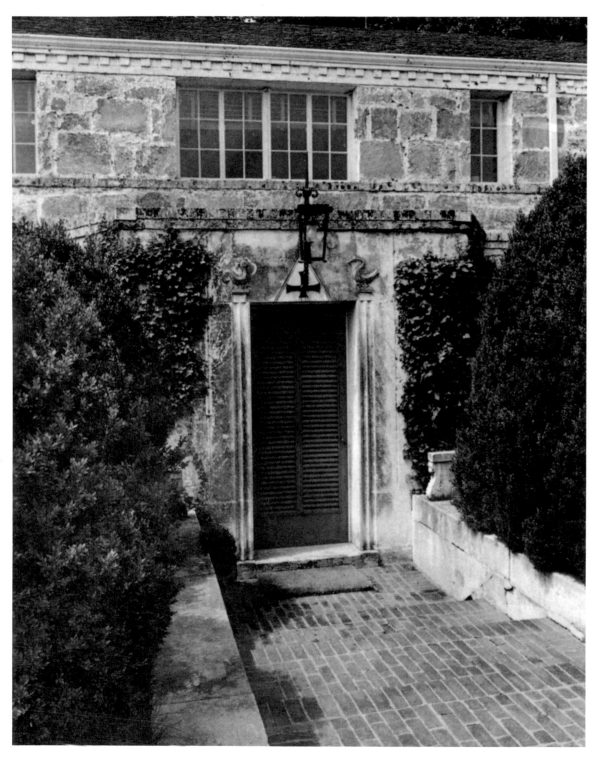

Boxwood's entrance with Yellin lamp,
sale brochure, circa 1968.

wish I could express myself more clearly. His work &
reputation [are] something for you all to be proud of &
[they] will live forever, I believe.
* Again expressing my deepest sympathy & my*
friendship & respect for Sam, I am most sincerely,
* Benno Janssen*

Samuel Yellin might have written similar sentiments
about Janssen. Fortunately, Yellin's legacy continues with
Samuel Yellin Metalworkers Inc., under his granddaughter's
direction, in an 18th century forge near Chadds Ford, Pa.

After writing this letter, Benno Janssen would have
twenty-four more years in retirement, playing golf, reading,
and remembering. Passing under that lamp, how often he
must have thought of his late friend and their experiences
together.

He must also have reflected that, although the world
was changing, he, too, could take pride in his accomplish-
ments and what had been created under his leadership. It
was enough for a lifetime.

Under him the firm had attracted national and interna-
tional attention with Mellon Institute and the Quebec pow-
erhouse. But it undoubtedly would have surprised and disap-
pointed Janssen to know he would probably be best remem-
bered today as the man who stirred in Edgar J. Kaufmann a
love of architecture, preparing him for Fallingwater, one of
the world's most admired dwellings. In the end, it was the
price tradition pays to innovation.

CATALOGUE OF PROJECTS

This catalogue consists of existing and past projects as well as those known from drawings, blueprints, period photographs, and illustrations in exhibition catalogues, magazines, and advertisements. Locations are in Allegheny County, Pa., unless otherwise noted. For further information, contact the Carnegie Mellon University Architecture Archives, Hunt Library, 5000 Forbes Avenue, Pittsburgh, Pa. 15213.

**WORKS OF
JANSSEN & ABBOTT,
1905-1918**

1905-1907:
COUNTRY CLUB, Ross Mountain, Pa., rural vernacular. Stone, slate roof. (Pittsburgh Architectural Club, 1907. Sketch.)

1907: JOHN M. ROBERTS & SONS COMPANY, jewelry merchants, Wood Street and Forbes Avenue, Downtown, Pittsburgh, early modern; extensively restyled neoclassical, 1925. (Pittsburgh Architectural Club, 1907, p. 100, Illus.)

1907-1908:
C. 1907: DUQUESNE HEIGHTS BAPTIST CHURCH, Duquesne Heights, Pittsburgh. Romanesque; brick, tile roof. (*Architectural Record*, "The Buildings of Pittsburgh" by Montgomery Schuyler, September 1911. Vol. 30, p. 251. Photo).

HOSPITAL FOR WOMEN'S MEDICAL COLLEGE, North College Avenue, Philadelphia, Pa. Italian Medievalistic. Brick, tile roof. (Pittsburgh Architectural Club, 1907. Sketch.)

1908: PORTERFIELD MEMORIAL GYMNASIUM, Western Pennsylvania School for Blind Children, North Bellefield Avenue, Pittsburgh. Renaissance Revival. Brick,

tile roof. Razed. (*Brickbuilder*, "Gymnasiums, Their Plan and Equipment," April 1909, p. 69. Photos. *Builder*, December 1910. Pl. between p. 18-35. *Architectural Record*, "The Buildings of Pittsburgh" by Montgomery Schuyler, September 1911, p. 263. Photos.)

WESTERN UNIVERSITY (University of Pittsburgh campus), Oakland, Pittsburgh. Competition entry. (American Competitions, 1908, pp. 45-47. *Architectural Review*, July 1908, pp. 117-120. Plan, elevation, section.)

1908: YOUNG WOMEN'S CHRISTIAN ASSOCIATION, Chatham Street, East Liberty, Pittsburgh. Renaissance Revival. Razed. (*Brickbuilder*, February 1911. Pl. 26-27. Following p. 44. Plans. Elevation. Photo. *Builder*, April 1912, p. 11. Pl. between pp. 18-36.) Its mansard roof with Dutch elements was at odds with its classical mass but provided more rooms. Pedimented windows and doors were precursors of William Penn Hotel, Downtown YMCA, Twentieth Century Club.

1909-1911:
1909: ARROTT HOUSE, 4205 Bigelow Boulevard at Lytton Avenue, Schenley Farms, Oakland, Pittsburgh. Tudor Revival: brick, stucco, and half-timber; tile roof. Remodeled in 1926. (*Brickbuilder*, January 1910. Vol. 19, No. 1, p. 8. Photos, plans.)

1909-11: FORT PITT HOTEL, eleven-story tower addition, Tenth Street and Penn Avenue, Pittsburgh. Renaissance Revival. Brick, steel frame, tile roof. Razed 1967. Contained Norse Room, designed with John Dee Wareham, of Rookwood Pottery, Cincinnati. Salvaged paneling from Elizabethan Room installed in Concordia Club

lobby and bar, O'Hara Street, Oakland. (Pittsburgh Architectural Club, 1910. *Builder*, September 1905. Vol. 27, p. 6. Pl. between pp. 18-35. Photo. *Brickbuilder*, "The Norse Room," April 1910. Vol. 19. No. 4. pp. 103-105. Pl. 51, 52. "A Rookwood Room," *Architectural Record*, April 1911. Vol. 29, No. 4, pp. 345-354. Photos. "The Monumental Treatment of the Fireplace" by David E. Fulton. December 1914. P. 300. Photo. Elevation. *Architectural Review*, April 1913. Vol. 2, p. 166. Photos.)

1909: FRANKLIN F. NICOLA HOUSE, Schenley Farms, Oakland, Pittsburgh. Not known.

Greensburg Country Club, Greensburg, Pa. Italianate. (Pittsburgh Architectural Club, 1910. Sketch.)

C. 1909: S.M. VAUCLAIR HOUSE, Pittsburgh. Slate roof. (Pittsburgh Architectural Club, 1909, p. 229, illus.)

1909-11: PITTSBURGH ATHLETIC ASSOCIATION, Fifth Avenue and Bigelow Boulevard, Oakland, Pittsburgh. Renaissance Revival. Inspired by Sanmicheli's Palazzo Grimani, Venice, 1549, and Sansovino's library of St. Mark's Basilica, Venice, 1536. (*Architecture*, "Proposed Building," February 1909, pp. 26-27. Pl. XIV. Following page 32. Plans. *Builder*, August 1909, pp. 11-14. Pl. between pp. 18-35; September 1912. Pl. between pp. 18-35. Pittsburgh Architectural Club, 1910. *Builder*, May 1911. Pl. between pp. 18-35. *Brickbuilder*, July 1911. Pl. 88-92. Following p. 158. Plans, elevations, photos. *Architectural Record*, "The Buildings of Pittsburgh" by M. Schuyler, September 1911, pp. 234-238. Photos. Pittsburgh Architectural Club, "Medallion by Atlantic Terra Cotta Company," 1919. *Art and Archaeology*, "Pittsburgh Architecture" by Alfred B. Harlow, November-December 1922, p. 285. Photo. *Winged Head*, Pittsburgh Athletic Club, Fiftieth Anniversary Publication of the P.A.A.: "The Stones of Venice in Pittsburgh: The Pittsburgh Athletic Association Clubhouse," "Athletes and Steel Mills: A Commentary," "On the Club's Art Collection" by James D. Van Trump, April 1961. "Seventy-fifth P.A.A. Anniversary," 1985.)

FRANKLIN ABBOTT HOUSE, 5356 Darlington Road, Pittsburgh. Tudor Revival; brick, slate roof. Razed. (Pittsburgh Architectural Club, 1910. Vol. 5, p. 52. Ibid. 1911. "The Houses of Pittsburgh," M. Schuyler, *Architectural Record*. September 1911. Vol. 30 No. 3, pp. 280-281. Photos.)

GEORGE W. NICOLA HOUSE, 4411 Bayard Street, Schenley Farms, Pittsburgh. English vernacular, brick, stucco, shingled roof. (Pittsburgh Architectural Club, 1911. *Architectural Record*, May, October 1912, frontispiece. *Western Architect*, May 1911. *Brickbuilder*, January 1910. Pl. 7 between pp. 10-11. Plans, photos.) One of Janssen's most eclectic houses.

D.H. HOSTETTER JR. HOUSE, 4107 Bigelow Boulevard, Schenley Farms, Pittsburgh. Tudor Revival, brick, slate roof. (*Brickbuilder*, March 1911. Pl. 35. Plans, photos. *Builder*, January 1916, p. 10. Pl. between pp.18-35. Photo. *Bulletin Index*, November 19, 1936. *The Pittsburgh Press*, July 17, 1938. *Pittsburgh Post-Gazette*, July 18, 1938.)

J. WALTON COOK HOUSE, 5423 Darlington Road, Squirrel Hill, Pittsburgh. (*Builder*, December 1909, p.9. Pl. (sketch) between pp. 18-36. Pittsburgh Architectural Club,

1911, p. 97.) Tudor Revival. Rear abutted W. L. Mellon's Ben Elm but was separated from it by high stone wall, still standing. Red brick house with exterior, interior Roman arches, steep front gable, side entrance and porch, watertable. Edgar J. Kaufmann once rented it.

GEORGE H. CALVERT HOUSE, 2538 Middle Road, Hampton Township. Vernacular; stone, timber, slate roof. Burned in 1930s and rebuilt. Made into five apartments, now a single dwelling. (Pittsburgh Architectural Club, 1912. *Builder*, April 1912, pp. 11-12. Plates pp. 18-36. *Country Life in America*, July 15, 1912, pp. 30-31. *House Beautiful*, April 1912, pp. 129-133. *House and Garden*, May 1912, pp. 40-41. Photos, plan. *Architectural Record*, "The Homes of Pittsburgh." September 1911 p. 282. Photo. *Architectural Record*. "Country House Design in the Middle West, Recent Work by Janssen & Abbott of Pittsburgh" by C. Matlack Price. October 1912, pp. 336-348. Plans, photos. *Architecture*, January 15. 1912, pp. 14-15. Plans, photos.) *Pittsburgh Post-Gazette*, "Estate Now a Home," June 4, 1997.

KIPP APARTMENTS, four stories, Georgian Revival, Negley Avenue and Elmer Street, Shadyside, Pittsburgh. (Pittsburgh Architectural Club, 1910.) Charming white-painted wooden roof railing and similar trim are gone but this red brick block appears to be well-maintained.

FIRST CHURCH OF CHRIST SCIENTIST, Youngstown, Ohio; Georgian Revival. (Pittsburgh Architectural Club, 1910. *Architecture*, January 15, 1912, p. 10, pls. X-XII. Photo, plan.)

THOMAS A. MCGINLEY HOUSE, Sewickley Heights.

Mission Revival. Samuel Yellin metalwork. Designed for first chairman, Duquesne Light Company. The building sits high on a terrace. "Country House Design in the Middle West" by C. Matlack Price, *Architectural Record*, October 1912, pp. 336-348. Plans, photos. *House and Garden*, "The Residence of Thomas A. McGinley, Sewickley Heights, Penn.," March 1914, pp. 192-193. *The Builder*, January 1915. Plans, photos. *Builder*, December 1915, pp. 9-11. Pl. between pp. 18-35. *Western Architect*, April 1917. Pl. after p. XVI.

JOSEPH T. MILLER STABLES, Edgewood. Vernacular stucco, stone, shingle roof. (Pittsburgh Architectural Club, 1912. C. Matlack Price, *Architectural Record*, October 1912, pp. 336-348. Location, status unknown.)

C. 1910: IDA H. CHANDLER HOUSE, Parkman Avenue near Bigelow Boulevard. Schenley Farms, Oakland, Pittsburgh. (*American Architect*, September 6, 1911, p. 14.)

FIRST BAPTIST CHURCH, Oakland, Pittsburgh competition; second place entry. Pittsburgh Architectural Club, 1910. *Architectural Record*, February 1910, pp. 19-20. Pl. 13-24.)

C. 1910: JOHN E. KANE HOUSE, Shady and Wilkins Avenues, Squirrel Hill, Pittsburgh. (Pittsburgh Architectural Club, 1910, p. 43.) Sketch.

MRS. E.R. MARVIN HOUSE, 6699 Kinsman Road, Point Breeze; Vernacular, stucco, brick, tile roof. Brick window surrounds have toothed pattern (now painted white). Roman porch arches long converted to windows. Door placement changed. Entrance off driveway. (*Architectural Record*, "The Homes of Pittsburgh" by M. Schuyler, 1911.

Vol. 30, No. 3, p. 278. Photo.)

1911: WILLIAM E. TRAINER HOUSE, 12 Fairmont Avenue, Duquesne, Pa. Colonial Revival. Stucco on terra cotta tile, shingled roof. (*Architectural Record*, October 1912, pp. 336-348. Plans. Photo. *Architecture*, March 1912, pp. 26-47. Plans, photos. (See 1939.)

BAGATELLE, Little Sewickley Creek Road, Edgeworth. West porch and incomplete plan for a solarium.

JACOB L. KENDALL HOUSE, Woodland Road, Pittsburgh, or possibly Edgeworth. Renaissance Revival; stucco, terra cotta, flat roof, cornice balustrade. Except for roof treatment drawing resembles Van Vorhis house, Sewickley Heights, architect unknown; but arched windows and french doors suggest Janssen.(*Builder*, April 1911, p. 12. Pl. between pp. 18-25, sketch. *Architectural Record*, "The Homes of Pittsburgh" by M. Schuyler, September 1911, p. 265, sketch. *Architecture*, March 1912, pp. 44-45. Plans, sketches. *Architectural Record*, October 1912, pp. 336-348.) Beautiful design with wings and balustered cornice received attention but was probably either not built as drawn or perhaps not built at all.

1912-13: KAUFMANN'S DEPARTMENT STORE; thirteen-story addition replaced 1878 store, Smithfield Street and Fifth Avenue, Pittsburgh. White glazed terra cotta exterior in fine Renaissance Revival patterns. (*Architecture and Building*, July 1914, pp. 258-267.)

ROSEMONT, elaborate Renaissance Revival mansion for John W. Converse, Philadelphia area? Not built. (Pittsburgh Architectural Club, 1912, sketch.)

1913: YOUNG WOMEN'S CHRISTIAN ASSOCIATION BUILDING, Harrisburg, Pa. Colonial Revival with mansard roof. (*Builder*, August 1913. Pl. between 18-35.) Competition drawing.

1913: BUHL BUILDING, formerly Nicola Building, 205 Fifth Avenue between Market Street and McMasters Way, Downtown, Pittsburgh. James L. Stuart Co., later Mellon Stuart, was contractor. This six-story Italianate office tower with embossed blue and white terra cotta tile in Renaissance Revival patterns (similar to Kaufmann's Department Store) is unique. Original tile window surround still exists on McMasters Way. Sadly contemporized first floors, interior cry for restoration. (*Builder*, August 1913, p.4. Pl. between pp. 18-35.) (*A Guidebook to Historic Western Pennsylvania* by George Swetnam and Helene Smith. University of Pittsburgh Press, p. 7.)

1914: KAUFMANN'S DEPARTMENT STORE ADDITION, Cherry Way, Downtown, Pittsburgh.

MASONIC TEMPLE, 4227 Fifth and Lytton Avenues, Oakland, Pittsburgh. Classical Revival. Huge proportions in exterior Greek temple doors, tall lobby, massive banquet hall, basement kitchen, lodge rooms, auditorium. Three sides limestone, rear white brick. University of Pittsburgh purchase, 1993. (*Builder*, April 1913, p. 12. Pls. between pp. 18-35. Photos. *Pittsburgh Post-Gazette*, "New Life for a Landmark" by Donald Miller, Feb. 9, 1993, pp. D 1-2.

1914: WOODSIDE, 130 Woodland Road, Edgeworth. Georgian, three story house. Red brick, tile roof. Large house reflects some Alden & Harlow influence, and Delano and Aldrich, New York. House has large comfortable rooms, sits on low terrace on corner lot. (*Pittsburgh Post-*

Gazette, "Edgeworth's Woodside" by Donald Miller, May 2, 1993.)

1914-16: HOTEL PENN MCKEE, McKeesport. Building stands at this writing between needed rehabilitation after fire and demolition.

J. HANSON ROSE HOUSE, Pittsburgh. Colonial Revival. Wood siding, tile roof. Drawing. (Pittsburgh Architectural Club, 1915. *American Architect,* February 2, 1916. Sketch.) Status, location not known.

C. 1914: JAMES E. ROGERS SCHOOL, now Rogers School for the Creative & Performing Arts, 5525 Columbo Street, Pittsburgh. Renaissance Revival. Brick, tile roof. (*Builder,* March 1915. Pl. between pp. 18-35. Pittsburgh Architectural Club, 1916.) City school retains its massive Italianate form dear to Janssen.

1914-1916: WILLIAM PENN HOTEL (WESTIN), twenty stories, William Penn Way, Grant Street, Downtown, Pittsburgh. Pittsburgh's grand hotel. Renaissance Revival. Brick, limestone, terra cotta, steel frame. Contractor: George A. Fuller Company, New York, N.Y. (Pittsburgh Architectural Club, 1915. *Builder,* February 1915. Pl. between pp. 18-35, sketch; March 1916. Plates between pp. 18-35. (Grant Street addition, 1927-1929). (*American Architect,* February 17, 1915, Pl. 2043. Sketch. *Architecture and Building,* March 1915, pp. 104-125; May 1916, pp. 71-78. *National Architecture,* April 1916, pp. 89-90. Pl. 25-40. *Brickbuilder,* July 1916, pp. 186-187. Pl. 102-105. Plans, sketch, photos.) For the hotel's addition Joseph Urban designed the Urban Room, seventeenth floor, and Chatterbox Room, basement night club, 1933. Retains

carved green glass panels probably designed by Urban.

PITTSBURGH TUBERCULOSIS HOSPITAL, Bedford Avenue and Wandless Street, Hill District, Pittsburgh. Tudor Revival. Painter John Kane (1860-1934) died here.

C. 1914: FORT PITT LAUNDRY BUILDING. (*The Builder,* December 1915. Photo.) Eleven-story red brick building had at top a semi-circular roofline, perhaps a false front, with three window bays at the top. Location was possibly in The Strip, Pittsburgh. Status unknown.

THE ALUMINUM CLUB, former Alcoa recreation building, Citizens General Hospital owner, 200 Freeport Road, New Kensington, Pa.

1917-18: ST. BARNABAS SHELTER FOR MEN, Meridian Road, Gibsonia, Pa.

ANSON E. CARNILL HOUSE, Abington Township, Montgomery County, Pa. Palacelike Georgian house. Not built.

C. 1917: EAST END CHRISTIAN CHURCH, Walnut Street and Shady Avenue, Pittsburgh. Colonial Revival. Location, status unknown.

1919-21: Alteration and addition, E.W. PARGNY HOUSE, 1034 Beechwood Boulevard, Squirrel Hill, Pittsburgh. Built 1919-20.

1919-1924: WASHINGTON CROSSING BRIDGE with engineer Charles Stratton Davis. Between Fortieth Street, Arsenal, Pittsburgh, and Millvale. Steel and concrete. Neoclassical-moderne. Dedication December 29, 1924. (Dedication booklet, n.d., pp. 18-19, Historical Society of Western Pennsylvania. *Discovering Pittsburgh's Sculpture* by Marilyn Everett; photos by Vernon Gay, University of

Pittsburgh, 1983.)

1920-21: ALUMNI HALL, University of Pittsburgh, University Drive, Oakland, Pittsburgh. Three stories with basement. Janssen stayed with Hornbostel's educational acropolis for this science building erected with alumni funds. Dedicated to George Wilkins Guthrie, mayor of Pittsburgh, 1908-09; ambassador to Japan, 1913-17. Restrained neoclassic style.

1920-23: JOHN HARTWELL HILLMAN HOUSE, 5045 Fifth Avenue, Pittsburgh. Drawings. Not built.

1921-24: LONGUE VUE CLUB, Nadine and Lincoln Roads, Penn Hills. (*Western Architecture*, June 1925. Vol. 34, p. 60; August 1930. Vol. 39, p. 122. Pl. 119. *The Architect*, July 1928. Vol. 10, pp. 499-513. Photos. *Architectural Record*, July 1930. Vol. 68, pp. 45-47. Plan, photos.)

1922-23: HARRY B. CROFT HOUSE, 100 Clapboard Ridge Road, Greenwich, Conn. Colonial Revival, brick, slate roof. (*Architecture*, February 1923. Vol. 47, pl. 23-29. Plans, photos.)

1922: JOSEPH HORNE COMPANY north addition, Penn Avenue, Stanwix Street, and Fort Duquesne Boulevard, Downtown, Pittsburgh. Now Penn Avenue Place, Venetian Renaissance.

1923: YOUNG MEN'S CHRISTIAN ASSOCIATION, 304 Wood Street and Third Avenue, Downtown, Pittsburgh. Sixteen stories. Now Wood Street Commons. Neoclassic. Exterior limestone ornament. Stone, brick, steel frame. (*The Pittsburgh Press*, "For Sale: YMCA,"

September 9, 1981, p. A-15.)

1924: YOUNG MEN & WOMEN'S HEBREW ASSOCIATION, 315 South Bellefield Avenue, Oakland, Pittsburgh. Now Bellefield Hall of University of Pittsburgh. Renaissance Revival. After Palazzo Piccolomini della Papesse, Siena, Italy. Brick, limestone, tile roof. Samuel Yellin ironwork. Elaborate coffered ceiling of two-story auditorium (*Architectural Record*, March 1923, "Pittsburgh Architectural Club Exhibition," p. 282. Sketch.)

EDWARD A. WOODS HOUSE, Sewickley, Pa., Colonial Revival. Stucco, tile roof. Drawing. (*Architectural Record*, November 1924, p. 131.)

1924-25: LA TOURELLE, 8 La Tourelle Lane, Fox Chapel (formerly Aspinwall). Norman Revival. Two-story house. Separate children's, servants quarters. Semi-attached garage with apartment/studio. Handmade brick, Vermont slate roof, stone retaining walls. Samuel Yellin ironwork. Edgar J. Kaufmann first owner. Many subsequent ones, including University of Pittsburgh. Landscape architect Albert D. Taylor. Decorator Chamberlin Dodds. (*Country Life*, New York, July 1928. Vol. 54, pp. 57-60. Photos. *The Architect*, August 1928. Vol. 10, pp. 611-629. Photos. *Architectural Record*, July 1930. Vol. 68, pp. 47-48. Plan, photos. "Public Votes on Architecture in Pittsburgh" by Benjamin F. Betts, *American Architect*, June 1930. Vol. 137, pp. 34-35. Photo. *Pittsburgh Post-Gazette*, "Pitt Given Fox Chapel Chateau" by Alvin Rosensweet, January 23, 1963. "Life and Architecture in Pittsburgh" by James D. Van Trump. *Pittsburgh History & Landmarks Foundation*, Pittsburgh, 1983. P. 115. Photo.)

**WORKS OF
JANSSEN & COCKEN,
1922-38**

SMITHFIELD STREET AND SIXTH AVENUE LAND COMPANY BUILDING, Downtown, Pittsburgh. Razed.

C. 1924: LEE L. CHANDLER HOUSE, Amberson Place, Shadyside, Pittsburgh.

DR. GEORGE L. HAYS HOUSE, 1300 Inverness Avenue, Squirrel Hill, Pittsburgh. Colonial Revival, brick, slate. Barrel-vaulted master bedroom. Original fireplace removed from living room.

1925: Janssen and associate architect E.J. Hergenroeder: ANNUNCIATION SCHOOL, Charles Street and Linwood Avenue, North Side, Pittsburgh.

1927: STOUFFER'S RESTAURANT, Penn Avenue and Mentor Way, Downtown Pittsburgh. Building now Allegheny County welfare offices. STOUFFER'S RESTAURANT, Smithfield Street and Sixth Avenue Building, Smithfield Street, Downtown, Pittsburgh. Razed. Contractor: Patterson & Shaw. (*Charette*, April 1927. p. 14.). STOUFFER'S RESTAURANT, Wood Street and Forbes Avenue, Downtown, Pittsburgh. Space totally changed.

1927-1930: KAUFMANN'S DEPARTMENT STORE RENOVATION, Downtown, Pittsburgh. Janssen and Cocken did simpler design than Joseph Urban's first floor drawings.

PENN-LINCOLN HOTEL, Wilkinsburg. Brick, six stories and basement. Contractor: E.Z. Peffer.

1927: UNION SWITCH & SIGNAL COMPANY administration building, Braddock Avenue, Swissvale. Brick. Now converted to offices.

CHURCH OF THE ASCENSION (Episcopal), Ellsworth Avenue and North Neville Street, Bellefield, Pittsburgh. Memorial vestibule. (*Charette*, February 1927, p. 14.)

THREE ENGLISH VERNACULAR BRICK AND STONE HOUSES, 2, 6, and 8 Robin Road, Squirrel Hill, Pittsburgh. (Two Robin Road was designed for William York Cocken.)

THOMAS RODD HOUSE, Beechwood Boulevard at Dallas Avenue, Squirrel Hill, Pittsburgh.

WESTINGHOUSE AIR BRAKE ADMINISTRATION BUILDING addition, Wilmerding, Pa. French Renaissance Revival. Four stories and attic. Brick, stone. Contractor: F. Hoffman Company.

1928: ROLLING ROCK CLUB STABLES AND KENNELS for Richard B. Mellon, Route 381, Ligonier, Pa. And some clubhouse rooms. E.P. Mellon did clubhouse and water tower/observatory.

KEYSTONE ATHLETIC CLUB, Wood Street and Boulevard of the Allies, Downtown, Pittsburgh. Later Sherwyn Hotel, now David L. Lawrence Hall, Point Park College. Twenty-one stories. Based on Mediterranean Gothicism of fourteenth-fifteenth centuries with art moderne elements. Brick, stone, steel frame. Contractor: Mellon Stuart Company. (*American Architect*, "Public Votes on Architecture in Pittsburgh," June 1930. Vol. 137, pp. 34-35. A *Guidebook to Historic Western Pennsylvania* by George Swetnam. University of Pittsburgh Press, 1976, p. 7.)

PHILLIPS GAS & OIL COMPANY BUILDING, Main and North Streets, Butler, Pa. Renaissance Revival. Three stories. Florentine palace style.

C. 1928; LIBRARY ADDITION, HILLIARD HOUSE, Aylesboro Avenue, Squirrel Hill, Pittsburgh. Wood paneling, ceiling plaster work recalls Janssen's English taste, as in Panel Room, Westin William Penn.

WILLIAM WATSON SMITH (Frick attorney) HOUSE, Laughlintown, Pa. Colonial Revival. Painted brick, shingled roof. (*Pencil Points*, "Some Recent Renderings by John Richard Rowe," August 1929, p. 548. Sketch.)

1929-1931: ELM COURT for Benjamin D. Phillips, Cliff Street, Butler, Pa. Forty rooms, many chimneys, randomly coursed Vermont slate roof. Tudor Gothic Revival. Furnishings sold at auction 1978. Exterior limestone renovation in early 1980s. Extensive renovations by Charles Young & Associates, New York; Felhandler/Steeneken, New York. (*Pittsburgh Post-Gazette*, "Butler Pair Study the Past to Restore Fantasy House" by Donald Miller, June 19, 1982, pp. 17, 25. *The Pittsburgh Press*, "40-Room Butler Mansion Sold for $1 million" by Patricia Lowry. *Butler Eagle*, "Frederick R. Koch Renovates 40-Room Mansion" by Sally R. Miller, December 1, 1988, p. 39. *Pittsburgh Business Times*, "Mystery Mansion" by Elizabeth Raffaele, December 18-24, 1995, pp. 1,29. Elevation, photos.)

TWENTIETH CENTURY CLUB, Bigelow Boulevard and Parkman Avenue, Oakland, Pittsburgh. Renaissance Revival. Five stories. Stone, brick, steel frame, tile roof. Complete reworking and addition to 1910 Neoclassical building. (*Pittsburgh Post-Gazette*, "Club Women to Build $500,000 Home in Oakland," January 18, 1929. Elevation. *Pittsburgh Sun-Telegraph*, "Changed 20th Century Club Is Last Word in the Artistic," October 4, 1930. *The Pittsburgh Press*, "Twentieth Century Club Nearing Completion, October 5, 1930." *Good Furniture and Decoration*, "The New 20th Century Club of Pittsburgh" by Althena Robbins, September 1931, pp. 107-113. Photos. *Bulletin Index*,

November 6, 1930, p. 11. Photo. *Charette*, "Faces of City Clubroom" by James D. Van Trump, August 1962, pp. 14-17. *Discovering Pittsburgh's Sculpture* by Marilyn Everett; photos by Vernon Gay. University of Pittsburgh Press, Pittsburgh, 1983. P. 207. Photo.)

HARRY DARLINGTON HOUSE. Colonial Revival, Darlington Road, Sewickley Heights. (*Pencil Points*, "Some Recent Renderings by John Richard Rowe." August 1929. Vol. 10, p. 548. Drawing.)

1927: RALPH MARSHALL DRAVO HOUSE, Way Hollow Road, Sewickley Heights. English vernacular, brick. Similar in some ways to R. Clipston Sturgis' 1929 Elizabethan Revival house, Edgeworth, for James C. Chaplin. (Ibid., p. 547. Drawing.)

1929: HENRY B. HIGGINS HOUSE, Sewickley Heights, Pa. English vernacular.

1929-1931: ADDITION TO DUQUESNE CLUB, 325 Sixth Avenue, Downtown, Pittsburgh. Moderne exterior, barber shop, health spa, etc. Neo-Romanesque garden patio. Brick, stone, steel frame. (*The History of the Duquesne Club* by Mark M. Brown, Lu Donnelly, and David G. Wilkins, 1989. Hoechstetter Printing Co., Pittsburgh. Pp. 73-82, 173. Photos. Duquesne Club, publisher. Penelope Redd, "Art in the Business World," *Pittsburgh Sun-Telegraph*, January 3, 1932.)

1930: J. LEONARD JOHNSON HOUSE, New Brunswick, N.J., owned by Thomas W.S. Craven. Unknown.

SANFORD HOUSE, Scott Township. Unknown.

1931: FANNY EDEL FALK ELEMENTARY SCHOOL, of University of Pittsburgh, Allequippa Street, Oakland,

Pittsburgh. Stone Tudor.

CENTRAL POWERHOUSE FOR DAM, Chute-a-Caron, Saguenay River, northern Quebec Province, Canada. Hydroelectric project for Arvida, now Jonquière, industrial city built by Aluminum Company of America. (*Pencil Points*, "Some Recent Renderings by John Richard Rowe." August 1929. Vol. 10, p. 545. Sketch.)

1931-37: MELLON INSTITUTE OF INDUSTRIAL RESEARCH, 4400 Fifth Avenue, Oakland, Pittsburgh. Neoclassical and art moderne. Contractor: Mellon Stuart Company. ("Behind These Columns: Dedication of the New Building to Science and Humanity for Andrew W. Mellon and Richard B. Mellon, Pittsburgh, 1937." *Architectural Record*, May 1935, p. 12. *Pittsburgh History*, "Building a Temple of Science" by Cathy A. Wilson. Winter 1994-95. Vol. 77. No. 4, pp. 150-158. Janssen & Cocken, "General Description of New Building," Pittsburgh, 1936. *Pittsburgh Sun-Telegraph*, "Full-Size Model of End of New Institute Made to Avoid Mistakes," July 24, 1931.)

1931: FRANK B. INGERSOLL HOUSE, R.D.2, Sharpsburg, O'Hara Township, Pa. Ellen Biddle Shipman did the gardens.

C. 1931-36. PITTSBURGH COUNTRY CLUB proposed apartment clubhouse. Not built.

C. 1934-35: PHILIP A. FLEGER HOUSE, Fox Chapel, Pa.

JEROME HILL HOUSE, Hill Crest, Scaife Road, Sewickley Heights, Pa.

J. HANSON ROSE HOUSE, Sewickley Heights, Pa.

1937: LIBRARY, ELMHURST, Roy A. Hunt Sr. house, 4875 Ellsworth Avenue, Pittsburgh. Preserved in new house on site.

1939: WILLIAM B. TRAINER HOUSE. Brick. Slate roof. Scaife Road, Sewickley Heights, Pa.

VERNER PURNELL HOUSE, Persimmon Road, Sewickley Heights, Pa. Colonial Revival.

1940: BOXWOOD, Benno Janssen house, 5 Blue Ridge Road, Farmington, Charlottesville, Va.

1945: A. PATTON JANSSEN HOUSE, Old Farm Road, Bellair, Charlottesville, Va.

BIBLIOGRAPHY

A MONOGRAPH OF THE WORK OF MELLOR MEIGS & HOWE. The Architectural Book Publishing Company; Paul Wenzel & Maurice Krakow. New York, N.Y. 1923.

AMERICA'S NATIONAL GALLERY OF ART: A GIFT TO THE NATION by Philip Kopper. Abrams. New York, N.Y. 1991.

ARCHITECTURAL RENDERINGS BY WINNERS OF THE BIRCH BURDETTE LONG MEMORIAL PRIZE. Edited by Minor L. Bishop. Architectural League of New York. New York, N.Y. 1965.

THE ARCHITECTURE OF CHOICE: Eclecticism in America, 1880-1930, by Walter C. Kidney. Braziller, New York, N.Y. 1974.

THE ARCHITECTURE OF RICHARD MORRIS HUNT. Edited by Susan R. Stein. The American Institute of Architects Foundation. The University of Chicago Press. Chicago, Ill. 1986.

B.D. PHILLIPS: LIFE AND LETTERS by James DeForest Murch. Privately printed. The Standard Printing Company, Inc., Louisville, Ky. 1969.

DISCOVERING PITTSBURGH'S SCULPTURE. Text by Marilyn Evert. Photographs by Vernon Gay. University of Pittsburgh Press. 1983.

DOMESTIC ARCHITECTURE BY H.T. LINDEBURG. Introduction by Royal Cortissoz. William Helburn Inc., New York, N.Y. 1940.

SEVEN VICTORIAN ARCHITECTS. Edited by Jane Fawcett. The Pennsylvania State University Press. University Park, Pa. 1977.

STYLES AND TYPES OF NORTH AMERICAN ARCHITECTURE: Social Function and Cultural Expression by Alan Gowans. Icon Editions, HarperCollins. New York, N.Y. 1992.

HISTORIC HOUSES OF THE SEWICKLEY VALLEY. Text by Stephen Neal Dennis. Photography by William J. Penberthy. Preservation Edgeworth. Edgeworth, Pa. 1996.

THE HISTORY OF THE DUQUESNE CLUB by Mark M. Brown, Lu Donnelly, and David G. Wilkins. Duquesne Club. Pittsburgh, Pa. 1989.

HOUSES AND GARDENS BY E.L. LUTYENS by Lawrence Weaver, 1913. Reprinted by Antique Collectors' Club Ltd., Woodbridge, Suffolk, England, 1987.

LANDMARK ARCHITECTURE: PITTSBURGH AND ALLEGHENY COUNTY by Walter C. Kidney. Pittsburgh History & Landmarks Foundation. Pittsburgh, Pa. 1985.

LANDMARK ARCHITECTURE OF ALLEGHENY
COUNTY by James D. Van Trump & Arthur P. Ziegler
Jr. Pittsburgh History & Landmarks Foundation.
Pittsburgh, Pa. 1967.

JOSEPH URBAN: ARCHITECTURE, THEATER,
OPERA, FILM by Randolph Carter and Robert Reed
Cole. Abbeville Press, New York, N. Y. 1992.

PITTSBURGH: An Urban Portrait by Franklin Toker. The
Pennsylvania State University Press. University Park,
Pa. 1986.

ARTICLES

"The Houses of Pittsburgh," by Montgomery Schuyler,
Architectural Record, September, 1911.

"Country House Design in the Middle West: Recent Work
by Janssen & Abbott of Pittsburgh, Pa.," by C. Matlack
Price, *Architectural Record*, October 1912.

"A House of Unusual Merit, the Mrs. William Thaw Jr.
Residence, Sewickley Heights," by Benno Janssen
(house designed by George Orth & Bros., architects).
The Brickbuilder, January 1913, p. 7-10.

"Public Votes on Architecture in Pittsburgh" by Benjamin
F. Betts. *The American Architect*, June 1930.

"Quick Studies: Sketches and Sketchbooks by Pittsburgh
Architects." Catalogue, Hunt Library, for exhibit by
Architecture Archives, Carnegie Mellon University,
Pittsburgh, Pa. November 2-December 31, 1993.

"The Rolling Rock Country Club, E.P. Mellon, Architect,"
Architecture, Vol. LII, No. 2. August 1925.

"Mellon Institute of Industrial Research: General
Description of New Building." Janssen & Cocken,
Pittsburgh, Pa. December 28, 1936.

"The Tudor Mansion: Ralph Marshall Dravo House," *The
Bulletin Index*, October 12, 1938.

"What Architecture Has Meant to Me" by Benno Janssen.
The Charette, Vol. 27, No. 6, August-September 1947.
Editor Stephen V. D'Amico. Pittsburgh Architectural
Club.

"Yet Once More O Ye Laurels" by James D. Van Trump.
The Charette, Vol. 115, No. 2, February 1965.

"The Salt and Pepper of Architecture" (ironwork by
Samuel Yellin) by Jane Calihan, *American Heritage*,
Oct. 1995, pp. 96-99. Illustrations include headboard
of bed Yellin duplicated for Edgar J. Kaufmann.

INDEX

NOTES

A. Patton Janssen has been the main source of personal
 information about his father.

Kaufmann's department Store: walls held stylized mural
 paintings, "The History of Mercantilism" by Boardman
 Robinson (1876-1952), who was in Paris when Janssen
 was there as a student. Robinson taught at the Art
 Students League, New York, and was first school director,
 Colorado Springs Fine Arts Center, 1939-47. Oliver
 Kaufmann gave the murals to Pittsburgh History &
 Landmarks Foundation. Some are now at Sheraton
 Station Square. ("Through the Ages," September 1931.
 Vol. 9, p. 23-27.)

Penguin Court: Annette Hoyt Flanders designed the gardens
 in 1939. ("A Century of Women Landscape Architects
 and Gardeners in Pittsburgh" by Judith S. Hull, Heinz
 Architectural Center, Carnegie Museum of Art, 1996.)

Permission has been given by Abbeville Press, New York,
 N.Y., to reprint the quotation from *Fallingwater: A Frank
 Lloyd Wright Country House* by Edgar Kaufmann Jr.

PICTURE CREDITS:

Illustrations are identified by page number:
 ii, Edward Massery. *xii, xiv,* Janssen family.
2-4, Agnes Weber Floyd. *9,* Johnson Schmidt
and Associates. *10,* Janssen family. *19,* Mary
Patton Janssen. *22,* Janssen family. *32, 36* right,
Edward Massery. *36* left, Carnegie Mellon
University Architecture Archives (CMUAA).
37, CMUAA. *38-47,* Edward Massery. *48,*
University of Pittsburgh. *51-53,* Edward Massery.
54, Westin William Penn. *55,* CMUAA. *56*
right and left, Westin William Penn. *57,* Edward
Massery. *58,* Westin William Penn. *59-62,*
Edward Massery. *63,* Larry Rippel, Westin William
Penn. *64-65* right and left, Westin William Penn.
66, CMUAA. *68,* CMUAA. *69,* Donald Miller.
70, CMUAA. *71-75,* Edward Massery. *76,*
Janssen family. *77,* CMUAA. *78,* Janssen family.

 79, Edward Massery. *80* top and bottom, *81,*
CMUAA. *82, 83,* Janssen family. *84,* Edward
Massery. *85* top, CMUAA. *85* bottom, Janssen
family. *86, 88, 89* right and left, *90,* Edward
Massery. *91,* Clare Yellin. *92-93,* CMUAA.
95-96, Edward Massery. *97-98,* Janssen family.
99 right and left, *100* left top and bottom, R. C.
Nelson. *100* right, *101,* Janssen family. *102-103,*
Edward Massery. *104,* Janssen family. *106,*
Edward Massery. *109,* Pittsburgh Photographic
Library, Carnegie Library of Pittsburgh. *110,*
CMUAA. *112,* Pittsburgh Photographic Library,
Carnegie Library of Pittsburgh. *113,* Janssen
family. *114,* CMUAA. *117-118,* Edward
Massery. *119,* CMUAA.

120-121, Edward Massery. *123-128,* Edward
Massery. *130,* Janssen family. *131,* CMUAA.
132, Janssen family. *134,* Edward Massery. *135*
top, CMUAA. *135* bottom, Edward Massery.
136-137, Pittsburgh Post-Gazette. *139* left and
right, Edward Massery. *141-143,* Janssen family.
144, Edward Massery. *145,* CMUAA. *147-151,*
Edward Massery. *152,* Hunt Institute for
Botanical Documentation. *153,* Edward Massery.
154 left, CMUAA. *154* right, Janssen family.
155 top and bottom, CMUAA. *156,* Janssen
family. *157,* Mary Patton Janssen. *159,* Stevens
& Company, Charlottesville, Va.

BOOK PRODUCTION:

Designed by Douglas Price of Maidens, Virginia.
Page layout was produced by designer using a Power
Macintosh 7600/132 computer with QuarkXPress 3.32
and Adobe Photoshop 3.0.5, and a Umax Power Look
scanner. Text was composed in Goudy Old Style
Roman and italic. Text was printed on acid-free 80-lb.
Productolith dull coated paper by Carter Printing
Company, Richmond, Virginia.